PALM SPRINGS ART MUSEUM

A PASSIONATE EYE
The Weiner Family Collection

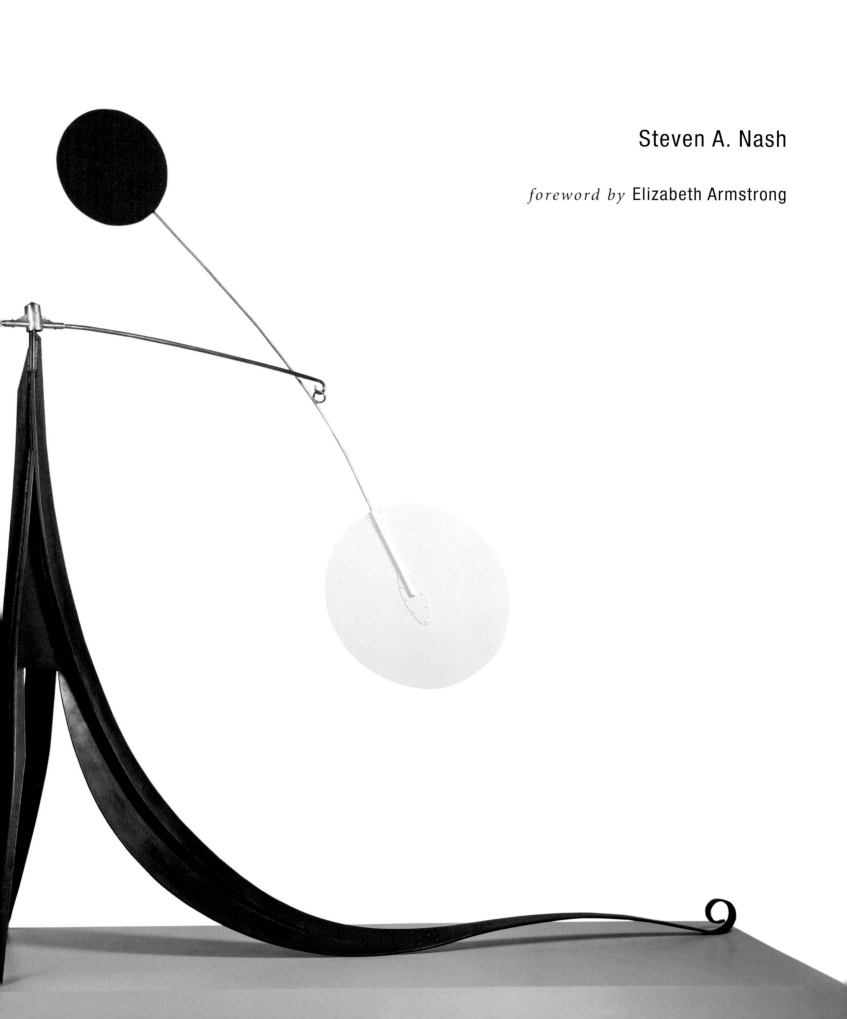

Steven A. Nash

foreword by Elizabeth Armstrong

The exhibition and publication are organized by Palm Springs Art Museum and funded in part by Faye Sarkowsky Exhibition Fund; Contemporary Art Council and its Platinum Sponsors Mary Ann and Charles P. LaBahn; its Silver Sponsors Carol Frankel, Dorothy Goldstein, Katherine and Greg Hough, Sharon and Steven Huling, Robert Moon and Robert Hammack, and Debra and Mickey Star; with additional support from Carol and Jim Egan and Yvonne and Steve Maloney.

Palm Springs Art Museum
101 Museum Drive
Palm Springs, California 92262
psmuseum.org

JACKET FRONT Henry Moore, *Two Piece Reclining Figure No. 3* (detail)
JACKET BACK, FROM LEFT Amedeo Modigliani, *Head* (detail); Jean Arp, *Growth* (detail); Jacques Lipchitz, *Draped Woman* (detail)
END SHEETS Günther Uecker, *Light Disc* (detail)
FRONTISPIECE Alexander Calder, *The Lizard*

ISBN 978-0-9862453-1-2

Library of Congress Cataloging-in-Publication Data

Nash, Steven A., 1944- author.
 A passionate eye : the Weiner family collection / Steven Nash ; foreword by Elizabeth Armstrong.
 pages cm
 "Published on the occasion of the exhibition, "A Passionate Eye: The Weiner Family Collection"
October 3, 2015-January 31, 2016, Palm Springs Art Museum, Palm Springs, California."

 Includes bibliographical references and index.
 ISBN 978-0-9862453-1-2 (pbk.)
 1. Art, Modern--20th century--Exhibitions. 2. Weiner family--Art collections--Exhibitions. 3. Art--Private collections--United States--Exhibitions. I. Armstrong, Elizabeth, 1952- writer of foreword. II. Palm Springs Art Museum, host institution, organizer. III. Title.
 N6488.5.W43N37 2015
 709.04--dc23
 2015023391

EDITOR Ann Karlstrom
INDEXER Jean Patterson
DESIGNER Lilli Colton
PRINTER Overseas Printing, Artron Ltd.
Printed in China

PALM SPRINGS
ART MUSEUM

Published in conjunction with the exhibition
A Passionate Eye: The Weiner Family Collection
3 October 2015 – 31 January 2016

Table of Contents

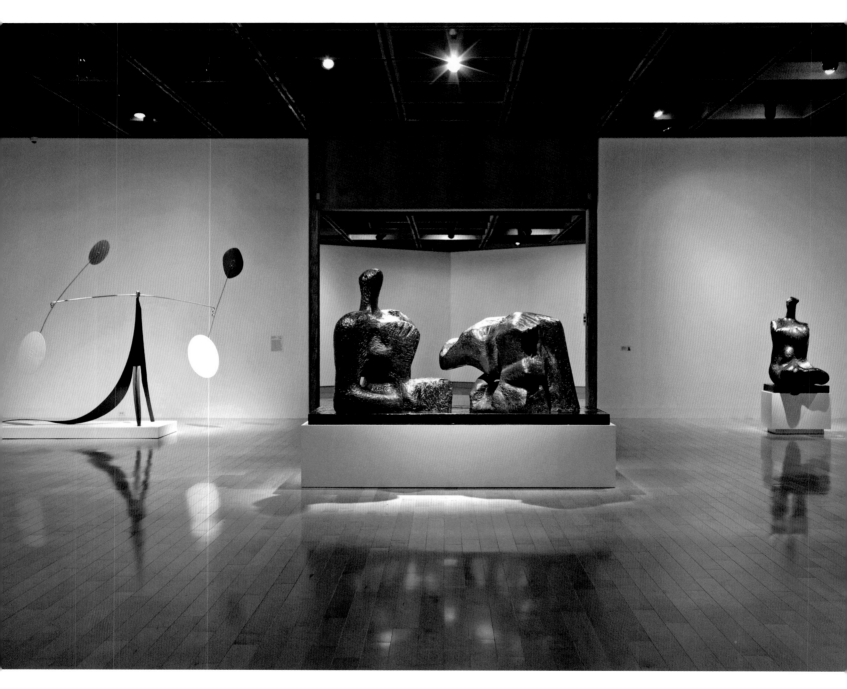

Picasso to Moore: Modern Sculpture from the Weiner Collection,
6 November 2007–19 October 2008, Palm Springs Art Museum

THE PALM SPRINGS ART MUSEUM has been the privileged custodian of one of the country's most important holdings of modern sculpture in private hands in the Southwest. During the 1950s–1960s, Texas oilman Ted Weiner acquired outstanding examples of modern European and American art. Amassed over the course of two decades, the Weiner collection includes such modernist masters as Jean Arp, Alexander Calder, Marc Chagall, Henry Moore, and Pablo Picasso, to name a few.

Foreword

Elizabeth Armstrong
The JoAnn McGrath Executive Director

Ted Weiner, his wife, Lucile, and their daughter, Gwendolyn, lived with this remarkable collection in their home and gardens in Fort Worth, Texas. In the early 1960s, they began to spend time in Palm Springs, where they established a winter home in 1963. Ted Weiner soon joined the museum's board of trustees (1967–79), and it was during this period that the museum began to feature the collection in a series of exhibitions. After these initial shows, much of the collection remained at the museum, including monumental sculptures that formed the core of the outdoor sculpture gardens.

Holdings from the Weiner collection have been on nearly continuous view since the opening of the museum's E. Stewart Williams building in 1978. They have also been featured in numerous exhibitions over the intervening years. Enter Dr. Steven A. Nash, art historian and museum director. In 2007 Dr. Nash moved from Dallas, where he had been director of the Nasher Sculpture Center, to take the reins of the Palm Springs Art Museum. As a scholar of modern sculpture, he was very familiar with the collection, and it was one of reasons he was first attracted to Palm Springs.

One of the first things he did after joining the museum was to contact Gwendolyn Weiner, who had been actively engaged with her father in the acquisition of many of the works in the collection. Their mutual love of sculpture formed the bond of a great friendship. They immediately decided to present a selective exhibition of thirty-four of the finest works from the collection, which was mounted in the fall of 2007, along with a small catalogue. Dr. Nash knew he wanted to do a larger show some day, along with an in-depth catalogue. This handsome exhibition and book, *A Passionate Eye: The Weiner Family Collection,* bring his goal to fruition and, for the first time, provide significant new scholarship and documentation of the works in the collection.

The museum is grateful to Gwen Weiner for her passion for art and patronage of the museum. In addition to sharing this collection on long-term loan, she has made generous

Picasso to Moore: Modern Sculpture from the Weiner Collection,
6 November 2007–19 October 2008, Palm Springs Art Museum

donations of key pieces to the museum. These include Henry Moore's *Two Piece Reclining Figure No. 3* and *Reclining Figure*, Marc Chagall's *Village*, Alexander Calder's *Lizard* (given in honor of the late chairman of the board, Harold Meyerman), Jean Arp's *Growth* (given in honor of Dr. Nash), and Pablo Picasso's ceramic *Owl*. It is an understatement to say that these modern masterpieces have enhanced the story of art that we share with the community at large and with visitors to the museum from around the world.

I also thank Dr. Nash for his heartfelt devotion to this project. His encyclopedic knowledge of modern sculpture and his intimacy with this collection offer a rare chance to understand the unique quality of each and every work on view. We are indebted to him for the insights he provides about this remarkable body of art and the related story of modernism that they tell. He has been supported in this quest by the Palm Springs Art Museum staff.

Finally, we are thankful to the museum's board of trustees, who provide the core support for our exhibitions, publications, and programs on an annual basis. We are extremely grateful to them for their generous and ongoing support. We also thank the Contemporary Art Council and its Platinum Sponsors Mary Ann and Charles P. LaBahn; and Silver Sponsors Carol Frankel, Dorothy Goldstein, Katherine and Greg Hough, Sharon and Steven Huling, Robert Moon and Robert Hammack, and Debra and Mickey Star. Additional sponsors for the exhibition include Faye Sarkowsky, Carol and Jim Egan, and Yvonne and Steve Maloney.

It is the museum's great honor to present *A Passionate Eye: The Weiner Family Collection* and to celebrate the Weiner family with this stunning exhibition and publication. It is our pleasure to share their legacy with our audiences.

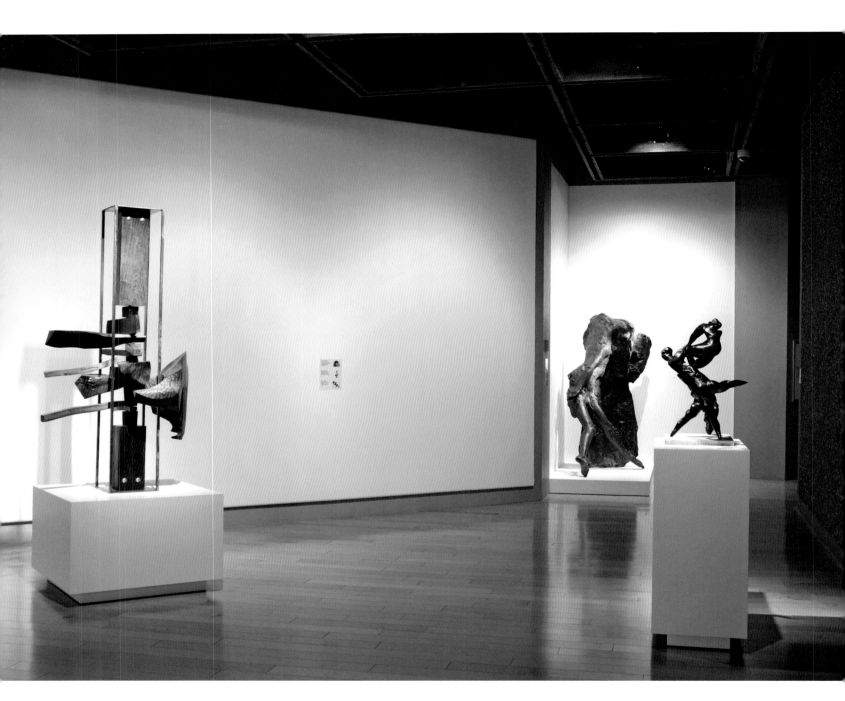

Picasso to Moore: Modern Sculpture from the Weiner Collection,
6 November 2007–19 October 2008, Palm Springs Art Museum

Preface and Acknowledgments

Steven A. Nash

PREPARATION OF THIS CATALOGUE for the exhibition *A Passionate Eye: The Weiner Family Collection* has been a multifaceted journey. The first step was an intense immersion into the Weiner collection, especially the sixty-one works in the exhibition. It involved thorough research on each object, compilation of catalogue entries with scholarly data and art historical analysis, and a campaign of necessary conservation and photography. The second stage was a comprehensive study of Ted Weiner and the history of the collection: its formation, record of exhibitions and publications, and meaning to the Weiner family. Underlying all the documentation is the fascinating story of the man behind the collection who, with the participation of his daughter, Gwendolyn, brought passion, a sharp eye, business acumen, and great determination to his quest to build a significant and personally gratifying collection of great modern art, with a signature emphasis on sculpture. Both segments of this journey were sources of immense pleasure.

Although major segments of the Weiner collection were accorded museum exhibitions in its early years, the catalogues accompanying those shows, while important historical documents, were little more than illustrated checklists. In 2007 the Palm Springs Art Museum presented thirty-four works in an exhibition entitled *Picasso to Moore: Modern Sculpture from the Weiner Collection*. The accompanying small catalogue included a brief history of the collection by Katherine Plake Hough and my essay entitled "The Weiner Collection and Modernism," surveying major trends in modern sculpture and the ways that works from the exhibition relate to them. Subsequently, a publication helping to mark this museum's seventy-fifth anniversary in 2013—*75 Years 75 Artworks: Selections from the Permanent Collection*—presented more in-depth studies of eight works from the Weiner collection.

Beyond these few art historical précis, and despite the renown of many works in the collection, scholarly examination of its contents has been surprisingly limited. On one hand, this relative paucity of information made cataloguing the sixty-one works in the exhibition in a short time-frame quite challenging. But on the other, it called for the kind of work that all art history sleuths enjoy, that is, original research often involving previously untapped sources. Especially useful were the archives of carefully preserved records on the collection maintained by Ted and Gwendolyn Weiner and their different office assistants dating back to the earliest acquisitions. This compilation of correspondence, photographs, notes, invoices, shipping records, and other documents provided the foundation upon which a large part of the historical information in this book was based. Equally if not more important was the information that Gwen Weiner generously provided through many enjoyable conversations during the last few years. Over the course of this research, a great deal of documentation on individual works

Gwen Weiner with Harold Meyerman, chairman of the board of trustees, at the dedication of her star on the Palm Springs Walk of Stars outside the museum on 16 November 2008

emerged as well as a much more complete picture of Ted Weiner, the man and collector, only small glimpses of which have ever come to public attention. The catalogue section of this book should provide useful background, documentation, and interpretation for anyone interested in the collection for decades to come, and the essay on the history of the collection will help others to understand more fully Ted Weiner's accomplishment. It has been an honor and pleasure to get to know this remarkable man more completely.

Many people have contributed time, expertise, and information to the realization of this book and the accompanying exhibition. Foremost among these is Gwendolyn Weiner, museum trustee and leading patron. This project celebrates and honors a history of generous support of the Palm Springs Art Museum from the entire Weiner family stretching back to 1969. An exhibition of the Weiner collection that year at the Palm Springs Desert Museum (as it was then named) brought to this city its first exhibition of internationally famous artworks. From that time onward, the presence in Palm Springs of the Weiner collection has provided an unmatched cultural asset for this region, one respected on an international level. Following upon early gifts of art to the museum by Ted and Lucile Weiner, Gwen has continued to donate works that have become iconic objects in the collection. Also, she has continued to lend on a long-term basis—as many as ninety works at any single time. The importance of these gifts and loans for the Palm Springs Art Museum is inestimable. They make a huge contribution to the museum's meaning and identity and provide one of the primary attractions for our audiences. In the years and months leading up to the completion of this catalogue, Gwen was a constant source of encouragement, friendship, information; and, in the face of a barrage of questions, she exhibited great patience. She also contributed by instructing her office assistants to do essentially whatever was necessary to help get the book completed on schedule. Simply put, it would have been impossible to realize the publication at this level of quality without her.

From the beginning, this project received enthusiastic support from the chairman of the board of trustees at the museum, Harold Meyerman, who was a close friend of Gwen Weiner. Tragically, Harold passed away before the completion of the project, but we think that he would have been proud of its outcome. At the museum, Executive Director Elizabeth Armstrong and Director of Art Daniell Cornell both lent encouragement and advice at key junctures. During my tenure as executive director of the museum, my two executive assistants, Darcy Carozza and Ana Pfaff, provided important help with all manner of logistical organization. Other staff members who deserve a large part of the credit for the project include our superb registration staff:

Alicia Thomas, managing director of registration and collections; Shelley Orlowski, registrar; and Emily Brown, registration assistant. Thanks go to Tom Johnson, exhibitions services manager, and his outstanding exhibitions team for a splendid installation, to Katherine Hough, chief curator, for her assistance with the exhibition budget and proofreading, and to Roy Komassa, who sourced photographs. I am especially grateful to Frank Lopez, archivist and librarian, for his unstinting assistance with research matters, interlibrary loan requests, and archival searches.

Lilli Colton provided a beautiful design for the catalogue and managed the catalogue production process with great efficiency, and Ann Karlstrom lent her characteristically deft hand to the editing and proofing of the catalogue. Alison Leard procured reproduction rights for all images in the book and also provided conservation services. Jean Patterson provided the very helpful index. Steve Colton carried out with outstanding results several conservation treatments on works in the exhibition, and David Blank gave excellent service as object photographer.

The compilation of catalogue entries benefited tremendously from the assistance of many professionals in the worlds of art and libraries across the country: Jacqueline Allen, director of libraries, and her staff at the Dallas Museum of Art; Alexis Curry and staff at the research library of the Los Angeles County Museum of Art; several staff members in the library of the Getty Research Institute; Cathy Spitzenberger, special collections librarian at the University of Texas at Arlington; Mary Landa of the Andrew Wyeth Catalogue Raisonné Project; Sam Jornlis of the Voulkos & Company Catalogue Project; Mary and Julian Ard; Peter Marcelle; Gerald Peters of the Gerald Peters Art Gallery; Dr. Sven Bruntjen; Jed Morse, curator of the Nasher Sculpture Center; Dakin Hart, senior curator of the Noguchi Museum; and Joseph Czestochowski, director, International Arts.

An unsung hero behind this project was the late Kathryn Votaw, longtime assistant to both Ted and Gwen Weiner. Ms. Votaw was directly responsible for the compilation and organization of documents relating to the Weiner collection and Weiner family businesses, without which research for this book would have been drastically hampered. Her role was later carried on by Linda Baird and, more recently, Pat Lorimer, who was a diligent unofficial assistant researcher and helped with myriad details related to the history of the collection. Two artists, Jack Zajak and Gene Owens, were also most helpful with recollections of Ted Weiner and his acquisition of works from them.

Finally, I want to give special recognition to a person who has lent incomparable moral and material support to me over hundreds of museum exhibitions, publications, and events—my wife, Carol Nash.

Steven A. Nash

THE STORY OF TED WEINER and his love of modern sculpture is one of the most remarkable in the history of twentieth-century collecting. Without formal training of any kind or curatorial assistance, Weiner assembled in the 1950s and '60s, in Fort Worth, Texas, a singularly impressive collection of sculpture by modern masters. Among them are Alexander Calder, Pablo Picasso, Amedeo Modigliani, Henry Moore, Jean Arp, and Marino Marini, artists who at the time were still considered radical by many outside the world's leading art capitals. Weiner's history is a chronicle of determination forged in the oil fields of West Texas, trust in personal judgment, and an innate attraction to the expressive forms of modern sculpture. His legacy still thrives in the collection of gifts and loans from the Weiner collection housed at the Palm Springs Art Museum, an inspiring tribute to Ted Weiner's prowess as a collector.

Beginnings

To fully understand the unique quality of this story, it is necessary to know something about Ted Weiner's far-from-privileged early years. He was born in 1911 to an immigrant father from Lithuania who had come to the United States to join his brother in the coal mines of Pennsylvania. His mother was an orphan of Russian descent who married at the age of sixteen. Ted, the eldest of six children, attended the New Mexico Military Institute for one semester but had to drop out when his father lost everything prospecting for oil in Arkansas. Ted then worked as a laborer in Arizona before joining his family to follow the oil boom to West Texas. In 1927 they settled in the humble town of Wink, close to Midland. It was a difficult, hardscrabble life, and even as a very young man Ted was called upon to help support the family by laboring in his father's small metalworking shop. He also had to lend a hand with problems brought about in part by the father's struggles with alcohol and gambling. Ted always said that his boxing lessons as a youth sometimes came in handy!

While still a teenager, Weiner took his first steps into the oil business by constructing a wooden drilling rig that he leased to others in exchange for pieces of wildcatting ventures. Opportunities continued to arise, and after a series of dry holes he finally "got lucky" (in his words) and made the first of what would eventually be a long series of important strikes. He turned out to be an astute businessman with a nose for oil and, surprisingly, for art. He later recounted, "When I got married I owed forty-seven thousand dollars…[from] a real sorry well…. I'd been broke many times, of course, but that was the big one. Then I got lucky and made a good discovery. It was 1938, and the discovery was what turned out to be the Weiner pool, in Winkler County."[1]

Ted Weiner, ca. 1954

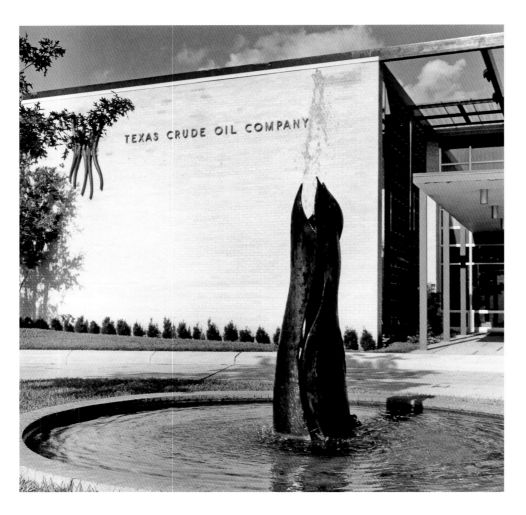

Headquarters of Texas Crude Oil Company in Fort Worth

That discovery was soon followed by others in the same western corner of Texas. As his good fortunes continued, Weiner brought in East Coast investors, who helped promote more expansion and formed or merged with several corporate entities, including his own Texas Crude Oil Company and eventually North American International in New York (where the Weiners maintained an apartment from 1963 onward). These companies eventually owned property and drilling rights not just in Texas, but also in Louisiana and Canada, both onshore and offshore. At an early stage, Weiner brought in his brothers Stanley and Charles as partners.

The year 1938 was indeed propitious for Weiner, as it was also the year of his marriage to Margaret Lucile Clements, a beautiful woman from a small town in West Texas, who had a no-nonsense approach to life. Having become head of the family, Weiner moved his parents to Fort Worth, where life was less strenuous and medical care more abundant. In 1939, he followed with his wife so their daughter, Gwendolyn, could be born there. He established the corporate headquarters of the Texas Crude company in Fort Worth and eventually constructed an office building for its operations. Designed in a fresh midcentury-modern style, that building still belongs to Gwen Weiner, who inherited the oil company from her father, changed its name to Ridgmar Oil and Gas, and continues to run it today. Also in Fort Worth came Weiner's serendipitous first awareness of art and the difference it can make in a person's life.

When furnishing a house he bought for his parents in Fort Worth, Weiner ordered a complete set of new furniture for them. The local store automatically included several paintings in the delivery. Ted later recalled that he was particularly struck by one of these works and realized that the paintings made a big contribution to the overall atmosphere of the house. "I discovered art some 25 years ago… [while] helping my parents decorate a new home…. From that time on, I have been extremely conscious of art in all its forms."[2]

Around this time Weiner was making trips to New York to line up investors. Through his contacts there he visited private residences that often included impressive selections of Impressionist and modern art among the other trappings of cultured life. Coming from West Texas and with limited schooling, he had virtually no experience with important art of any kind, but he became more and more intrigued by what he saw and eventually started visiting museums and galleries. Through this process his life changed dramatically. He discovered that he possessed an innate and never-before-tapped responsiveness to modern art and especially sculpture, which gradually became more and more a centerpiece of what he considered essential in his daily existence and that of his family. And he grew to love the adventure of acquisition—the search and discovery.

Over the course of the next two decades, Weiner collected hundreds of art objects, ranging from ancient Asian and Pre-Columbian art to paintings by young contemporary artists, and from masterpieces to minor objects that struck his fancy. He collected art with the same acquisitiveness that he banked drilling land, and he could act just as impetuously in both arenas. Gwen Weiner relates a story about how, during a visit to Knoedler and Company in New York, her father spotted, hanging in a stairwell, the large painting by Roger de La Fresnaye that is now in their collection (p. 80); he immediately announced that he was going to buy it. His developing tastes might be unabashedly

eclectic, but it was the field of modern European and American sculpture that most engaged his imagination and to which he devoted most of his collecting energy and dollars. Unfortunately, Weiner left very little record of his thoughts about art and what made certain types of art appeal to him with particular power. He seems to have been reticent about what became a dominant passion. (Later in life he was asked about his favorite things in life and replied that, after family, it was art, golf, and business, in that order.) But in trying to answer the question of "Why sculpture?" we can conjecture that there was something about three-dimensional form (and very often massively solid form) that struck a chord with him. It may have appealed to his rugged experiences of work with his own two hands and to an internalized sense of large scale that was an everyday component of life in West Texas. His taste was never for the intimate and delicate. Strong and confident statement was an important part of his understanding of quality in art.[3]

Gwen, Ted, and Lucile Weiner with
The Harpists *by Jacques Lipchitz, ca. 1960*

Birth of a Collection

Critical for Weiner's art education were the close relationships he struck up with several of the leading dealers in New York and eventually in London. Among these were Otto Gerson at Fine Arts Associates, Curt Valentin at Buchholz Gallery and later his own gallery, and Harry Brooks at Knoedler and Co. It was a time when major works by such masters as Pablo Picasso, Henry Moore, Constantin Brancusi, Jacques Lipchitz, and many other pioneers of modern sculpture were readily available. These dealers and others worked closely with Weiner to locate desirable objects and often to help on the financial side by arranging discounts, trades, or other favorable terms. After a short apprenticeship in the ways of the art market, Weiner learned to trust his natural instincts for quality and importance, just as he trusted his instincts in the oil business, and it wasn't long before he was making such major purchases as Arp's *Growth* (p. 44), Lipchitz's *Draped Woman* (p. 84), and Chagall's *Village* (p. 54).

His purchase of the magnificent stone *Head* by Amedeo Modigliani is an excellent example of Weiner's determination when it came to prized acquisitions (p. 102). The sculpture came into the hands of Knoedler and Co., and both Weiner and Harry Brooks realized full well its rarity and special qualities. It was one of only twenty-eight surviving sculptures by Modigliani; his creation of this powerful, roughly hewn block of stone in dialogue with the delicately chiseled face emerging from it has a complexity and strength of expression that set it apart from all other works of its type. Gwen Weiner recalls some of the discussions that took place. As a young woman Gwen enjoyed accompanying her father on business and art trips to New York; her mother,

Interior of Weiner home in Fort Worth with Modigliani stone Head *in the left foreground and Kline* Accent Grave *hanging on the wall*

Lucile, troubled by health problems, including chronic bronchitis, did not travel often. Gwen's early interests in music (she was an accomplished pianist) and study of art and design (she eventually started her own interior design business) helped prepare her for aesthetic decisions, and sometimes she was instrumental in considering important purchases. She remembers well the conflict that existed for both her father and herself as to whether the Modigliani *Head* or another sculpture that Brooks had available, the *Tête de cheval* by Georges Braque, would be the more desirable purchase. And of course, there was a considerable price differential. Brooks sent both works to their home so a decision could be made and, while Weiner first decided on (and made a payment for) the Braque, he and Gwen eventually decided that the Modigliani could not be passed up. Brooks took back the Braque and gave a credit toward the new purchase, but he also agreed to help them try to sell another work to raise additional funds.[4] The Modigliani *Head* has been and always will be the crowning glory of the Weiner collection, and while Gwen was sorry to lose the Braque, the story had a satisfactory ending when a good friend in Dallas who lived around the corner from Gwen purchased the Braque and good-naturedly promised her visitation rights.[5]

Weiner was an entrepreneur through and through, and was never averse to "trading up" in the pursuit of a more favored work. Correspondence in the Weiner family archives reveals that Ted Weiner's dealings with art galleries were almost invariably harmonious and professional. Of course, there were a few exceptions to the rule, as with the time when Weiner discovered that one prominent dealer was manipulating the price on a Marino Marini sculpture that he dearly wanted—*The Warrior* (p. 100), which had been on view at the Spoleto Festival in Italy and the last cast of which still belonged to Marini. Without knowing about the first offer, a different dealer said he could get the piece for Weiner at a price considerably lower. Weiner certainly was not pleased, but even then his correspondence back to the first dealer was calm. He simply said that he wanted a still better price, and he got it.

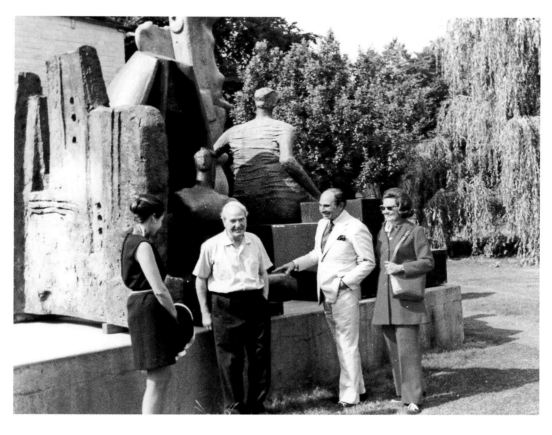

Weiner family visiting with Henry Moore outside his studio in Perry Green, Much Hadham, England, early 1960s. Behind Moore is the bronze Woman from 1957–58, a cast of which Weiner purchased in 1960.

From surviving letters it is apparent that people doing business with Ted Weiner respected him as an honorable and gracious person, and the same degree of mutual respect typified the friendships that Weiner forged with artists. He counted Henry Moore, Jacques Lipchitz, and Alexander Calder among his friends but also struck up meaningful relationships with much younger artists such as Jack Zajac, Gregory Sumida, and the Texas painter Michael Frary. Of all the artists he knew, there seems to have been a special bond with Moore, perhaps partly because of the natural appeal of his work to Weiner, but it was also certainly due to the special congeniality of both men. At one point the collection contained eleven works by Moore, and Weiner and his family greatly enjoyed visits with the artist at his country home and studio at Perry Green. The first of these visits took place in 1959, and further visits were facilitated when Weiner and his family spent several months in London in 1969. Weiner was there to oversee the production of a movie he financed entitled *Arthur? Arthur!,* starring Shelley Winters, Donald Pleasence, and Terry-Thomas. (He had invested in other films and was friendly with many notables from the movie industry, but this production did not do well in distribution, which discouraged further ventures of the kind.) Weiner enjoyed sending Pre-Columbian artifacts to Moore as gifts and sometimes made purchase selections directly on-site. The two men corresponded from time to time, mostly about practicalities such as finding dates to get together, and always with a sense of friendship.

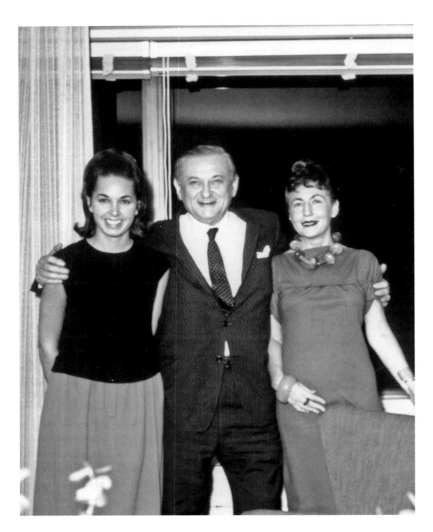

Gwen Weiner with Jacques and Yulla Lipchitz

Similar conditions obtained with Jacques Lipchitz and his wife Yulla. Lipchitz was another artist whose work Weiner collected in depth, and both Jacques and Yulla became close friends of the family, with many mutual visits over the years. Weiner admired Lipchitz as "a man who speaks his mind in no uncertain terms,"[6] and Gwen remembers him as a vigorous person with a great quality of avuncular warmth. He entertained the family, for example, with tales of his life together with Modigliani in early twentieth-century Paris. He recounted to them how his friend acquired the limestone for their wonderful Modigliani stone carving (p. 104) by scavenging building sites around Paris such as excavations for the Metro. He left a particularly strong impression with Gwen when she asked him if he was ever able to transpose completely into sculpture the ideas and images he had in his head, and he answered, "No, never!"[7]

Calder was another artist who had a special place in the collection. As with Moore, a friendly correspondence sprang up, and while Weiner did not own an unusual volume of works, he was able to acquire one of the great standing mobiles, *The Lizard* from 1968 (p. 50), as well as a large hanging mobile.[8] He was also fond of Calder's gouaches (e.g., p. 52). In one special arrangement very meaningful to Weiner and his family, Calder agreed in 1952 to design for their home in Fort Worth a five-foot-high brass fountain, which only recently has re-emerged after years in storage (opposite page).[9] *The Lizard* came into the collection much later from a Calder exhibition at the Fondation Maeght in St. Paul de Vence in the south of France. Ted, Gwen, and Lucile traveled together to see the show and stayed at the famous Colombe d'Or hotel, where Calder was also in residence. Gwen and Ted walked together to the Fondation, and when they entered, father asked daughter what work she liked most. With little hesitation Gwen pointed to *The Lizard*, and a purchase soon followed.

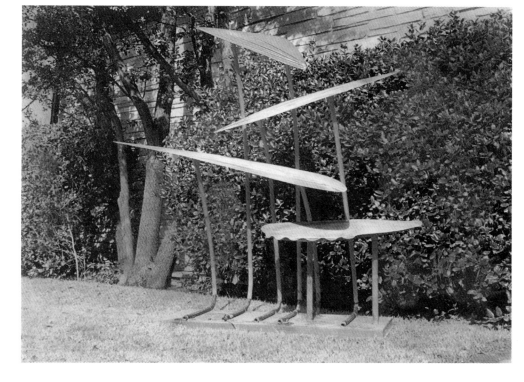

The Calder fountain commissioned by
Ted Weiner in 1952, standing without its
catchment basin

Interior of the Weiner home in Fort Worth,
designed by Edward Larrabee Barnes,
with two Feininger drawings on the wall
and the Calder fountain in the planter box

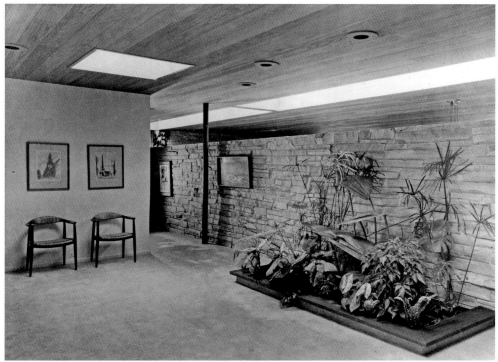

Weiner sculpture garden with Zajac's Deposition II

Weiner's friendships in the art world extended not only among well-known artists but also to young painters and sculptors whose work he found exciting. One such artist was Jack Zajac, who was just coming into his own as a mature sculptor when Weiner made his acquaintance early in 1960 through introductions by their mutual friend, Billy Pearson. Billy was an ex-jockey who became an art dealer in San Francisco specializing in Pre-Columbian works. Weiner had done a considerable amount of business with Pearson, and even had a financial interest in his gallery. Weiner was also establishing his own small gallery operation in Fort Worth, and there were discussions from the beginning about possibly representing Zajac's work. Weiner was enthusiastic about what he saw in photographs of recent plasters and soon became not only a collector, but an ardent supporter who made his best efforts to help Zajac place sculptures in important collections. This led, for example, to extensive discussions with René d'Harnoncourt, director of the Museum of Modern Art in New York, about the possible donation of a large piece for the museum's sculpture garden. These negotiations, unfortunately, did not reach fruition. In the meantime, Weiner was helping to sponsor the casting by Zajac of new pieces in Rome, where he had relocated because of the opportunity to work closely with highly experienced Roman foundries at much lower costs than in the United States. In return, Weiner was given steep discounts on any works he chose to purchase. Through this arrangement he acquired, among other sculptures, the large *Deposition II* (p. 170), a work that demonstrated Zajac's commitment to historic and humanistic themes at a time when such subjects were widely out of favor.

Zajac remained a good friend of the family from that time on and remembers Ted Weiner as "a very kind and generous man." [10] One story he likes to relate concerns a meeting in New York when Weiner proposed to take the artist to dinner at the 21 Club. Zajac showed up in casual clothes, so Weiner had to lend him a jacket and tie in order to meet the club's dress code; after dinner he told Zajac just to keep everything.

Similarly supportive relationships existed with two other artists whom Weiner hoped to introduce to larger audiences—the Italian sculptor Eros Pellini and the American watercolorist Gregory Sumida, both of whom Weiner patronized with extensive purchases. Pellini (p. 134) was the son of turn-of-the-century Symbolist sculptor Eugenio Pellini (p. 136). Weiner discovered his work during a visit to Milan and responded favorably to its conservatively modern blend of naturalism and subtle stylizations. He developed plans to promote his work in the US, which began with the donation of a large sculpture to the Fort Worth Art Association. He also gave pieces to influential friends in Texas and Hollywood and offered works for sale through his Fort Worth gallery. Similar enthusiasms and promotional efforts extended to Sumida (p. 154), a gifted painter with watercolors and gouache, whom Weiner appreciated as a distant protégé of Andrew Wyeth (see p. 166), and whose work also falls into the area of conservative modernism. Again, Weiner made numerous purchases and worked hard to place the paintings with other dealers. In both cases, his efforts met with only limited success, but the good will and encouraging intentions with which he approached such ventures are another measure of his generous spirit.

A New Home for Sculpture

The 1950s were a foundational period for the Weiner collection, during which it acquired important works by Arp, Picasso, Marcks, Chagall, Lipchitz, Laurens, and Moore, among others. Some of these early choices must have seemed adventuresome for a beginning collector. Jean Arp's *Growth* is a sleekly modeled abstraction in the reductive mode pioneered by Constantin Brancusi; its acquisition shows Weiner stepping into an area of highly refined modernism. And Lipchitz's *Sacrifice* (p. 90) is a particularly powerful expression of wartime angst.

Interior of the Weiner home in Fort Worth showing Picasso's Angry Owl, *Degas's* Bather, *Moore's* Mother and Child: Hollow, *a sculpture of a lioness by Gerhard Marcks, and Picasso's* Dancers *vase*

Acquisition activity then reached new levels around 1960–62. In that three-year period alone, Weiner purchased six bronzes by Moore, including a triad of large-scale figures—*Reclining Figure, Two Piece Reclining Figure No. 3*, and *Woman* (pp. 112, 124, and 116)—all of which have the large scale and strong impact that Weiner especially esteemed in sculpture. And he also added works by Richier, Butler, and Noguchi (pp. 146, 48, and 126). Those were soon followed in 1963 by the Modigliani *Head* and Marini *Warrior* (p. 100).

This does not include the many works by Texas sculptors that Weiner also enthusiastically acquired, among which were over ten works each by Charles Umlauf and Charles Williams, two of the deans of Texas sculpture in the 1940s and '50s who helped significantly to introduce modernism into the state's discourse on sculpture. Numerous paintings by young contemporary artists, including several from Texas, such as Michael Frary, also came into the collection around this time, most of which were installed in the family home and Weiner office building.

Below left: Fort Worth arts patrons Ruth Carter Johnson and Lucile Weiner loading Picasso's Angry Owl *into a car for delivery to the hotel suite that President and Mrs. Kennedy would occupy the night before his assassination.*

Below right: Detail of a marble bench entitled Earth Mother, *designed for the Weiner garden by Charles Williams in 1958.*

26

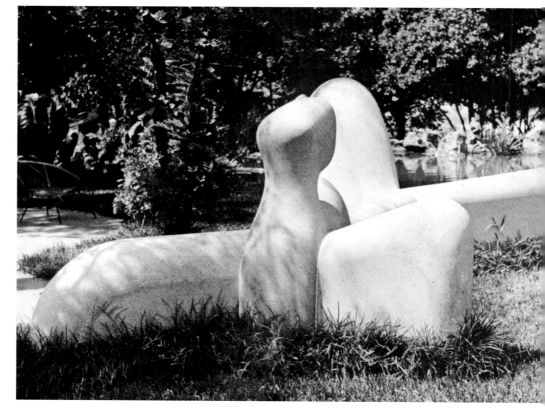

An exhibition of the Weiner collection held at the Fort Worth Art Center in 1959 totaled fifty-seven works, all sculptures except for the painted ceramic mural by Chagall. The Weiners were exceptionally generous in lending works to exhibitions in Texas and neighboring states, and shows drawn strictly from their collection were held in Houston, Corpus Christi, Little Rock, Wichita, Oklahoma City, and Austin. For an especially large collection survey in 1966 at the Art Museum of the University of Texas, ninety works were selected. And again, this show consisted almost exclusively of sculptures, with only two paintings, by Roger de La Fresnaye and Nicolas de Staël, and a handful of drawings by Franz Kline, Lyonel Feininger, and Aristide Maillol. Paintings were never a focus for Weiner, and the only major examples he acquired, besides the ceramic mural by Chagall, were La Fresnaye's *Landscape with Woman, Cow, and Dog,* an abstraction and a nude by de Staël,[11] and an important study of a standing figure by Francis Bacon. The latter two were eventually traded.

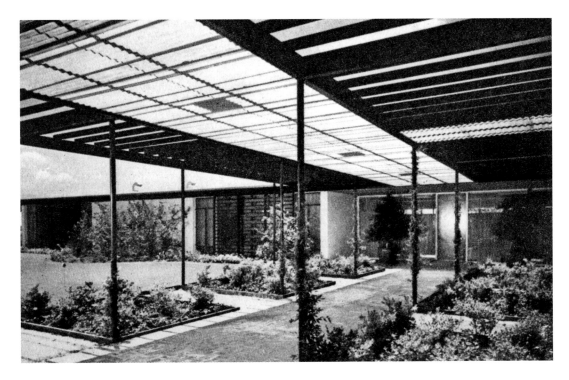

Main entrance to the Weiner house partially roofed with a trellis of translucent plastic

Weiner must have somehow envisioned back in 1949 the breadth and depth the collection would attain one day, because he began planning at that early point to build a proper showcase to house it. He later recalled that, as the collection began to grow, he "soon realized that we needed a place to house our purchases. And so in 1951 when we built our house in Fort Worth, we built it to be compatible with art and particularly sculpture.... And after the house came the gardens, which were several years in the making."[12] He acquired a 6-½-acre parcel of land in western Fort Worth and teamed up with young New York architect Edward Larrabee Barnes to design a house in what would become a large, rolling, heavily landscaped sculpture park.

Barnes was a particularly prescient choice. He was not well known at the time but later gained acclaim for several museum buildings distinguished by a fine sensitivity for the

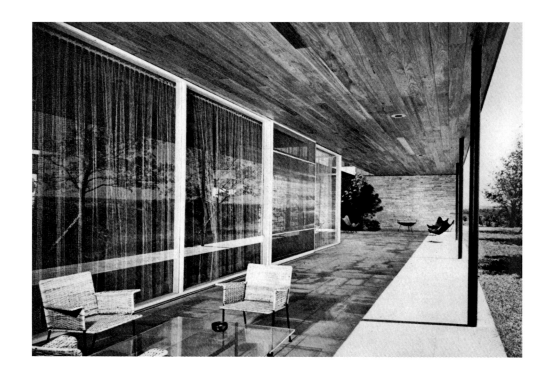

Right: Overhung terrace on the rear of the Weiner house, showing the strong influence of Mies van der Rohe

Below: Exterior glass wall of the Weiner house, looking out onto the sculpture garden

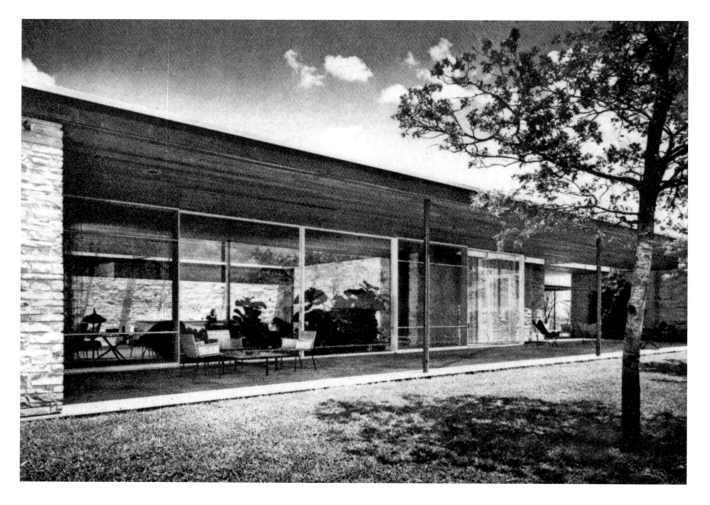

display of art. He planned a pavilion-style post-and-beam structure very much in the tradition of Mies van der Rohe's international modernism, a movement that had not previously reached Texas.

It was strongly rectilinear and horizontal, with a grace of proportion, an easy flow of space, and an abundant use of stone and wood to bring warmth and texture into the clean geometry of form. Expanses of glass beneath flat overhangs looked out onto terraces and lushly planted grounds leading downward through stands of trees.[13]

Weiner consulted a landscape designer and lighting expert from Dallas but also played a direct and important role himself in development of the garden. He brought in hundreds of truckloads of Palo Pinto sandstone to build waterways, ponds, and rock gardens. This was so massive an undertaking that Weiner's friend and golfing partner, the professional Ben Hogan, nicknamed him "Rocky." Once the grounds were prepared, Weiner interspersed sculptures throughout the park in view corridors and other carefully selected locations to create interactions of art and nature both dramatic and intimate. Sculptor Charles Williams wrote about his assistance in the construction of the garden with foundations and bases for sculptures and added, "I have shared the excitement of opening crates, and watched with interest the intense delight in Mr. Weiner's face as the newest acquisition came into view."[14] Documentary photographs show just how pleasurable the experience of walking those grounds must have been. It ranks as one of the most remarkable private enclaves ever conceived for modern art in general, but especially modern sculpture.[15]

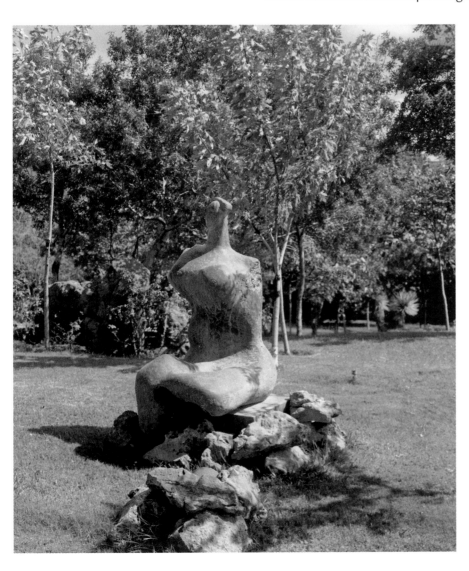

Henry Moore's Woman *installed in the Weiner sculpture garden*

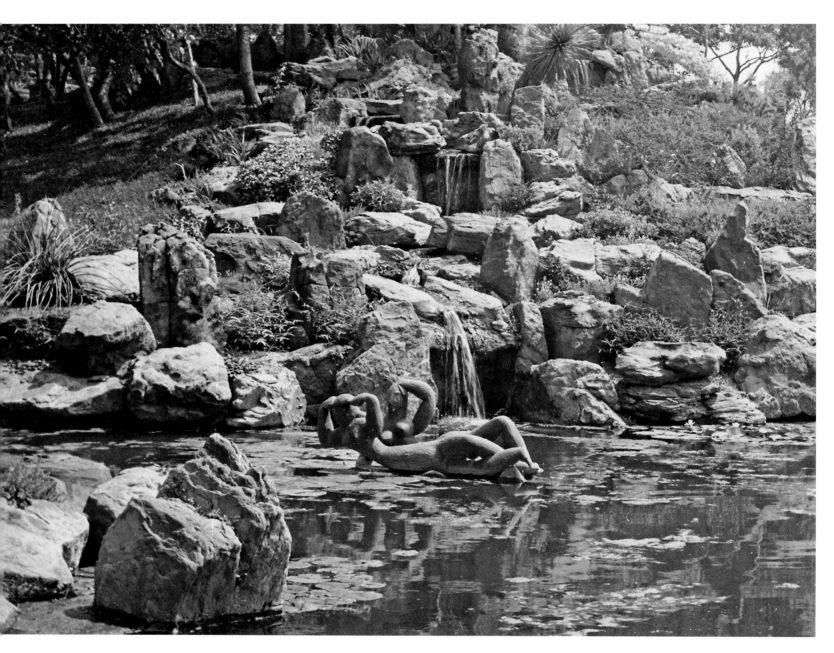

Henri Laurens's Ondines *installed in a pool in the Weiner sculpture garden in front of a rock garden with waterfall that Ted Weiner added to the landscape*

The Move to Palm Springs

The Weiner home and garden quickly became well known as an outstanding destination for art tours and photographic essays. In 1961, John Bainbridge included a profile of Ted Weiner in his colorful book centered on the Texas oil industry entitled *The Super-Americans: A Picture of Life in the United States, as Brought into Focus, Bigger than Life, in the Land of the Millionaires—Texas*.[16] And the BBC followed suit with a short film on Weiner in 1965 that highlighted his accomplishments both as an oil man and as an art collector.[17]

Growth of the collection continued throughout the 1960s but reached a crescendo in the last two years of that decade, perhaps in anticipation of another large exhibition scheduled to open in November 1969 at the Palm Springs Desert Museum, as the museum was named at that time. Because of the favorable effects of the climate on her health, Lucile took an apartment in Palm Springs in 1961, and Gwen and Ted visited frequently. Ted also enjoyed it for the accessibility to his Hollywood friends, many of whom had residences there, and for the abundant golfing opportunities. He was an ardent golfer and played every day if circumstances allowed. He also took an interest in the Palm Springs museum, which was located at the time on Tahquitz Drive in the very center of town, in a modest-sized but beautifully designed modernist building. Under the dynamic leadership of its director Frederick Sleight, the museum was beginning to favor the fine arts more and more in its divided mission between natural history and art. Important collectors such as Joseph Hirshhorn and Walter and Leonore Annenberg were involved and helped raise the museum's ambitions for a strong program of modern art, setting the stage for the introduction of the Weiner family into the city's cultural life. Weiner soon joined the museum's board, and he bought a family house in the Vista las Palmas area of the city.

Left: Ted Weiner in front of a helicopter in a photograph staged by the director of the BBC film Inside America: The Oil Man *in 1965*

Right: Ted Weiner with Kirk Douglas and Howard Hawks on the Indian Canyons golf course in Palm Springs

As the family spent more time away from their Fort Worth home, Weiner began to think about the ultimate disposition of the collection and garden, a subject of the greatest seriousness for him as well as for his wife and daughter. A collection of such size, featuring many large sculptures, presented definite management challenges and was not something that could easily be moved. Concerns about holding the collection and garden intact as a vital cultural asset must have weighed heavily in Weiner's mind, along with the competing pride of accomplishment and desire for continued safekeeping. Whatever his exact thinking may have been, he decided to offer the collection and the land it occupied to the city of Fort Worth.

Developed around cattle and oil businesses, Fort Worth had a strongly western character but also growing cultural aspirations. In the visual arts, the Fort Worth Art Association, where Weiner had been actively involved, presented consistently interesting exhibitions. Also, the Amon Carter Museum of American Art and the Kimbell Art Museum, both nascent institutions at the time, enjoyed promising futures, thanks to the generous patronage of their respective founders. The addition of the Weiner collection as another gem in this crown of strong art programs had to represent an attractive proposition for city leaders.

The Palm Springs museum may also have entered Weiner's thoughts on this subject. Certainly the museum extended itself to impress upon the family its own candidacy for consideration in plans for the future of the collection. The title alone of the exhibition the museum was planning with Weiner for 1969—*Modern Sculpture from the Weiner Palm Springs Collection*—was a clear indication of such desires. And Weiner's aggressive collecting in the months leading up to the exhibition signaled his intention to make the show as spectacular as possible. Calder's *Lizard* was purchased just in time for the exhibition. After its appearance at the Fondation Maeght in the summer of 1969, it traveled on to another iteration of the same exhibition at the Louisiana Museum of Modern Art in Denmark; the dealer who made the sale, Jeffrey Loria in New York, was barely able to have it transported to the United States and cleared through customs in time for the opening. And five other key works were acquired in the months leading up to the show, undoubtedly with an eye to enhancing the exhibition: Lipchitz's *Harpists*, Moore's *Stringed Figure: Bowl* (p. 106), Zadkine's *Seated Figures*, Marini's *Horse and Rider*, and Manzù's *Cardinal* (p. 94).

For the exhibition's opening celebration, invitations went out to the Weiners' list of over two hundred prominent friends and associates, and the museum made a concerted, and successful, effort to attract Henry Seldis Jr., art critic for the *Los Angeles Times*, to Palm Springs to review the show in depth. Museum directors from all over the country were invited, and a full-scale campaign was made to generate as much publicity as possible.

The show was a huge success and, if nothing else, signaled to the world that the Palm Springs Desert Museum had reached a level of maturity where it could organize exhibitions of not just regional but also international importance. The momentum gathered by the museum through this exhibition was a large factor in its soon-to-come campaign to build a new and much larger facility, an effort that reached fruition in 1976 with the opening of a 75,000-square-foot facility (later expanded to 150,000 square feet) designed by desert-modern architect E. Stewart Williams.

Installation photograph of a section of the Weiner collection exhibition at the Palm Springs Desert Museum in 1969

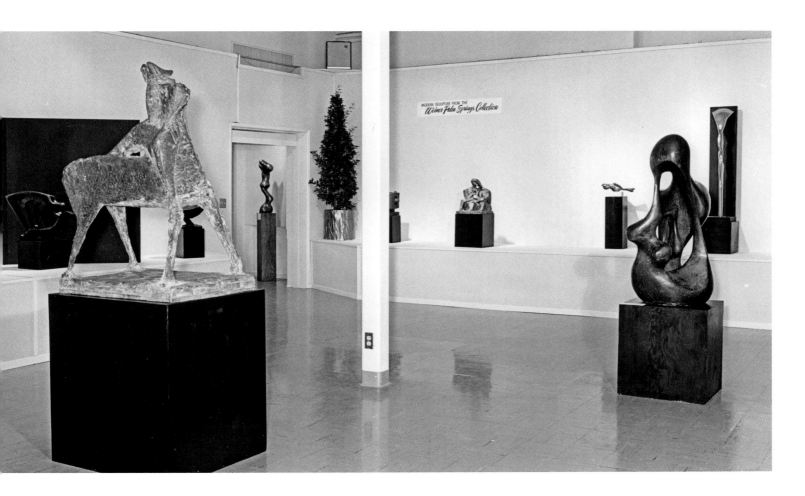

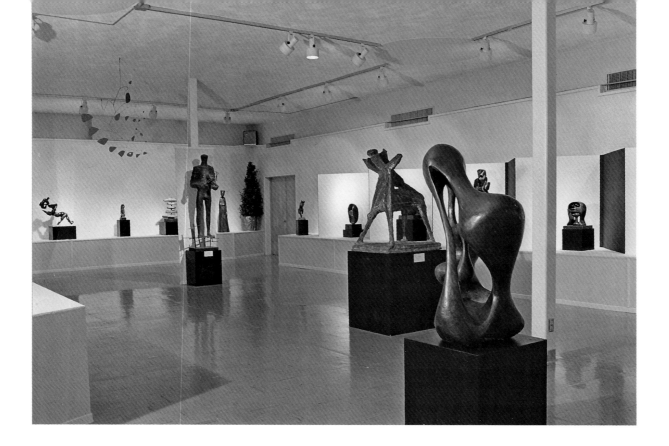

Another view of the Weiner collection exhibition at the Palm Springs Desert Museum in 1969

But the fate of the Weiner collection still rested in the hands of Fort Worth civic leaders. An article in the Fort Worth *Star-Telegram* of 30 June 1971, entitled "Oil Man Just Can't Give Gardens to City," recapped the prolonged negotiations that took place between Weiner and various Fort Worth officials concerning his offer to donate the collection and garden to the city. It begins, "Former Fort Worth oil man Ted Weiner says he made repeated attempts to give his famous gardens, containing millions of dollars worth of sculpture, to Fort Worth, but was not successful." Weiner expressed frustration over the outcome, saying that his prime consideration in making the offer to the city was to keep everything intact. The newspaper's investigation into negotiations revealed that the main reason for the city's decision not to accept the offer was one of costs associated with the care and maintenance of so large a tract of land and so many works of art. Weiner estimated annual maintenance costs for the gardens at $100,000, and while the various art museum officials interviewed all expressed deep regret over the loss of the collection, they mostly pointed out that the annual operating costs would be a large burden. One official expressed the opinion that the inability to bring individual works into the different museums was a major drawback, and another thought that management of a site so distant from the close-knit complex of three art museums on the near west end of Fort Worth would have been problematic.

From his winter residence in Palm Springs, Weiner announced that, as a result of this failure to reach agreement with Fort Worth, the collection would instead go on long-term loan to the city of Palm Springs. He also mentioned plans for outdoor gardens near the city center populated with sculptures from his holdings.

From the time of that announcement of collection plans onward, highlights of the Weiner collection have remained an unsurpassed cultural treasure for Palm Springs, its art museum, and the entire region. As plans developed for the museum facility designed by E. Stewart Williams on Museum Drive (which was completed in 1976), thought was given to expansive, landscaped open spaces with water features in front of the museum where selections from the Weiner collection could be installed. Those plans did not materialize, but soon after the new museum opened, it featured an installation of the huge *Warrior* by Marino Marini at the museum's front entrance. It was a gift from the Weiner family, in addition to important loans both in and outside the museum, including Moore's *Two Piece Reclining Figure No. 3*. Out of gratitude for the support the Weiner family provided the museum dating back to its 1969 exhibition of their collection, the landing around the museum entrance was dedicated in 1978 as the Ted Weiner Sculpture Terrace. Tragically, Weiner had developed health problems

J. R. Hollingsworth for Williams, Clark, and Williams: Architectural rendering of the Palm Springs Desert Museum, watercolor, 1972. The sculpture garden that had been envisioned as a walkway leading to the building's front entrance was never realized.

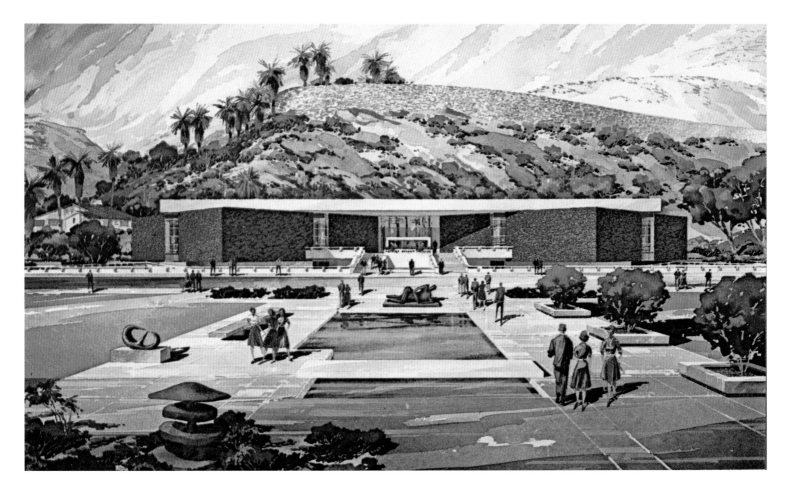

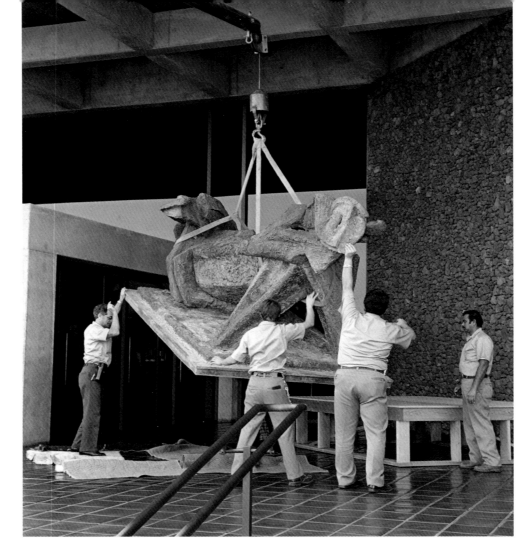

Marino Marini's Warrior being installed on the Ted Weiner Sculpture Terrace of the Palm Springs Desert Museum in 1978

Lucile, Ted, and Gwen Weiner standing at the entrance to the Palm Springs Desert Museum in front of their gift of Marino Marini's Warrior at the time of the dedication of the Ted Weiner Sculpture Terrace in 1978

in the early 1970s, and what was at first thought to be kidney failure was later diagnosed as multiple melanoma. Ted Weiner died just one year after the dedication, but his commitment to the museum has been carried forward by Gwen Weiner. Her many loans and ongoing gifts from the collection, as well as her support in other ways, including her graciously shared passion for art, are a true Weiner legacy.

Ted Weiner the Collector

Ted Weiner was a man of many interests. Husband and father, oil wildcatter, business manager, golfer, executive in oil associations, movie producer, architectural and landscaping planner, art lover and collector—his was an active life, and he lived it to the fullest. It is not hard to see that the gusto with which he approached life in general also characterized his collecting. But was there any underlying methodology to his purchases? Once asked if her father had a sense of curatorial concerns while building the collection, such as "filling gaps" or following critical judgments, Gwen answered, "No, it wasn't about what critics or historians thought. It was about personal intuition."[18] That character trait seems to have been true for Weiner whether he was prospecting for oil, choosing a little-known architect to build his dream house, or selecting works from an exhibition. In one of the few statements we have from Weiner concerning his motivations as a collector, he talked about his first awakening to art through those paintings shipped to his parents' house. And he continued, "As to my own collection, I have difficulty remembering the purchase of a single piece, but I will never forget the discovery of each one. The collection and the garden seem to have slowly taken shape, not from my own creativeness, as I only bought the art, but as the result of the imaginative powers of others—the artists."[19]

The Weiner collection is large in overall numbers but its core holdings are more limited in scale—around seventy to eighty works in different media, primarily three-dimensional. Although not assembled with an eye to documenting a historical narrative, the collection does cover a broad sweep of modernist developments. From works by Edgar Degas and Eugenio Pellini in the late nineteenth-century figurative tradition, to Cubism, Surrealism, Arp's purified abstraction, the multiple styles of Picasso and Moore, the Constructivist tradition, postwar Expressionism, and a variety of sculptural directions in works from the 1950s and '60s—the collection has historical range, if not by design, then by instinct.

Of course, Weiner had his favorite artists, and high on that list were Henry Moore, Jacques Lipchitz, and Alexander Calder. Each one had a clear and strongly resolved expressive viewpoint, a quality that appealed to a man who operated according

to decisive action. He became friendly with all three, which certainly affected his patronage of their work, but more important was his natural predilection for the art. It is interesting to note that his selections from each, whether guided consciously or subconsciously, spell out different key phases of their careers.

Ted Weiner's history as a collector resembles that of numerous other American businessmen who, with little or no formal education in art history or experience in the art market, followed their individual vision and passion and built major art collections of one kind or another. Commonly shared traits between such collectors include, for example, outstanding business acumen, determination, a thirst for knowledge, and often a desire to leave behind a notable cultural legacy, all qualities that clearly apply to Ted Weiner. Other factors, however, set him apart. According to some who knew him well, his was a complex, even enigmatic, personality. For all his high spirits and generosity, he could also be shy, inward, and ill-at-ease in social settings. Part of this was self-consciousness about his limited formal education, something he overcame through voracious reading on a wide variety of subjects. On one hand, he loved the adventure of risk, enjoyed challenge, and had a keen sense of humor, but on the other, he was private, self-effacing, and exceptionally thoughtful. Gwen Weiner has pointed out that wealth for him was never an end in itself. It was a way out of poverty and a means to other ends, including the collecting of art and support for young artists. These pursuits gave him joy, his ultimate motivation.

Ted Weiner will always have a place in the history of modern art, for his powerful attraction to the expressiveness of modern sculpture, the fact that he navigated the complex field of art collecting with very little help from outside advisors or consultants, and his conception and realization of a unique venue expressly suited for the installation and delectation of sculpture. His nearly exclusive self-reliance in acquisition decisions occasionally led to problems in areas where he was not well-versed, but in modern sculpture his instincts were astute.

Today, when the building of sculpture gardens is a more and more common phenomenon, it is easy to forget how few large-scale parks or gardens custom-tailored for outdoor sculpture existed in America in the 1940s and '50s. Ted Weiner lived life and collected art on his own terms, and should be remembered as the visionary he truly was.

Lucile, Ted, and Gwen Weiner at the opening of the Weiner collection exhibition at the Palm Springs Desert Museum in 1969

NOTES

1 John Bainbridge, *The Super-Americans: A Picture of Life in the United States, as Brought into Focus, Bigger than Life, in the Land of the Millionaires—Texas* (Garden City, New York: Doubleday and Co., 1961, 73.

2 Austin 1966, 3.

3 Gwen Weiner attributes some of her father's innate love of art to his mother who, despite a hard life, always had an appreciation for things decorative and visually pleasing. The mother's brother was an accomplished amateur artist, who helped promote Gwen's early interest in art and her desires to paint.

4 The urge to make a deal was almost as big a part of Weiner's collecting life as it was his business life, and in the quest to improve the collection he traded or sold several works that may later have caused regrets. One loss that Gwen Weiner has always bemoaned was a wonderful Calder mobile entitled *Sumac*, and important works by Moore and Francis Bacon were also relinquished in trades.

5 This was Margaret McDermott, a legendary collector and arts patron in Dallas. Coincidentally, the McDermotts lived just around the corner from land on which Gwen later built a house for herself, so the Braque was in the same neighborhood.

6 Letter to Henry Moore dated 31 October 1963. Weiner family archives, Fort Worth.

7 From conversations between the author and Gwen Weiner, August 2007. The degree to which Lipchitz became almost a member of the family is indicated in a letter from Henry Moore to Weiner dated 13 November 1963: "I am very touched by what you tell me—Jacques Lipchitz polishing the Henry Moore RECLINING FIGURE because he thought it would look better waxed. I like him very much indeed." Letter in the Weiner family archives in Fort Worth.

8 See note 2.

9 The fountain was commissioned through the Curt Valentin Gallery. The unpainted brass "model" is preserved more or less intact, while the painted outdoor version exists in pieces and requires a complete restoration. It nevertheless is exciting to be able to add this work, in its two forms, to the corpus of published sculptures by Calder.

10 Conversations with the author, 24 March 2015.

11 Illustrated in Austin 1966, 9.

12 Quoted in a letter from Weiner's secretary to the Palm Springs Desert Museum, 7 October 1969. Archives of the Palm Springs Art Museum.

13 The Barnes-designed house was accorded the honor of inclusion in an exhibition at the Museum of Modern Art in New York in 1952 of forty-three exemplary modernist buildings constructed in the United States after World War II. The show was accompanied by a catalogue that included a preface by Philip C. Johnson: Henry Russell Hitchcock and Arthur Drexler, eds., *Built in USA: Post-war Architecture*, exh. cat. (New York: Museum of Modern Art; distributed by Simon and Schuster, 1952).

14 Introduction to Wichita 1965, 3.

15 The house survives but is currently undergoing major renovations, and the grounds have been converted into a housing development that retains much of the beauty of the landscape. One interesting feature that Weiner had hoped to add to the garden was a Buddhist temple designed by Isamu Noguchi. Plans for the temple had been exhibited in Noguchi's exhibition at the Fort Worth Art Center in 1961. Weiner contacted Noguchi to ask if he would agree to have the temple constructed in Fort Worth, and Noguchi agreed, but the project stalled and Noguchi never did find a venue for his temple. (Correspondence in the Weiner family archives in Fort Worth.) Weiner did add various Asian artifacts to the garden including a group of headstones that he acquired from a Buddhist cemetery in Japan.

16 Garden City, New York: Doubleday & Co., 1961, passim.

17 This documentary on Weiner was a 30-minute film entitled *Inside America: The Oil Man*. It was part of a series of short films on prominent Americans produced by the BBC television documentary division. Charles Denton was director. A copy of the film without its soundtrack exists in the Weiner family archives.

18 Conversations between the author and Gwen Weiner, August 2007.

19 Austin 1966, 3.

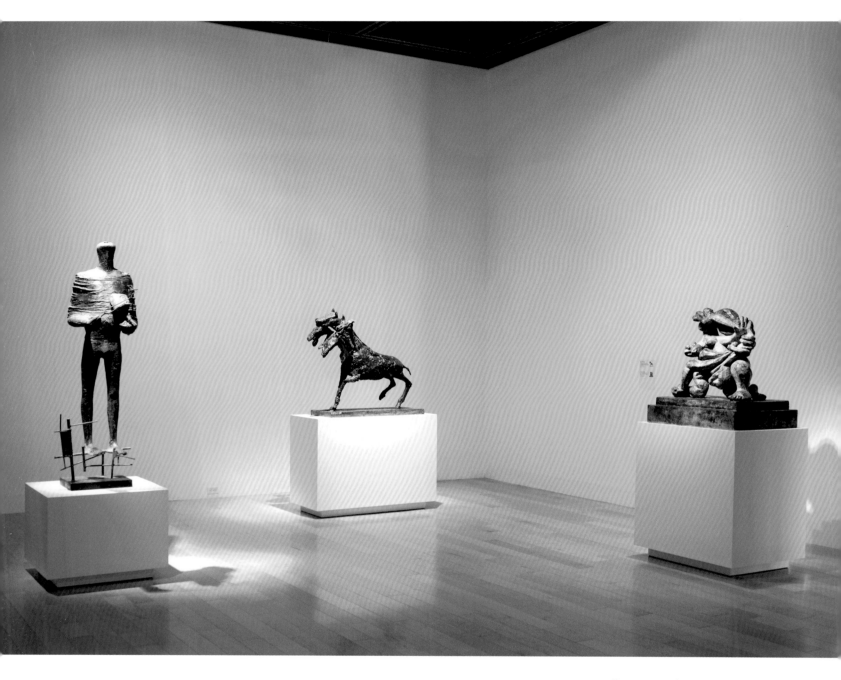

Installation view of sculptures from the Weiner collection at Palm Springs Art Museum in 2007

THE COLLECTION

Abbreviated References

Argan 1972 | Argan, Giulio Carlo. *Henry Moore*. New York: Harry N. Abrams, 1972

Austin 1966 | Austin: Art Museum of the University of Texas. *An Exhibition of the Collection of Mr. and Mrs. Ted Weiner*. Exh. cat. Austin: Art Museum of the University of Texas, 1966

Barañano 2009 | Barañano, Kosme de. *Jacques Lipchitz: The Plasters, A Catalogue Raisonné 1911–1973*. Bilbao: Fundación Bilbao Bizkaia Kutxa, 2009

Biller 2008 | Biller, Steven. "Maverick Vision." In *Art and Culture, Palm Springs Life* (Winter/Spring 2008) 26–31

Compton 1988 | Compton, Susan, et al. *Henry Moore*. Exh. cat. London: Royal Academy of Arts, 1988

Fort Worth 1959 | Fort Worth Art Center. *The Sculpture Collection of Mr. and Mrs. Ted Weiner*. Exh. cat. Fort Worth: Fort Worth Art Center, 1959

Garrould | Garrould, Ann. *Henry Moore: Complete Drawings*. 7 vols. London: Henry Moore Foundation and Lund Humphries, 1994–2003

Grohmann 1960 | Grohmann, Will. *The Art of Henry Moore*. New York: Harry N. Abrams, 1960

Hammacher 1960 | Hammacher, A. M. *Jacques Lipchitz: His Sculpture*. New York: Harry N. Abrams, 1960

Hedgecoe 1968 | Hedgecoe, John, and Henry Moore. *Henry Moore*. New York: Simon and Schuster, 1968

Houston 1964 | Houston: Contemporary Arts Museum. *Collection of Mr. and Mrs. Ted Weiner*. Exh. cat. Houston: Contemporary Arts Museum, 1964

La Jolla 1970 | *Modern Sculpture from the Palm Springs Collection of Mr. and Mrs. Ted Weiner*. Exh. La Jolla Museum of Art, 1970

Lipchitz 1972 | Lipchitz, Jacques, with H. H. Arnason. *My Life in Sculpture*. New York: Viking Press, 1972

Lund Humphries | Lund Humphries. *Henry Moore: Complete Sculpture*. 6 vols. London: Lund Humphries, 1957–1988 (various authors)

Melville 1968 | Melville, Robert. *Henry Moore: Sculptures and Drawings 1921–1969*. New York: Harry N. Abrams, 1968

Mitchinson 1998 | Mitchinson, David, et al. *Celebrating Moore*. Berkeley and Los Angeles: University of California Press, 1998

Nash and Hough 2007 | Nash, Steven, and Katherine Plake Hough. *Picasso to Moore: Modern Sculpture from the Weiner Collection*. Exh. cat. Palm Springs: Palm Springs Art Museum, 2007

Otterlo 1968 | Otterlo: Rijksmuseum Kröller-Müller. *Henry Moore*. Exh. cat. Otterlo: Rijksmuseum Kröller-Müller, 1968

Palm Springs 1969 | Palm Springs Desert Museum. *Modern Sculpture from the Weiner Palm Springs Collection*. Exh. cat. Palm Springs: Palm Springs Desert Museum, 1969

Read 1965 | Read, Herbert. *Henry Moore: A Study of His Life and Work*. London: Thames and Hudson, 1965

Seldis 1973 | Seldis, Henry. *Henry Moore in America*. New York: Praeger Publishers, 1973

75 Years 2013 | Steven A. Nash, et al. *75 Years 75 Artworks: Selections from the Permanent Collection*. Palm Springs: Palm Springs Art Museum, 2013

Wichita 1965 | Wichita Art Center. *Collection of Mr. and Mrs. Ted Weiner*. Exh. cat. Wichita: Wichita Art Center, 1965

Wilkinson 1987 | Wilkinson, Alan G., et al. *Henry Moore Remembered: The Collection at the Art Gallery of Ontario*. Exh. cat. Toronto: Art Gallery of Ontario, 1987

Wilkinson 1989 | Wilkinson, Alan G. *Jacques Lipchitz: A Life in Sculpture*. Exh. cat. Toronto: Art Gallery of Ontario, 1989

Wilkinson 1996 | Wilkinson, Alan G. *The Sculpture of Jacques Lipchitz: A Catalogue Raisonné. Volume One, The Paris Years 1910–1940*. London: Thames and Hudson, 1996

Wilkinson 2000 | Wilkinson, Alan G. *The Sculpture of Jacques Lipchitz: A Catalogue Raisonné. Volume Two, The American Years 1941–1973*. London: Thames and Hudson, 2000

Notes to the Catalogue

The lists of literature and exhibitions contain the selections most pertinent to the object presented.

Dimensions are given in the order of height before width before depth.

Jean Arp
French, born Germany, 1886–1966
Growth (Croissance), 1938

Bronze and gold patina; edition of 3
31 x 11 ½ x 7 ¾ in. (80 x 33 x 21.6 cm)
Palm Springs Art Museum, 75th Anniversary
gift of Gwendolyn Weiner in honor of
Executive Director Steven Nash 101-2013

JEAN ARP'S EARLIEST SCULPTURES were painted wood reliefs, essentially a three-dimensional outgrowth of his work with paper collages. In 1930 he made the transition into freestanding sculptures, very much under the influence of Constantin Brancusi's elegantly purified abstractions of natural forms. But while Brancusi's sculptures often reveal an essential reference to some element of the living world, Arp worked at a greater distance from nature. He often said that his sculpture proceeded not *from* nature but *in harmony* with nature, implying that he attempted to capture an inner sense of its animating forces of fertility, growth, and regeneration.

As clearly indicated by its title, *Growth* is a key example of these principles. Its composition is representative of a basic type in Arp's work: the vertical, columnar form with smooth curves that twist and expand in different directions in tune with the malleable silhouettes of budding plants or mutating organisms. Its freestanding, highly polished shape seems to glide effortlessly through space, turning and stretching upward as a solid but dynamic emblem of change. One author observed that Arp "considered the evolution and transformation in his art to be analogous to his understanding of metamorphosis as he found it in nature where everything is in a continuous process of growth and decay."[1] Together with Brancusi and Henry Moore, he was a primary explorer of the interaction of nature's vitality and abstract form.

Growth is one of Arp's best-known works and exists in a number of different versions and materials. A recently published catalogue raisonné identifies the following variants: The 1938 version measuring 31 inches high includes within its class one marble, four bronzes (edition 0/3–3/3), and three plasters. A later version from 1968 measuring 43 inches high is composed of one marble, six bronzes (edition 0/5–5/5), and three plasters.[2] There is some question as to whether certain of these variants were actually authorized, but the Weiner example is very well documented.

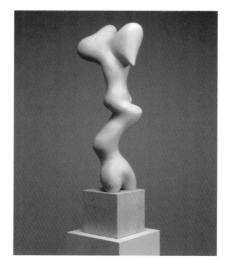

Jean Arp, Growth, *1938,*
Solomon R. Guggenheim Museum, New York

Provenance: Curt Valentin Gallery, New York; to the Weiner collection, 12 March 1952; donated to Palm Springs Art Museum, 2013

Literature and exhibitions:

Carola Giedion-Welcker, *Jean Arp* (New York: Harry N. Abrams, 1957), 63, cat. no. 49.2

James Thrall Soby, *Arp*, exh. cat. (New York: Museum of Modern Art, 1958), cat. no. 76 (different cast)

Herbert Read, *The Art of Jean Arp* (New York: Harry N. Abrams, 1968), 94–95 (different version)

La Jolla 1970

Stefanie Poley and Jane Hancock, *Arp 1886–1966*, exh. cat. (Minneapolis: Minneapolis Institute of Arts, 1987), cat. no. 182, pl. 189 (different cast)

Hans Arp: Metamorphosen 1915–1965, exh. cat. (Appenzell, Switzerland: Museum Liner Appenzell, 2000), cat. no. 24 (large version)

Jean Arp: Les plâtres, exh. cat., Paris: Galerie Natalie Seroussi, 2003, 18 (plasters)

Nash and Hough 2007, 14–15, cat. no. 1

Biller 2008, 30

Richard R. Brettell and C. D. Dickerson III, *From the Private Collections of Texas: European Art, Ancient to Modern,* exh. cat. (Fort Worth: Kimbell Art Museum, 2009), 428–29, cat. no. 109

Biomorph!/Hans Arp, exh. cat. (Rolandseck, Germany: Arp Museum, 2011), 48–49 (large version)

Claude Weil-Seigeot and Renaud Ego, *Atelier Jean Arp et Sophie Taeuber* (Clamart, France: Fondation Arp, 2012), 20–21 (plasters)

Kai Fischer and Arie Hartog, *Hans Arp: Sculptures: A Critical Survey* (Ostfildern, Germany: Hatje Cantz Verlag, 2012), cat. nos. 49 and 49a

75 Years 2013, 54–55

[1] Walburga Krupp, *Arp: Line and Form*, exh. cat. (New York: Mitchell-Innes and Nash, 2000), 14.

[2] Fischer and Hartog, cat. nos. 49 and 49a.

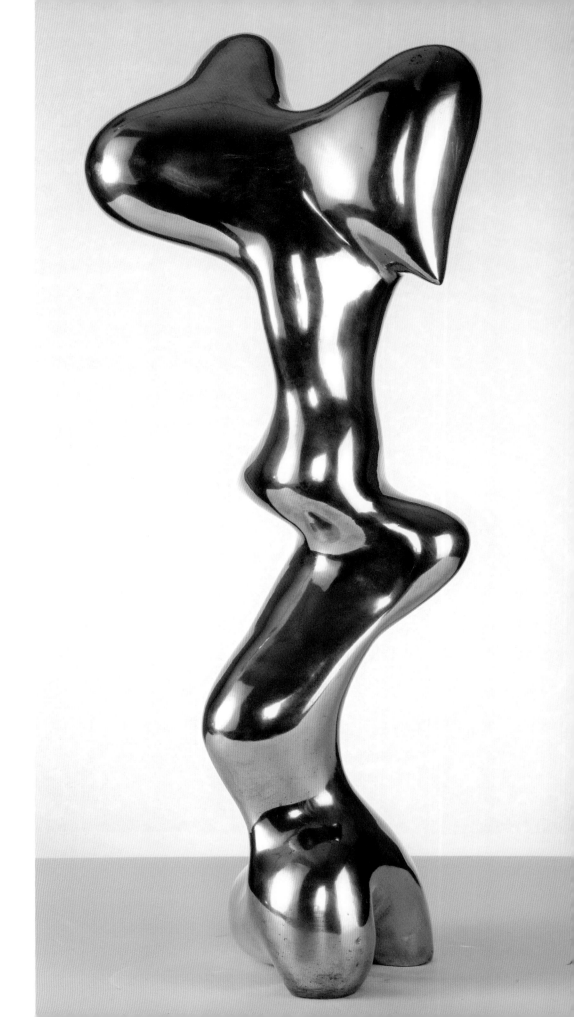

Fernando Botero
Colombian, born 1932
Último retrato de los Arnolfini, 1956[1]

Oil on canvas
Signed on front: *Botero*; inscribed on verso:
Van Eyck/Botero
20 ½ x 23 ¾ in. (52 x 60.3 cm)
Collection of Gwendolyn Weiner L1995-3.8

Provenance: Galeria de Antonio Souza,
Mexico City; to the Weiner collection,
12 March 1958

Literature and exhibitions:
*An Exhibition of Contemporary Paintings and
Sculpture from the Collection of Mr. and Mrs.
Ted Weiner*, exh. pamph. (Austin: Laguna
Gloria Museum, 1963), 4

[1] The date of this painting is firmly
established as 1956 by a label on the back
from the Galeria de Antonio Souza, from
whom Ted Weiner bought it.
[2] See Carter Ratcliff, *Botero* (New York:
Abbeville Press, 1980), pl. 75, and Cynthia
Jaffee McCabe, *Fernando Botero*, exh. cat.
(Washington, DC: Hirshhorn Museum and
Sculpture Garden, 1979), cat. no. 16.
[3] For these works, see John Sillevis,
The Baroque World of Fernando Botero,
(Alexandria, Virginia: Art Services
International, 2006), cat. nos. 2, 15 and 16,
and 13.

FERNANDO BOTERO WAS BORN IN MEDELLÍN, Colombia, and showed an early interest in art. He exhibited drawings in a number of exhibitions between 1948 and 1952, when he embarked on a lengthy museum tour in Europe. He went first to Barcelona then to Madrid, where he attended art school and steeped himself in the work of Spanish masters such as Diego Velázquez and Francisco Goya. Further travels to Paris, Florence, and Umbria, and eventually to Mexico City, brought a love of the art traditions of those regions, along with influences that still remain strong for him today. Back in Colombia, he was appointed professor of painting at the Academia de Bellas Artes in Bogotá and began a series of works based on European old master paintings. By the late 1960s he had developed his signature style of rotund bodies and quiet monumentality, which he later transferred into sculpture as well.

Botero's *Último retrato de los Arnolfini* belongs to an early phase in his development, before his signature style was fully formed and while his handling of paint and form was considerably looser. Based upon the famous *Arnolfini Portrait* from 1434 by Jan van Eyck (right), it combines influences from a number of sources, including Italian and Northern Renaissance art, the Mexican muralists, and even Latin American folk art. Although van Eyck's figures are shown full-length, Botero cropped his so they are farther forward in the picture space, more monumental, and seeming to press outward toward the viewer. While paying homage to this fifteenth-century artist who helped perfect the technique of oil painting, the composition also has a distinctly modern character due to its simplified color scheme and thorough stylizations. Botero returned to the same subject several times later, as in *Los Arnolfini 3* from 1964 and *The Arnolfini (after van Eyck)* from 1978, bringing his rendering steadily closer to the original model.[2]

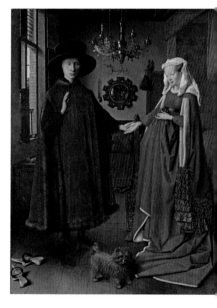

Jan van Eyck, The Arnolfini Portrait, *1434
National Gallery, London*

One sign of Botero's enduring love of earlier art is his long chain of works based upon favorite old master paintings. His *Boy from Vallecas* of 1959 refers directly to studies of court dwarfs by Velázquez; two portraits entitled *After Piero della Francesca* reinterpret Piero's paintings of the duke and duchess of Urbino; *The Rape of Europa* from 1995 is a direct descendant of Titian's painting of the same title; and so forth.[3] Although such works have a caricaturist quality, they are not parodies but instead represent dialogues with beloved masterworks.

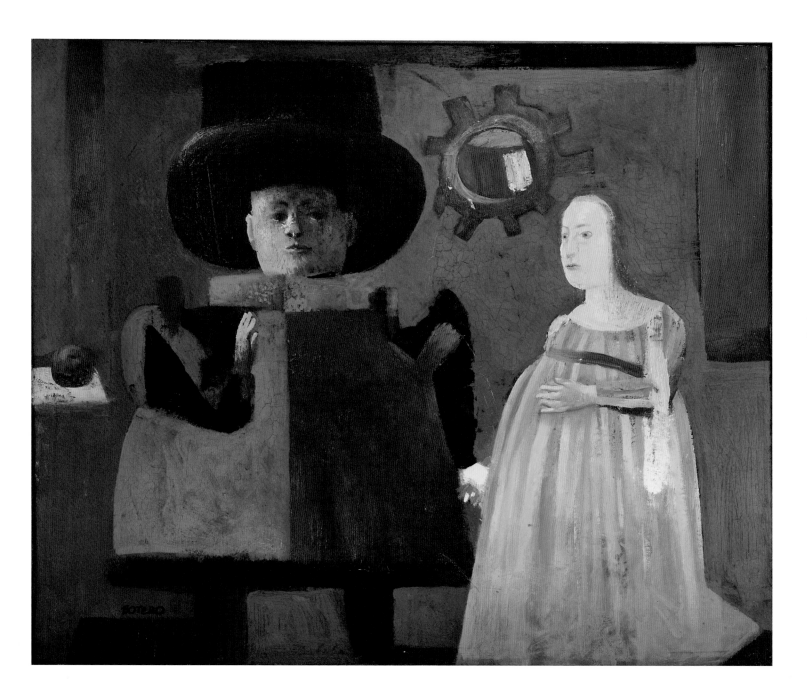

REG BUTLER'S EARLY WORK FROM THE 1940S featured abstracted figures influenced by Henry Moore and Picasso-like compositions of skeletal, highly distorted bodies. By 1953, however, he had developed a more representational figurative style. His *Manipulator* from 1953–54 is one of the earliest and best-known examples of this new direction. It shows a slender, elongated male figure standing stiffly erect on a grid of narrow rods that elevates him into space. His head is bent backwards so his gaze is straight up, and his hands are extended in front holding an imaginary implement. The figure has a mysterious air that subtly recalls Butler's earlier Surrealist essays.

In a letter that Butler wrote to the Fine Arts Associates gallery in New York in 1956,[2] he provided an informative précis of this work: "The *Manipulator* is a large version of a series of small 'studies for a Manipulator' made in 1953. The large one being made during 1953 and 1954. The original idea is obviously connected with the *Child with a Stick* [of] 1953, because the stance is similar and the hands hold an object in a similar way."[3] He added, "Most sculptors doing a male figure are bound to evoke some sensations of themselves and in some way he is rather like me, particularly the stance which must have been affected by the fact that I had recently slipped a vertebrae in my back and was in a metal jacket at the time."

At face value, the work and its title invoke possible interpretations of the figure as a scientist or inventor who holds a scientific apparatus and looks upward perhaps for inspiration, but Butler in his letter of 1956 provides mundane information that dissuades too creative a reading. "[The sculpture] gained its name because the English art critic Robert Melville in writing about the smaller version had to give it a reference and he—not I—called it *Manipulator*.... The Head looking up belongs to the whole story of my figures having heads made in that way. *Perhaps* because I used to work in Hatfield where the sky is full of aircraft. *Perhaps* because I feel the face on top is stronger sculpturally than turning it at right angles to the body." The woman who produced the casts of *Manipulator* reported that the implement held by the figure was a late addition prior to a visit by the painter-critic Patrick Heron to Butler's studio, as he feared that Heron would find the empty hands unsatisfactory.[4]

Reg Butler
British, 1913–1981
Manipulator, 1953–54

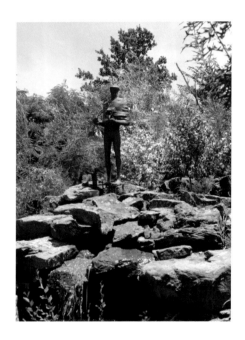

Weiner sculpture garden in Fort Worth with Butler's Manipulator

Bronze; edition of 6 (cast by Rosemary Young)[1]
66 ¾ x 23 ½ x 19 in. (169.5 x 60 x 48.3 cm)
(including base)
Collection of Gwendolyn Weiner L2007-15.4

Provenance: Curt Valentin Gallery, New York;
to the Weiner collection, 2 May 1956

Literature and exhibitions:

Reg Butler, exh. cat. (New York: Curt Valentin
Gallery, 1955), cat. no. 42

Andrew Carnduff Ritchie, *The New Decade:
22 European Painters and Sculptors*, exh. cat.
(New York: Museum of Modern Art, 1955) 69
(different cast)

Reg Butler: A Retrospective Exhibition,
exh. cat. (Louisville, Kentucky: J.B. Speed
Memorial Museum, 1963), cat. no. 56
(different cast)

Contemporary British Painting and Sculpture,
exh. cat. (Buffalo, New York: Albright-Knox
Art Gallery, 1964), cat. no. 10 (different cast)

La Jolla 1970

Reg Butler, exh. cat. (London: Tate Gallery,
1983), cat. no. 51 (different cast)

Margaret Garlake, *The Sculpture of Reg Butler*
(Aldershot: Henry Moore Foundation and
Lund Humphries, 2006), cat. no. 149, figs. 5
and 39 (different cast)

Nash and Hough, 2007, 24, cat. no. 2

Biller 2008, 29

75 Works 2013, 44

[1] All six of the casts are shown in Garlake
2006, fig. 5.
[2] A copy is in the Weiner family archives, Fort
Worth.
[3] Butler's *Child with a Stick* (aka *Girl with a
Stick*) is illustrated in Garlake 2006, cat. no.
121. The "small 'studies for a Manipulator'"
Butler refers to are now known as
Manipulator 1 and 2, 1953 (Garlake 2006, cat.
nos. 124 and 125). A plaster version exists
(mentioned by Garlake 2006, cat. no. 149).
There are also two smaller, much later
Manipulators, both more straightforwardly
realistic (Garlake 2006, cat. nos. 209 and 214).
[4] Garlake 2006, 142–43.

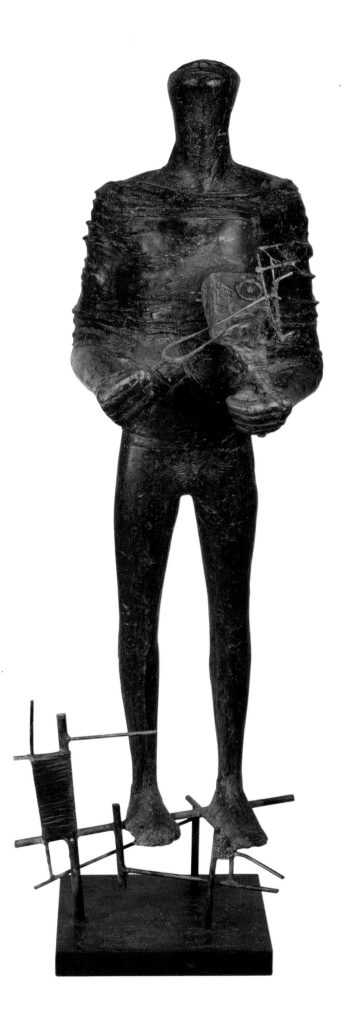

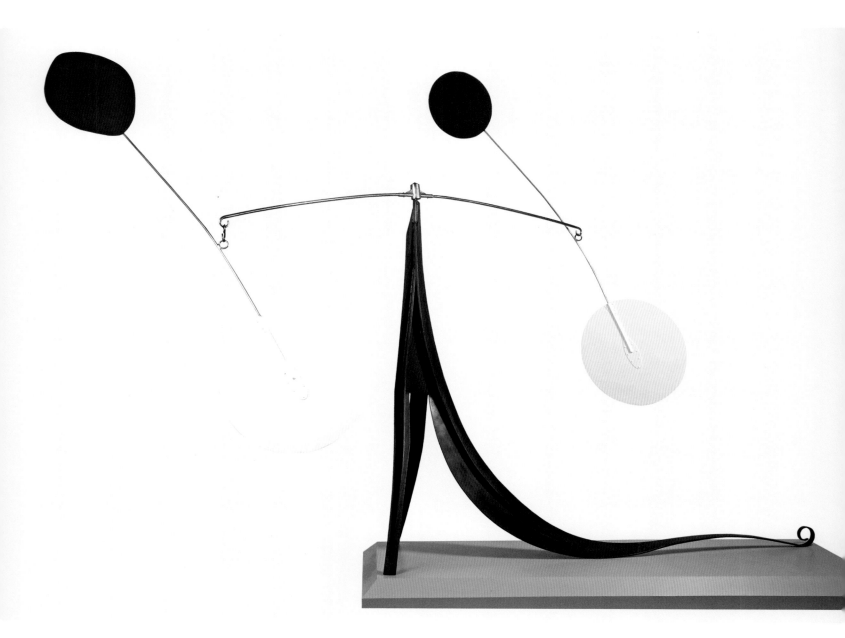

Alexander Calder
American, 1898–1976
The Lizard (Lézard), 1968

Painted metal
Marked: *AC 68*
104 ½ x 165 x 31 ¾ in. (265.4 x 419.1 x 80.6 cm)
Palm Springs Art Museum, gift of Gwendolyn
Weiner in honor of Harold Meyerman 80-2011

Provenance: Jeffrey H. Loria & Co., New York;
to the Weiner collection, 13 September 1969

Literature and exhibitions:

Alexander Calder, exh. cat. (Saint-Paul-de-
Vence: Fondation Maeght; Humlebaek,
Denmark: Louisiana Museum, 1969), 15,
cat. no. 217

La Jolla 1970

Nash and Hough 2007, 15–16, cat. no. 3

Biller 2008, 30

75 Years 2013, 76–77

THE BASIC COMPOSITION OF Alexander Calder's *Lizard*, which combines forms famously known as the stabile and mobile, has a long history. Living in Paris in the late 1920s, Calder came in contact with a diverse group of modernists including Fernand Léger, Joan Miró, and Piet Mondrian. He gave credit to Mondrian's studio environment as particularly instrumental in his conversion to abstraction and commented to Mondrian during a visit to his studio in 1930 that he would like to see the colored rectangles on his walls move. Later he pronounced, "Why must art be static? . . . The next step in sculpture is motion."[1] By 1931 he had introduced movement into his abstract sculptures, using cranks and motors and, more simply, by dangling delicate constructions in space from wires. From the outset, he hung his mobiles from both ceilings and standing bases. Over time the bases became more prominent and took on a compositional life of their own, as strong abstract forms often resembling animals or architectural elements. One well-known example of this development is his *Performing Seal* from 1950, a direct forerunner of *The Lizard*.[2]

Contrary to the title of this work, perhaps suggested to Calder by the sculpture's long curly "tail," the form just as easily could be a trained circus seal balancing a wired-together assembly of four colored balls, its two front legs spread apart and its nose straight up in the air. This typology relates closely to the *Performing Seal* of 1950, although that work is considerably smaller (33 inches high), completely black, and the seal has a short tail and balances seven balls. In *The Lizard*, the red-black-white color combination of the large balls gives the work a festive quality that is enhanced by the buoyant curves of the animal's back and tail. The contrast of delicacy and stability, the entertaining, balletic movement of balls balanced on a single point, and the clever play of abstraction and representation are all part of Calder's brand of formalism. He seems not to have fashioned any seals for his *Cirque Calder*, the early ensemble of wire figures and assemblages manipulated by him in light-hearted performances. However, he did include seals in some of his drawings related to the *Cirque* and in textiles he designed featuring highly abstracted seals balancing large balls.[3]

[1] "Objects to Art Being Static, So He Keeps It in Motion," *New York World-Telegram*, 11 June 1932.
[2] Marla Prather, *Alexander Calder 1898–1976*, exh. cat. (Washington, DC: National Gallery of Art, 1998), cat. no. 225.
[3] See Jean Lipman and Nancy Foote, *Calder's Circus* (New York: E. P. Dutton & Co. in association with the Whitney Museum of American Art, 1972), 8, 141.

Alexander Calder
(American, 1898–1976)
Chapeau phrygien, 1968

Gouache on paper
Marked on verso: *9971*
Signed and dated: *calder 68*
29 ⅜ x 43 ⅛ in. (74.6 x 109.6 cm)
Collection of Gwendolyn Weiner L1980-3.2

Provenance: Galerie Maeght, Paris; to the
Weiner collection, 22 May 1969

Literature and exhibitions:
None identified

¹Quoted in Jean Lipman, *Calder's Universe*,
exh. cat. (New York: Whitney Museum of
American Art, 1976), 119.
²Lipman, 120.
³Lipman, 148.

IN ADDITION TO HIS WORK WITH SCULPTURE, Alexander Calder had a prolific practice as painter, draftsman, and printmaker, with projects ranging from the painting of a model airplane with new designs for Braniff Airlines, to well over a thousand gouaches and the illustration of numerous books. *Chapeau phrygien* has all the high spirit typical of his work in these different media, with simplified forms, bold colors, strong contrasts, and an energetic sense of movement. Calder produced his many "gouacheries," as he called them, with remarkable speed and ease, noting at one point that "I very much like making gouaches. It goes fast, and one can surprise oneself." Calder authority Jean Lipman wrote of his production in this arena:

> Calder's gouaches, seemingly simple, are infinitely inventive works that only a masterly painter could produce. Some are based on natural forms; some are abstract designs. The best ones, joyously conceived, firmly structured, brilliantly colored, add up to one of the most remarkable bodies of work in our time. In recent years he has produced stupendous numbers of gouaches, doing some almost daily the way other people do morning exercises.[2]

Critics have noted that such volume inevitably leads to varied levels of effectiveness, but the best of these works rank high in Calder's overall oeuvre.

The main motif in the painting in the Weiner collection, the Phrygian cap, dates back to ancient Greece, when the distinctive conical cap with its top pulled forward or to the side was associated with the people of Phrygia in Anatolia and hence with non-Greek populations such as the Trojans. Later in Republican Rome, it was the cap of freedmen and became a general symbol of freedom from tyranny. The cap acquired special significance in France, where Calder lived and worked on and off for much of his life. It was the red bonnet worn by antimonarchists in the French Revolution and became the country's national symbol. Calder must have appreciated it as a loaded emblem, leading him to use it in other works as well, including his *Phrygien et fer*, a color lithograph from 1969 that is closely related in design to *Chapeau phrygien*.[3]

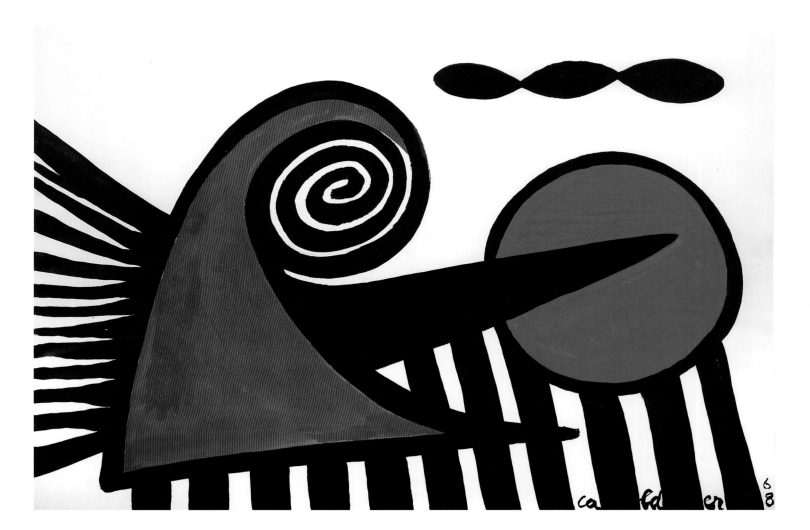

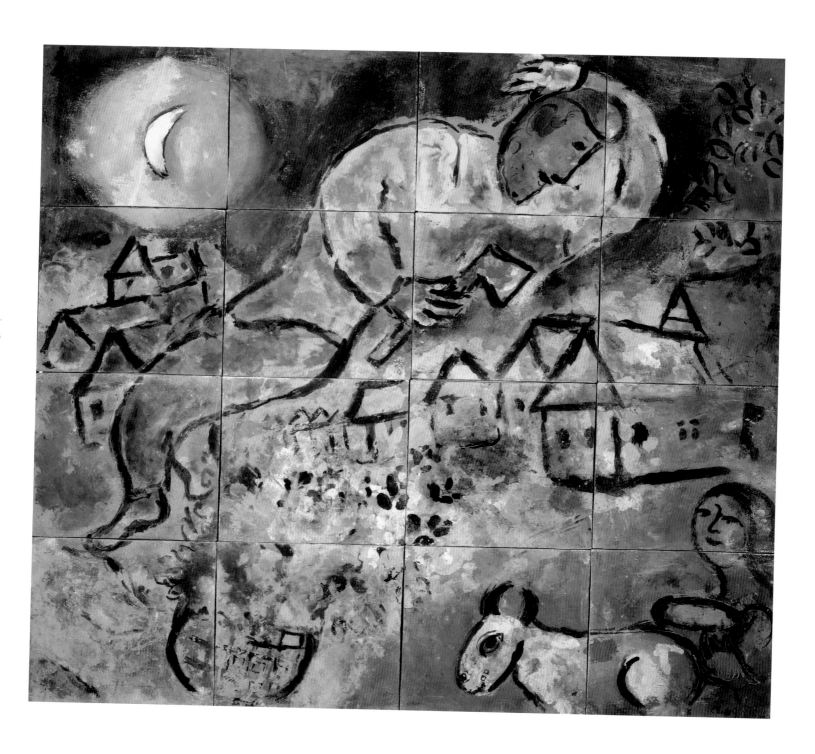

Marc Chagall
Russian, 1887–1985
The Village, 1952

Paint on ceramic tiles
Signed and dated: *Chagall 1952*
48 x 52 in. (122 x 131 cm)
Palm Springs Art Museum,
gift of Gwendolyn Weiner 156-2009

Provenance: Curt Valentin Gallery, New York;
to the Weiner collection, 4 March 1953

Literature and exhibitions:

Franz Meyer, *Marc Chagall* (New York: Harry
N. Abrams, 1963), 522, cat. no. 861

André Malraux and Charles Sorlier, *The
Ceramics and Sculptures of Chagall* (Monaco:
Éditions André Sauret, 1972), cat. no. 170
(dated 1950–1952)

75 Years 2013, 70–71

[1] Malraux and Sorlier, passim.
[2] Meyer, 521.
[3] For illustrations of several other large
paintings on ceramic, see Malraux and Sorlier
1972, cat. nos. 34, 80, 138, 149, 169.

MARC CHAGALL'S RUSSIAN AND JEWISH HERITAGE—he grew up in Vitebsk, in present-day Belarus—was fundamental to his art throughout his life, and images of rural villages pay frequent homage to his boyhood memories. Although Vitebsk was a flourishing town in the early twentieth century, Chagall lived in the poor Jewish quarter of Pestovatik. His disadvantaged circumstances did not, however, impair his romance with the town, and rooftop images of Vitebsk figured in many early works, often with people, animals, and various symbols flying overhead. Such scenes continued into many later paintings, including *The Village*.

Here, a man with a hatchet floats above the roughly sketched townscape. In one corner, a quarter-moon shines brightly, in opposite corners sit two bouquets of flowers, and at the lower right appear a donkey and woman holding a bowl. Any particular symbolism intended by Chagall is obscure. The motif of a man holding a hatchet is relatively rare in his work and may be emblematic of a woodcutter, or it could possibly relate to the notion of animal sacrifice, highly important in Hebrew history. And the friendly farm girl at lower right could be simply that, although a proffered bowl is sometimes the symbol of libation or the blood of sacrifices.

The technique employed by Chagall in this work, paint on fired ceramic tiles or bricks, is unusual for him, especially for a painting of this large scale. Undoubtedly influenced by Pablo Picasso's postwar interest in the artisanal traditions of ceramic production in southern France, Chagall, who had recently moved to the small town of Vence close to the Mediterranean, started around 1950 to work with various well-known pottery ateliers. Among these were the workshops of Madame Bonneau at Antibes, Serge Ramel in Antibes and Vence, and L'Hospied group at Golfe-Juan. But most important was the Madoura workshop owned by Georges Ramié and his wife at Vallauris, where Picasso had done so much of his ceramic work (following page). Chagall made well over two hundred painted plates, vases, jugs, and tiles, for the most part small in size.[1] But in a series of so-called ceramic murals, including *The Village*, he expanded the scale and ambition of his work, creating paintings of major importance that take advantage of his new medium for special formal effects. In *The Village*, the terracotta tint of the fired clay provides a ground color that Chagall allowed to show through the upper layers of paint, giving an airy and sensual quality to the composition. The sketchy paint handling throughout and the dreamy subject matter add to that quality, while the physicality of the fired tiles, with their slightly irregular edges and thick dimensionality, provides a counterimpression of permanence and solidity.

right
Pablo Picasso (left) and Marc Chagall at the Madoura pottery atelier, 1948

opposite
The Village and Picasso's ceramic Owl *on view at the Palm Springs Art Museum in 2015*

© 2014 Getty Images / Gamma/Gamma-Rapho

Franz Meyer has made the important point that his ceramic murals provided Chagall with a closer connection between painting and architecture, picture and wall.[2] He notes an exhibition at the Maeght Foundation in Saint-Paul-de-Vence in 1952 in which around ten of the murals were displayed, all produced at the Madoura workshop and each composed of six to twelve tiles. (It has proved impossible to identify exactly which paintings were included.) Four years later he made an even larger ceramic mural that was installed in the baptistery in the church of Notre-Dame-de-Toute-Grâce in Assy, France.[3]

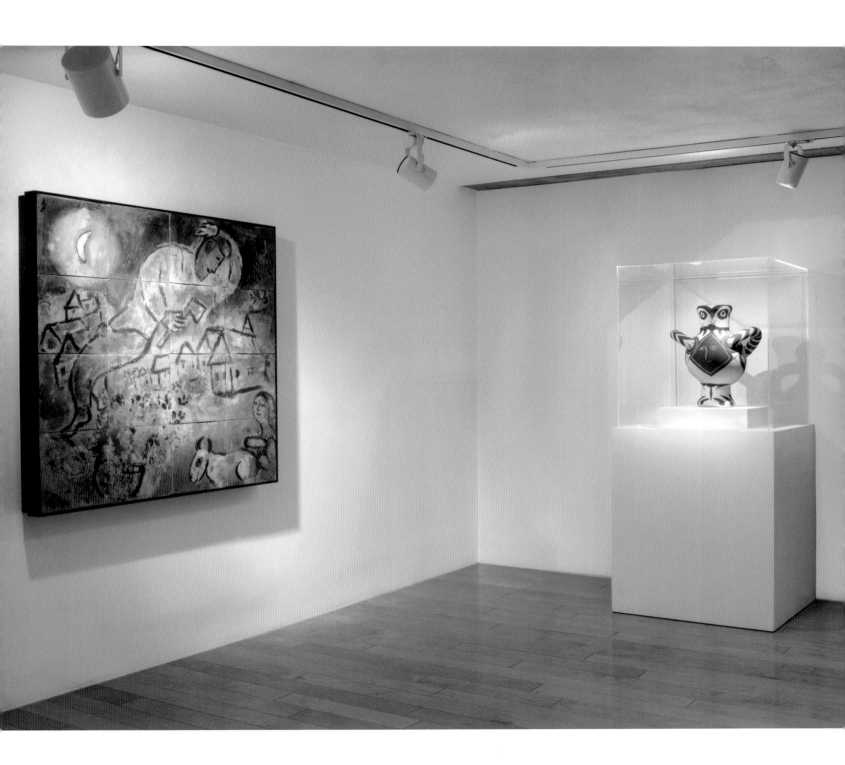

Edgar Degas (attributed to)
French, 1834–1917
Woman Getting Out of Bath, fragment
(*Femme sortant du bain, fragment*),
1896–1911

Bronze; edition 15/22
Marked: *Degas CIRE PERDUE/A A HEBRARD
71/O* (date of cast uncertain)
16 ⅝ x 6 ¹⁵⁄₁₆ x 8 ¹⁄₁₆ in. (42.2 x 17.6 x 20.5 cm)
Collection of Gwendolyn Weiner L2007-15.6

Provenance: Curt Valentin Gallery, New York;
to the Weiner collection, 24 September 1952

Literature and exhibitions:

Exposition des sculptures de Degas, exh. cat.
(Paris: Galerie A. A. Hébrard, 1921), cat. no. 71
(different cast)

John Rewald, *Degas, Works in Sculpture: A
Complete Catalogue* (New York: Pantheon
Books, 1944), cat. no. LIX

Sculpture from Rodin to Lipchitz, exh. cat.
(Dallas: Dallas Museum of Contemporary Art,
1958), n.p.

Fort Worth 1959, cat. no. 10

Houston 1964, cat. no. 8

Wichita 1965, cat. no. 9

Austin 1966, cat. no. 10

Palm Springs 1969, 35

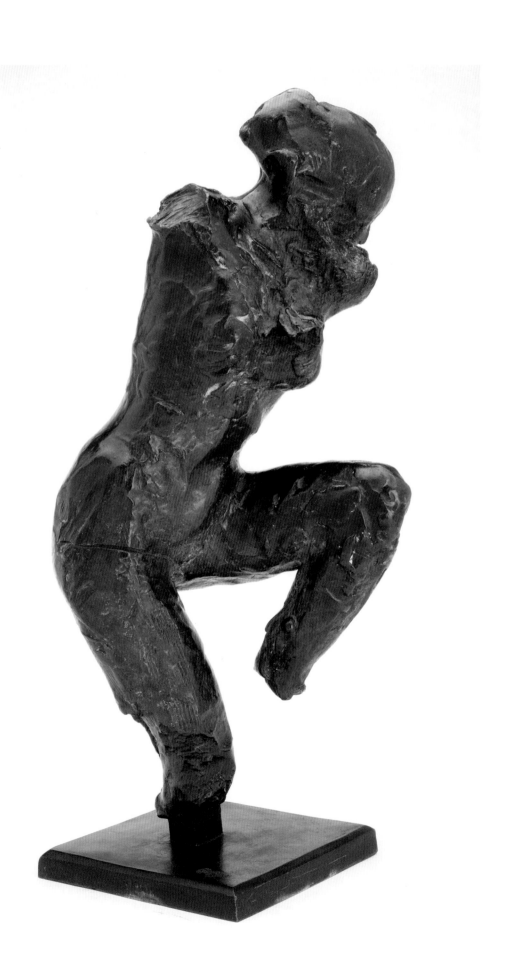

Franco Russoli and Fiorella Minervino, *L'opera completa di Degas* (Milan: Rizzoli, 1970), cat. no. S65

La Jolla 1970

John Rewald, *The Complete Sculptures of Degas*, exh. cat. (London: Lefevre Gallery, 1976), cat. no. 65 (different cast)

John Rewald, *Degas's Complete Sculpture: Catalogue Raisonné* (San Francisco: Alan Wofsy Fine Arts, 1990), cat. no. LIX

Anne Pingeot, *Degas Sculptures* (Paris: Imprimerie Nationale Éditions, 1991), cat. no. 65

Joseph Czestochowski and Anne Pingeot, *Degas Sculptures: Catalogue Raisonné of the Bronzes* (Memphis: The Torch Press and International Arts, 2002), 260–61, cast letter O

Nash and Hough 2007, 5, cat. no. 4

S. G. Lindsay, D. S. Barbour, and S. G. Sturman, *Edgar Degas Sculpture* (Washington, DC: National Gallery of Art, 2010), 371

[1] For a full account of the posthumous casting of Degas's sculpture, see Czestochowski and Pingeot 2002.

[2] The most complete information to date on these works is found in *The Complete Sculptures of Edgar Degas*, exh. cat. (Athens: Herakleidon Museum, 2009).

[3] Letter to the author of 9 February 2015. It is interesting to note that Weiner's source for this acquisition, Curt Valentin, worked for Flechtheim in Germany.

[4] Lindsay, Barbour, and Sturman 2010.

ALTHOUGH EDGAR DEGAS'S WORK in sculpture was a private enterprise during his lifetime—he exhibited publically only one object, his celebrated *Little Dancer of Fourteen Years*—he can now be regarded as one of the greatest sculptors of the nineteenth century. He worked in the highly perishable medium of wax, and after his death more than 150 statuettes were discovered in various states of disrepair.[1] The 72 best-preserved were conserved to the degree possible and cast in bronze by A. A. Hébrard between 1919 and 1921, with a 73rd added later. With the exception of the *Little Dancer of Fourteen Years*, all were published in 22 casts, with 20 lettered A to T and with two sets reserved. The marking on the Weiner cast—71/O—indicates that it was the fifteenth cast of sculpture number 71. Subsequent castings of the sculptures were made but the first edition, to which the Weiner cast belongs, is considered the most historically legitimate. In recent years a theretofore unknown set of plaster casts came to light and were cast, but the exact circumstances of their origin is still undergoing examination.[2]

No information has been uncovered as yet concerning the early provenance of the Weiner bather or its casting history. Czestochowski and Pingeot, in their census of casts published in 2002, provide a listing for the O cast of sculpture no. 71, indicating that it belonged early in the twentieth century to the Österreichische Galerie in Vienna, and by 12 July 1926 to the Flechtheim gallery in Düsseldorf. And Czestochowski indicated more recently that a cast apparently matching that provenance has been located.[3] Until the exact history of these two casts has been conclusively established, we are led to identify the Weiner cast as "attributed to Degas."

Degas valued modeling for its spontaneity and as a means of capturing fleeting impressions. *Woman Getting Out of Bath* is a prime example of the way his sculptures often freeze complex movements (another is his series of horses running and rearing). The woman twists and bends as she athletically lifts one leg over the edge of a bathtub. It is a moment of exertion also studied by Degas in drawings and pastels, but in this sculpture he isolates the movement and clarifies and simplifies the figure by truncating its limbs so the torque of the pose is more fully expressed. This presentation of a partial figure was undoubtedly influenced by the work of Auguste Rodin, which includes many fragmented torsos and figures, as well as Degas's interest in ancient sculpture which, through the fortunes of time, is often preserved in fragmented form. The sensitively textured modeling of the figure, in which the physical action of the artist's tools and hands is made visible, also helps activate the forms and, through the reflections it creates, provides a sense of wet skin.

Many of the original wax maquettes of Degas's sculptures survive in different collections, most importantly at the National Gallery of Art in Washington, DC, but none is known for *Woman Getting Out of Bath*.[4]

BEST KNOWN AS ONE OF THE ORIGINAL EUROPEAN SURREALISTS, Enrico Donati was born in Italy and first studied sociology at the University of Pavia. But he soon turned his attention to a variety of fields including music, anthropology, and commercial art before dedicating himself to painting. Over his long career he transformed his approach to art several times, although each of his stylistic phases reveals a Surrealist's devotion to the magical world of imagination and mystery.

Enrico Donati
American, born Italy, 1909–2008
Stalagmite, 1967

Oil and sand on canvas
Inscribed back of stretcher and canvas:
Stalagmite / Enrico Donati / 25 x 30 1967
25 x 30 in. (63.5 x 76.2 cm)
Collection of Gwendolyn Weiner L1980-4.2

Provenance: Staempfli Gallery, New York;
to the Weiner collection, 23 January 1969

Literature and exhibitions:
None identified

In 1939 Donati moved permanently to New York, where he studied at the New School for Social Research and the Art Students League. He had his first one-artist show in 1942. Critical to his development were the friendships he formed with European artists living in New York during World War II, including André Breton, Marcel Duchamp, and Max Ernst. His early Surrealist paintings were visions of strange organisms swirling in colorful, cloudy spaces, which gave way in the late 1940s to hard-edge abstractions, and then to dark and earthy abstractions much influenced by Jean Dubuffet. These featured thickly textured surfaces built up by mixing dust and debris with oils. That development then led to a long series of works, including *Stalagmite*, in which Donati mixed sand with oils for crusty, three-dimensional surfaces. He titled these compositions the Sargon series, after Sargon II, an Assyrian king. Such works give the impression of an archeological artifact made of carved stone, although another analogy is found in ethnographic sand paintings.

In *Stalagmite*, a large black circle ringed by two thick bands of sand forms a commanding central motif that suggests a devotional or ritualistic function. A vertical column across its center adds to the work's solidity of structure, while three very thin red lines relieve the otherwise earthy palette. Centralized floating orbs are a recurrent motif in Donati's paintings, but the effect here is particularly iconic.

Lyonel Feininger
American, 1871–1956
Gothic Church II, 1942

Watercolor and ink on paper
Signed and inscribed: *Feininger Gothic
Church II 1942*
18 ¾ x 13 ⅞ in. (47.6 x 35.2 cm)
Collection of Gwendolyn Weiner L1980-4.4

Provenance: Curt Valentin Gallery, New York;
to the Weiner Collection, 10 April 1952

Literature and exhibitions:

*Feininger: A Memorial Exhibition of His Work
from Fort Worth Collections*, exh. cat. (Fort
Worth: Fort Worth Art Center, 1956), cat.
no. 6

Lyonel Feininger: A Retrospective, exh. cat.
(Dallas: Dallas Museum for Contemporary
Arts, 1963), cat. no. 39

Austin 1966, cat. no. 14

LYONEL FEININGER WAS BORN IN NEW YORK but spent his early years as an artist in Germany. He lived there from 1887 until 1936, when he returned to the United States after having been declared a "degenerate artist" by the Nazi party. He studied art in Hamburg, Berlin, and Paris and began his career as a caricaturist working for several publications in both Germany and the US. At the age of thirty-six, Feininger turned to the fine arts and soon joined the Berliner Sezession and became engaged with different German Expressionist groups, producing paintings, drawings, and prints in a distinctive style deriving out of Cubism and Expressionism. These works featured a prismatic breakdown of both solid forms and their surrounding spaces and an integration of both into unified, energy-infused fields. When Walter Gropius founded the Bauhaus in 1919, he hired Feininger as his first appointment to head the printmaking program.

Gothic Church II dates from after Feininger's return to the United States but continues the stylistic hallmarks of his earlier work. Although many other of the churches that Feininger drew and painted can be identified (see p. 64), this one cannot. It possibly represents a general type rather than a particular structure. Nevertheless, the basic theme is the same as that of *Gelmeroda II*: the tall spire of a church pierces the skies in exaltation of the spirit of Gothic architecture. Here the space around the spire is made palpable by thin dark lines scored in two directions that are suggestive of rays of sunlight. It is the same style of line used to render the solid buildings below, creating a dialogue of pattern between the two regions that draws them together visually and repeats a statement common in Feininger's art about the unity of space and matter.

The condition of this drawing, as with that of *Gelmeroda II*, is unusually fine.

Feininger. Gothic Church II 1940

Lyonel Feininger
American, 1871–1956
Gelmeroda II, 1946

Watercolor and ink on paper
Signed and inscribed: *Feininger 4. xi. 46.*
18 ⅞ x 13 ⅝ in. (48 x 34.7 cm)
Collection of Gwendolyn Weiner L1980-4.3

Provenance: Curt Valentin Gallery, New York;
to the Weiner collection, 10 April 1952

Literature and exhibitions:

*Feininger: A Memorial Exhibition of His Work
from Fort Worth Collections*, exh. cat. (Fort
Worth: Fort Worth Art Center, 1956),
cat. no. 8

Sam Canty III, *A Selection from Fort Worth
Collections*, exh. cat. (Dallas: Dallas Museum
for Contemporary Arts, 1959), cat. no. 35

Lyonel Feininger: A Retrospective, exh. cat.
(Dallas: Dallas Museum for Contemporary
Arts, 1963), cat. no. 48

Austin 1966, cat. no. 13

THE SUBJECT OF THIS WORK WAS A FAVORITE of Lyonel Feininger's, the Gothic church in Gelmeroda, a small village near Weimar. He made his first studies of the church in 1906 and returned to it obsessively throughout his career in all of his media, including prints, caricatures, and even sculpture. A particularly well-known series of thirteen oil paintings dating between 1913 and 1936 depicts the church with distinctly different compositions, color, and lighting effects.[1]

The simple, blocky forms of the church and its unusually tall and slender spire obviously struck a special chord within the artist, perhaps because of the way the tower slices so dramatically upward from earthbound solidity to ethereal spaces above. He once said that he was more interested in painting the space around objects than the objects themselves, and a church spire affords a perfect opportunity to exercise this principle and to express a general spirituality that Feininger felt in life. Just how important the form-dissolving properties of space and light were to him is apparent in *Gelmeroda II*. The church and its surrounding buildings and trees are reduced to an intersecting network of fine lines and light washes of color, as if their density had been eroded by atmospheric conditions. Very similar compositional treatments are found in several other of Feininger's Gelmeroda drawings.[2]

[1] For reproductions of ten of these works, see Wolfgang Büche, *Lyonel Feininger: Ein Maler und sein Motiv*, exh. cat. (Moritzburg Halle: Staatliche Galerie Moritzburg Halle, 1995), cat. nos. 2–7 and 10–13.
[2] See, for example, Büche, cat. nos. 26, 29, 32, and 40.

Feininger 4. XI. 46.

Manuel Felguérez
Mexican, born 1928
Contrition, 1958

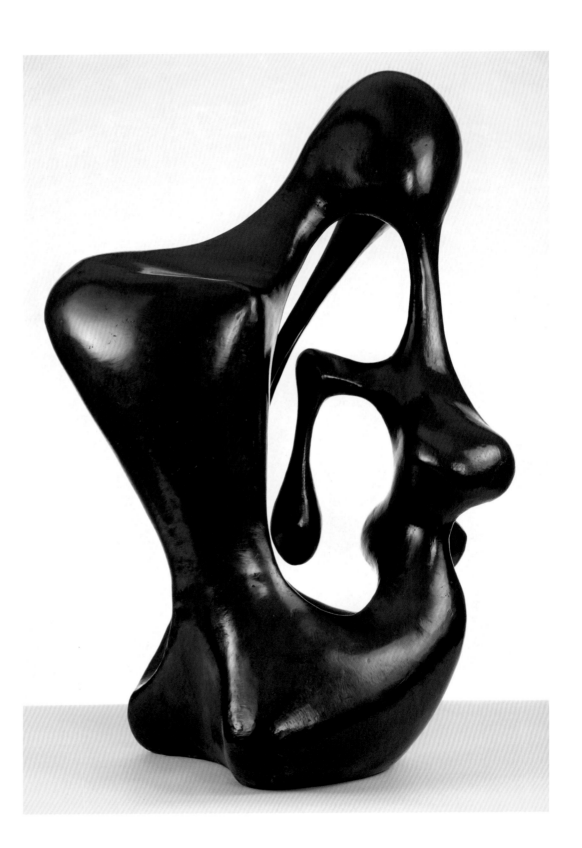

Bronze
44 ½ x 28 x 20 in. (113 x 71.1 x 50.8 cm)
Palm Springs Art Museum, gift of
Gwendolyn Weiner 83-1980

Provenance: Galeria de Antonio Souza,
Mexico City; to the Weiner collection,
12 March 1958

Literature and exhibitions:

Fort Worth 1959, cat. no. 11

Wichita 1965, cat. no. 10

Austin 1966, cat. no. 15

Palm Springs 1969, 6

La Jolla 1970

Nash and Hough 2007, 17–19, cat. no. 5

Dore Ashton et al., *Manuel Felguérez:
Constructive Invention*, exh. cat. (Mexico
City: Palacio de Bellas Artes, 2009), 194
(newspaper clippings)

[1] Margaret Sayers Peden, *Out of the Volcano:
Portraits of Contemporary Mexican Artists*
(Washington, DC, and London: Smithsonian
Institution Press, 1991), 219.
[2] Two newspaper clippings from 1957
(Ashton, 194) illustrate this plaster version.
One shows Felguérez with the plaster in a
workshop at the Universidad Iberoamericana
in Mexico City.
[3] Both letters and the previously mentioned
typed biography are in the Weiner family
archive in Fort Worth.

THE MEXICAN ARTIST MANUEL FELGUÉREZ was part of the so-called Generación de la Ruptura in Mexico. Members of this generation rejected the muralist tradition of Diego Rivera and others, with its representational style and concentration on social and political themes. Felguérez was among those who took inspiration from European modernism, ancient Mexican art, and avant-garde artists including Carlos Mérida and Gunther Gerzso to explore more contemporary approaches. Though Felguérez had limited formal training, he drew upon these sources, as well as museum visits in the US and abroad and two periods of work with the sculptor Ossip Zadkine in Paris, to develop both geometric and biomorphic abstract styles. A prolifically diverse artist, Felguérez is well known in Mexico for his long series of paintings in both hard-edge and expressionistic styles, in addition to his large sculpted murals and outdoor geometric sculptures.

Contrition is a relatively early work. Its flowing, polished forms bring to mind both the smooth organic shapes in works by Henry Moore and the dripping or dissolving objects in paintings by Salvador Dalí. Seen from most perspectives, the composition appears fully abstract, but one view reveals the structure of a face with forehead, nose, lips, and, in an inner spatial cavity, a hanging shape that can be read as a tear, a narrative element in keeping with the work's title. Felguérez once said of his work, "I want not to create form in space but form that creates space, movement that creates space."[1] In *Contrition*, the winding rhythm of solid forms carves both positive and negative spaces, giving the eye few places to relax as it peruses the composition.

Additional casts of this work are unknown. A photograph in the Weiner family archive documents a full-size plaster maquette that might have been the image on which Ted Weiner based his decision to purchase a bronze version.[2] A handwritten note on a typed biography of the artist supplied to Weiner by the Antonio Souza gallery gives "The Nun" as an alternate title, supplementing the work's depictive side. In a letter of 14 January 1958 from Antonio Souza to Ted Weiner, he states the price of the sculpture and notes that "the artist will need half of it to run the expenses of the Foundry which he can accomplish in a month or a little more." And he wrote again on January 24, reporting, "I will tell the artist to start working on the Foundry so you will have your piece in the shortest time."[3]

Adolph Gottlieb
American, 1903–1974
Red Halo, 1960

Ink and pastel on paper
Signed and dated: *Adolph Gottlieb 1960*
31 x 22 ¼ in. (78.8 x 56.5 cm)
Palm Springs Art Museum, gift of Gwendolyn
Weiner 109-2010

Provenance: David Gibbs and Company,
London; to the Weiner collection,
10 October 1962

Literature and exhibitions:
*An Exhibition of Contemporary Paintings and
Sculpture from the Collection of Mr. and Mrs.
Ted Weiner*, exh. pamph. (Austin: Laguna
Gloria Museum, 1963), 5

[1] Sanford Hirsch, Lawrence Alloway, and
Mary Davis MacNaughton, *Adolph Gottlieb: A
Retrospective*, exh. cat. (New York: The Arts
Publisher in association with the Adolph and
Esther Gottlieb Foundation, 1981), fig. 30 and
cat. no. 88.

AS WITH SEVERAL OTHER ARTISTS FROM the Abstract Expressionist movement, Adolph Gottlieb first worked during the late 1920s and 30s in a Social Realist style. In the 1940s, however, under Surrealist influences, he developed a new approach in works he termed Pictographs, which consisted of personally invented hieroglyphic and emblematic signs contained within gridlike matrices. His interest in mythic and timeless symbolism then carried over, starting in the early 1950s, into the two abstract forms of work for which he is best known: the so-called Imaginary Landscapes and the Bursts. In the first, the formats are generally horizontal and divided into upper and lower registers, with basic color shapes floating against light backgrounds above, and dark, heavily worked passages below. These compositions can be loosely interpreted as opposing the celestial and the earthbound. In the Bursts, the compositions are most often vertical, with two or sometimes three "bursts" of color aligned on white grounds.

Red Halo is a prime example of the latter series. Gottlieb repeated this particular formulation many times, with a red disk floating above a freely painted patch of black. It is also found, for example, in the large oil-on-canvas paintings *Blast I* from 1957 and *Jagged* from 1960. Together with *Red Halo*, these paintings demonstrate how Gottlieb varied to a degree the two basic shapes from work to work.[1] All of these paintings convey a sense of cosmic phenomena: celestial forms floating in limitless spaces. The red disks or globes are radiant, warm, and translucent, while the black forms are dense, cold, and nocturnal. Perhaps Gottlieb found in these stark dualities an intimation of the yin and yang principle of complementary forces, of life and death, or some other philosophical notion. It is certain, however, that he never intended any literal symbolic message. As he often said about abstraction, it is not a matter of meanings but of the power of "emotional truth."

69

Dimitri Hadzi
American, 1921–2006
Centaur, 1955–56

Bronze; edition 3/4
Marked: *HADZI III/IV*
25 ½ x 28 ¾ x 20 ¾ in. (64.8 x 73 x 52.7 cm)
Collection of Gwendolyn Weiner L1980-3.6

Provenance: Felix Landau Gallery, Los
Angeles; to Weiner collection, 10 March 1962

Literature and exhibitions:

Fort Worth 1959, cat. no. 72 (added to a
republished version of the catalogue)

Houston 1964, cat. no. 11

Wichita 1965, cat. no. 14

Austin 1966, cat. no. 27

Palm Springs 1969, 26

La Jolla 1970

Roger Mandle, *Dimitri Hadzi: A Retrospective*,
exh. cat. (Toledo, OH: Owens-Illinois World
Headquarters, 1982), cat. no. 12 (different
cast)

Seamus Heaney et al., *Dimitri Hadzi* (New
York: Hudson Hills Press, 1996), 19 (plaster
version)

Nash and Hough 2007, 26, cat. no. 6

[1] Heaney, 74–75 and pl. 26.
[2] For example, Heaney, 75–79, and pls. 1, 26,
and 33.
[3] Heaney, 19.

DIMITRI HADZI'S WORK BELONGS TO a tradition of post–World War II Expressionist sculpture exemplified by the work of such European and American artists as Marino Marini, Germaine Richier, Herbert Ferber, and Ibram Lassaw. Their heavily worked bronze forms, seemingly distressed or eroded, convey a somewhat menacing sense of fantasy or a dream state. The basic sculptural language is figurative, but with a Surrealist spirit.

Centaur, however, also reflects Hadzi's classical Greek heritage. It derives from a lengthy series of drawings and sculptures he made exploring the theme of the battle of Centaurs and Lapiths. In this Greek myth, the wedding of the king of the Lapiths was disrupted by rampaging Centaurs, creatures half-man and half-horse, who carried off many of the Lapith women. In Hadzi's depictions, abstracted human and animal shapes are caught in dramatic poses of struggle and frenzy. *Centaur*, for example, is clearly interpretable as a scene of intense action in which a centaur rears up on its hind legs and grasps the hands and feet of a convulsed woman who is curled over backwards. The sculpture rises forcefully upward and outward and carves out a strong silhouette in which negative and positive spaces are equally dynamic. Born of Greek parents, Hadzi lived and studied abroad in Greece and Italy for different periods and found continued inspiration in ancient myths and their manifestation in classical art. Unlike their European postwar Expressionist counterparts, American sculptors working in a similar vein often moved into abstract idioms, Hadzi among them.

Confusion exists as to the precise dates of the conception and earliest model of *Centaur* and its casting. Information that accompanied the work when purchased in 1962 gave its date as 1957–58, which could possibly apply to the time the casts in this edition were made. Seamus Heaney, in his monograph on the artist, dates a smaller version of the sculpture (11 in. long) to 1955–56, and two versions of a closely related but somewhat different composition to 1951 and 1954.[1] Until more conclusive evidence is available, we adopt here a dating of 1955–56, recognizing that the casting of the work into bronze could have occurred later.

Hadzi produced several close variations on this basic composition, some of them in more monumental scales.[2] An apparently larger working plaster is known from a photograph from the 1960s of one of Hadzi's studios in Rome.[3]

Plaster maquette of Centaur *in Hadzi's studio in Rome, 1950s*

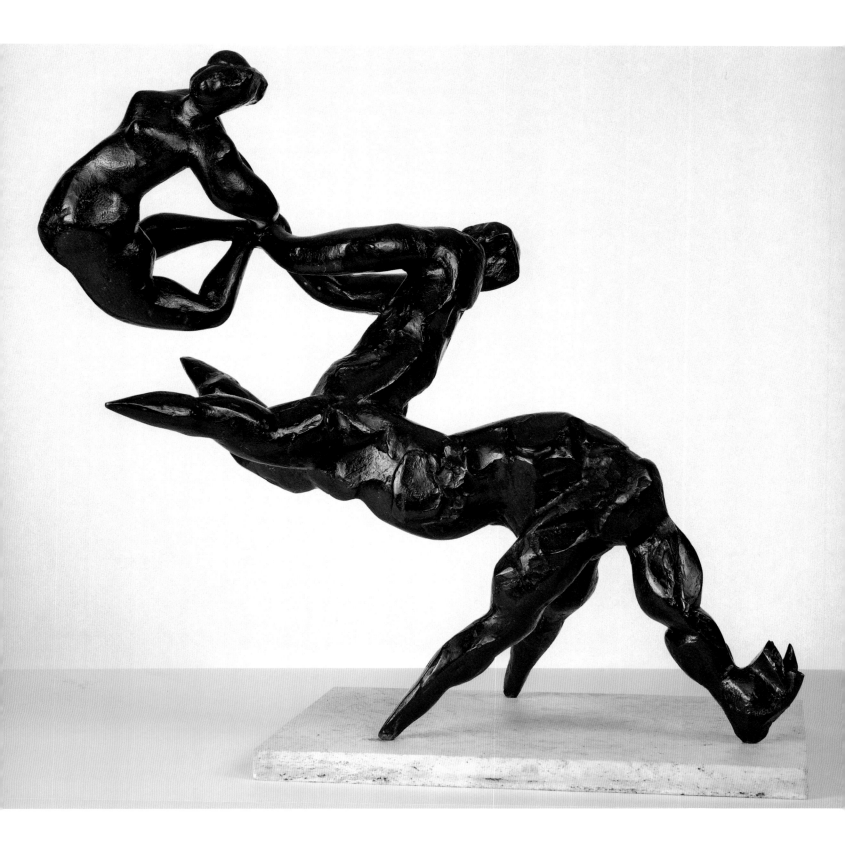

Franz Kline
American, 1910–1962
Study for Accent Grave, 1954

Oil wash on paper
Signed on verso: *FRANZ KLINE*
14 ½ x 10 ⅛ in. (36.8 x 25.4 cm)
Collection of Gwendolyn Weiner L1980-4.10

Provenance: David Gibbs and Co., London;
to the Weiner collection, 10 October 1962

Literature and exhibitions:

Houston 1964, cat. no. 5

Recent American Paintings, exh. cat. (Austin:
Art Museum of the University of Texas,
1964), cat. no. 24

Austin 1966, cat. no. 31

Six Painters, exh., University of St. Thomas,
Houston, 1967

Recent Acquisitions of Local Collectors, exh.
cat. (Fort Worth: Fort Worth Art Center
Museum, 1968), n.p.

Art in Embassies: Budapest, exh. organized by
Museum of Modern Art, New York, 1970

Olivier Meslay et al., *Hotel Texas: An Art
Exhibition for the President and Mrs. John F.
Kennedy*, exh. cat. (Dallas: Dallas Museum of
Art, 2013), 30, 58, 60, pl. 5, cat. no. 5

FRANZ KLINE'S FREELY BRUSHED, endlessly inventive works on paper share credit with his oil paintings for his reputation as one of the most important Abstract Expressionist artists. He drew extensively throughout his abstract period from roughly 1947 until hobbled by ill health in 1962, working with brushes and ink and/or oils, generally in black and white, but often with color in his later work. Because of the dashing brushwork typical of his drawings, an analogy with Chinese calligraphic art is often proposed, although Kline himself denied any such connection.

Kline's paintings are generally seen as exemplary of action painting, with its spontaneity, sweeping tracks of the brush, and physical and psychological investment in each work. It is surprising, therefore, to discover how closely Kline's large-scale paintings are patterned after small studies. *Study for Accent Grave* offers a case in point and follows a well-documented routine in Kline's working methods. Comparing it with the painting it engendered—*Accent Grave* from 1955 in the Cleveland Museum of Art (below)—we see just how fastidious was Kline's transfer of the composition into expanded dimensions. It is not accurate, however, to assume that he simply copied the design onto canvas. In the process he made certain adjustments, such as stretching the design horizontally, straightening some of the lines, and smoothing contours, to give the overall composition a more tectonic, somewhat less free-flowing quality. And the process of painting itself was full of struggle and decisions, as Kline worked black over white but also white over black, creating the dramas of paint handling that constitute the best of his works. Such adjustments suited the monumental scale of the painting but left behind some of the gusto of the drawing.

The title of this work derives from the downward sloping line at the top that suggests the *accent grave* mark in French phonetics. It is representative of a type of relatively sparse, horizontal composition that recurs in Kline's paintings, for example in his *Hazelton* of 1957 and *Riverbed* of 1961.[1]

[1] See Harry Gaugh, *Franz Kline: The Vital Gesture*, exh. cat. (Cincinnati: Cincinnati Art Museum, 1985), pl. 57, and *Franz Kline 1910–1962*, exh. cat. (Rivoli-Turino, Italy: Castello di Rivoli Museo d'Arte Contemporanea, 2004), 81.

*Franz Kline, Accent Grave, 1955,
The Cleveland Museum of Art*

Franz Kline
American, 1910–1962
Black and White Drawing, 1955

Oil wash on paper
Signed on verso: *FRANZ KLINE*
12 ½ x 9 ¼ in. (31.8 x 23.5 cm)
Palm Springs Art Museum, gift of Gwendolyn
Weiner 111-2010

Provenance: David Gibbs and Co., London;
to the Weiner collection, 10 October 1962

Literature and exhibitions:

Houston 1964, cat. no. 3

Recent American Paintings, exh. cat. (Austin:
Art Museum of the University of Texas,1964),
cat. no. 25

Austin 1966, cat. no. 29

Six Painters, exh., University of St. Thomas,
Houston, 1967

Recent Acquisitions of Local Collectors, exh.
cat. (Fort Worth: Fort Worth Art Center
Museum, 1968), n.p.

Abstract Expressionism, exh. cat. (Corpus
Christi: Art Museum of South Texas, 1969)

UNLIKE FRANZ KLINE'S *Study for Accent Grave* (p. 72), his *Black and White Drawing* from 1955 cannot be linked to any particular painting, although it shares elements in common with numerous works. The motif of an open rectangular boxlike form appended to longer structural members in a vertical composition appears, for example, in drawings such as *Black and White* from 1953 and *Abstraction* from 1955.[1] And analogies for the highly architectural towerlike composition are found in a number of large paintings, including *Tower* from 1963 and *Meryon* from 1960–61.[2]

Even in its relatively diminutive scale, this study packs the kind of visual impact typical of Kline's works in black and white, both large and small, and demonstrates again how fruitful his drawings were as starting points for monumental compositions. In addition to the strength of black and white contrasts, the animated brushwork, and the strong girderlike forms (another important compositional ingredient that is almost universally present in Kline's work) is the virtual expansion of the visual field. He creates this not only by engaging the edges of the field but by seeming to force internal shapes beyond the edges into surrounding space. Through the lens of Kline's works we observe fragmental force fields, but enlarge those forces in our imagination.

[1] *Franz Kline 1910–1962*, exh. cat. (Rivoli-Turino, Italy: Castello di Rivoli-Turino d'Arte Contemporanea, 2004), 211, and David Anfam, *Franz Kline: Black and White 1950–1961*, exh. cat. (Houston: The Menil Collection, 1994), pl. 33.
[2] *Franz Kline 1910–1962*, 211, and Harry Gaugh, *Franz Kline: The Vital Gesture*, exh. cat. (Cincinnati: Cincinnati Art Museum, 1985), pl. 125.

Franz Kline
American, 1910–1962
Lyre Bird, 1957

Oil on composition board
Signed and dated on reverse: *FRANZ KLINE '57*
18 ¾ x 24 in. (47.1 x 61 cm)
Collection of Gwendolyn Weiner L1980-4.8

Provenance: Collection of N. Richard Miller,
Philadelphia; Weintraub Gallery, New York;
to the Weiner collection, 11 October 1968

Literature and exhibitions:

Institute of Contemporary Art, University of
Pennsylvania, 1963

Philadelphia Collects 20th Century, exh. cat.
(Philadelphia: Philadelphia Museum of Art,
1963), 20

Two Generations of American Painting, exh.,
Wilcox Gallery, Swarthmore College, 1964

LYRE BIRD IS ONE OF NUMEROUS small-scale paintings done in color (in oil on paper or board) that Franz Kline produced in the last five years of his life. Although Kline's position in the history of Abstract Expressionism is most dependent upon his powerful black-and-white paintings, color also played an important role in his aesthetics. His earliest abstractions in the 1940s were highly colorful. Even in the early '50s, when his black-and-white style reached maturity, he sometimes included colors in the early stages of compositions but then painted them out or left only a trace. In 1956, however, he readmitted color as an essential ingredient in his paintings. Though this development struck some critics as a deviation, he felt that color added an important dimension to his work, and he used it for new spatial, structural, and expressive effects. These late works with color have come to be respected equally with the black-and-white paintings. In *Lyre Bird*, a range of colors from tinted white to dark blue is loosely brushed into broad areas that form a ground for the sprightly black form at the center, which Kline uncharacteristically identified as a realistic shape—a flying bird. Native to Australia, lyrebirds are known for their distinctively long tail feathers that suggest the curved form of a lyre, the stringed musical instrument of the harp class that appears frequently in Greek art. Literal images are extremely rare in Kline's abstractions. He perhaps "discovered" the shape in the course of painting and preserved it for self-amusement.

Georg Kolbe
German, 1877–1947
Crouching Nude (Kauernde), 1917

Bronze
Marked: *GK H.NOACK BERLIN 5* (inside base)
9 1/8 x 7 ¼ x 5 ⅜ in. (23.2 x 18.4 x 13.7 cm)
Collection of Gwendolyn Weiner L2015.19.2

Provenance: Felix Landau Gallery, Los Angeles; to the Weiner collection, 10 March 1962

Literature and exhibitions:

Georg Kolbe, Richard Scheibe, Gerhard Marcks, exh., Galerie Möller, Berlin, 1919

Georg Kolbe, exh., Galerie Paul Cassirer, Berlin, 1921

Wilhelm R. Valentiner, *Georg Kolbe: Plastik und Zeichnung* (Munich: Kurt Wolff Verlag, 1922), pl. 23

Georg von Alten, "Georg Kolbe," *Die Kunst für Alle* (April 1922), 217

Georg Kolbe: Plastiken aus den Jahren 1908 bis 1925, exh., Galerie Ernst Arnold, Dresden, 1925

Fort Worth 1959, cat. no. 76 (added to republished catalogue)

Austin 1966, cat. no. 32

Eberhard Roters, *Galerie Ferdinand Möller: Die Geschichte einer Galerie für Moderne Kunst in Deutschland 1917–1956* (Berlin: Gebr. Mann Verlag, 1984), 74

Ursel Berger, *Georg Kolbe—Leben und Werk, mit dem Katalog der Kolbe-Plastiken im Georg-Kolbe-Museum* (Berlin: Gebr. Mann Verlag, 1990), cat. no. 31

[1] For similar examples see Berger, cat. nos. 13, 16, 44, 45, 55, 68, 69, 76, 77, 115, 127, 132.
[2] Details provided by the Felix Landau Gallery at the time of Ted Weiner's purchase of this work indicated that it came from an edition of eight casts made in 1938, but it is possible that this information actually refers to the posthumous edition. The numeral 5 stamped inside the base seems most likely to be a casting number.

ESSENTIALLY SELF-TRAINED AS A SCULPTOR, Georg Kolbe was one of the primary adherents in early twentieth-century Germany of classicism and the figurative tradition of Auguste Rodin. He had studied art at the academies in Dresden and Munich, as well as the Académie Julian in Paris, with the intention of becoming a painter. It was only after independent studies in Rome that he decided in 1898 to devote himself instead to sculpture. Except for a brief period around 1919 to 1923 when his work veered into the orbit of German Expressionism, he followed a more conservative path that featured athletic nudes in graceful poses often related to modern dance, modeled with smooth, flowing contours and a sense of lyrical expression. The imprint of Rodin's dancers is apparent but without that master's more strenuous movement and muscular anatomies. In the 1930s, the idealized naturalism of his monumental figures seemed complementary to the National Socialist party's propagandizing of a heroic Aryan race, and he received the dubious honor of its approval, even though some of his Expressionist works were removed from public display.

Crouching Nude from 1917 is representative of the classicizing style for which Kolbe is best known and is similar in scale and pose to many other of his seated or kneeling figures.[1] The woman's lithe body is shaped with a delicate touch that produces an even, gentle play of light. Seated with her head raised, arms akimbo, and knees up, she is in a nearly symmetrical pose, adding to the sense of balance and composure. The example of Aristide Maillol weighs heavily here, particularly that of famous works such as *Night* from ca. 1902–09, which features a seated figure with very similar proportions and head bowed in a totally symmetrical composition much influenced by Egyptian cube figures. Without the same restraint, Kolbe's figure is also contained within a basic geometric framework, although she seems capable of springing upward into motion at any moment.

This small figure was one of Kolbe's best-known works from his early career. Noack foundry in Berlin made the first edition of fifteen casts in 1919, one of which was immediately exhibited at the Galerie Möller, also in Berlin. Because of the work's popularity, Kolbe authorized a second edition in 1940, but because of the war this series was capped at three casts. A final posthumous edition, approved by the artist before his death, contained approximately thirteen casts, but the exact number is unknown. To which edition the Weiner cast belongs has been impossible to ascertain.[2]

Roger de La Fresnaye
French, 1885–1925
Landscape with Woman, Cow, and Dog (Marie Ressort avec ses Vaches, La Bergère), ca. 1913

Oil on canvas
Signed (partially covered): *R. de...*
78 ½ x 62 ¾ in. (200 x 160 cm)
Collection of Gwendolyn Weiner, L1995-3.5

Provenance: Ragnar Moltzau, Oslo; Marlborough Fine Art, London; Galerie des Arts Anciens et Modernes, Zurich; to the Weiner collection, 30 November 1962

Literature and exhibitions:

Kunstnerforbundet, Oslo, 1916

The Moltzau Collection, exh. cat. (Oslo: Kunstnernes Hus, 1946), cat. no. 90

Raymond Cogniat and Waldemar George, *Oeuvre complete de Roger de La Fresnaye* (Paris: Éditions Rivarol, 1950), 41–42, pl. 10 (Albright-Knox Art Gallery version)

Fra Renoir til Villon: Franske malerier og tegninger, ulaant fra Ragnar Moltzaus samling, Oslo, exh. cat. (Stockholm, Nationalmuseum, 1956), cat. 23

Collection of Ragnar Moltzau, exh. cat. (Edinburgh: Royal Scottish Academy, 1958)

Collection of Ragnar Moltzau, exh. cat. (London: Tate Gallery, 1958), cat. no. 35

Masters of Modern Art, exh. cat. (London: Marlborough Fine Arts, 1960), cat. no. 49

AROUND 1910, ROGER DE LA FRESNAYE painted two works in a primitivist style entitled *La bergère, Marie Ressort, enfant*, possibly based on a scene he viewed during recent trips to Beauvernay in eastern France, where he maintained a studio, or in Brittany.[1] He then reprised this theme around 1912–13 in two closely related paintings, *Marie Ressort* in the Albright-Knox Art Gallery in Buffalo and this larger and slightly later version in the Weiner collection,[2] both done in his mature Cubist style. A shepherdess is seen standing outdoors with a dog and cow. The whole scene, including sky, figures, and landscape, is subjected to a geometric stylization that reduces three-dimensional form to flat, angular planes interworked with straight and curved linear accents. La Fresnaye's breakdown of form and reorganization of space, however, do not have the same complexity found in Picasso and Braque's Analytic Cubism. Also, the colors are much brighter, with rich reds, blues, and greens more reminiscent of Paul Cézanne's late landscapes. A sense of classical balance prevails, as is traditional in much of French painting, perhaps indicative of La Fresnaye's admiration for Puvis de Chavannes, who had recently revised J. A. D. Ingres's earlier neoclassicism. This is particularly true of the larger version of the theme in the Weiner collection, which is considerably more simplified than its predecessor at the Albright-Knox Art Gallery.

Roger de La Fresnaye, *Marie Ressort*, 1912–13, Albright-Knox Art Gallery, Buffalo, NY

Important European Paintings from Texas Private Collections, exh. cat. (New York: Marlborough-Gerson Gallery, 1964), cat. no. 15

The Heroic Years: Paris 1908–1914, exh., Houston Museum of Fine Arts, 1965

Austin 1966, cat. no. 33

Germain Seligman, *Roger de La Fresnaye* (Neuchâtel: Éditions Ides et Calendes, 1969), cat. no. 125 (titled *Marie Ressort avec ses Vaches, La Bergère*)

Richard Wattenmaker, *Puvis de Chavannes and the Modern Tradition*, exh. cat. (Toronto: Art Gallery of Ontario, 1975), cat. no. 79

Georges Seligman, *Roger de La Fresnaye* (Neuchâtel: Éditions Ides et Calendes, 2002), 56, 58

[1] Seligman 1969, cat. nos. 72–73.
[2] Seligman 1969, cat. nos. 124 and 125 respectively. On the earlier version, see Steven Nash, *Albright-Knox Art Gallery: Painting and Sculpture from Antiquity to 1942* (New York: Rizzoli International Publications, 1979), 388–89. La Fresnaye also painted a large watercolor of the same scene that corresponds with the two oils, but somewhat more closely with the Weiner version. See Seligman 1969, cat. no. 126. Roger de La Fresnaye was part of the second wave of Cubist painters in Paris. From 1908 to 1910, he studied at the École des Beaux-Arts, then at the Académie Ranson, where he worked briefly under Maurice Denis and Paul Sérusier. More important for his development, however, was the recent pioneering work of Pablo Picasso and Georges Braque, although his personal style of Cubism merged their inventive treatment of form and space with a more conventional and colorful figurative approach. His productive career was cut short by tuberculosis, which he contracted during service in World War I and from which he never fully recovered.

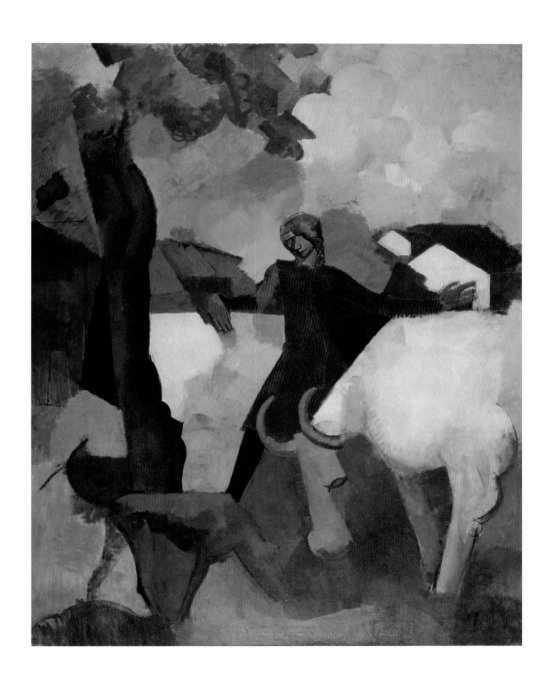

Henri Laurens

French, 1885–1954

Les ondines (Water Nymphs), 1934

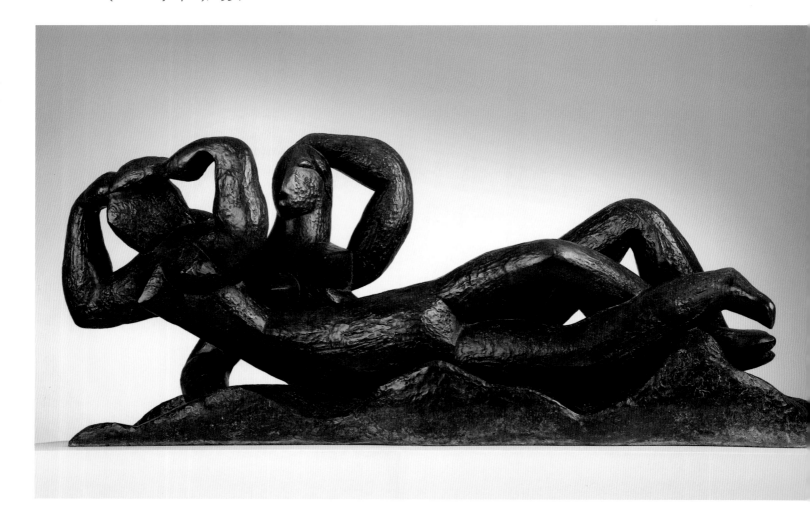

Bronze; edition 2/6
Marked: *HL 2/6 C. VALSUANI/CIRE PERDUE*
29 ¼ x 61 ½ x 18 in. (74.3 x 156.2 x 45.7 cm)
Collection of Gwendolyn Weiner, on long-term loan to Morton Meyerson Symphony Center, Dallas

Provenance: Fine Arts Associates, New York; to the Weiner collection, 27 February 1959

Literature and exhibitions:

Henri Laurens: Sculpture, exh. cat. (New York: Fine Arts Associates, 1958), cat. no. 2

Fort Worth 1959, cat. no. 16

Henri Laurens: Monumental Sculpture, exh. cat. (New York: Marlborough-Gerson Gallery, 1966), cat. no. 6 (different cast)

Henri Laurens: Exposition de la donation aux Musées Nationaux, exh. cat. (Paris: Grand Palais, 1967), cat. no. 38 (different cast)

Henri Laurens, exh. cat. (London: Hayward Gallery, 1971), cat. no. 45 (different cast)

Elizabeth Cowling and Jennifer Mundy, *On Classic Ground: Picasso, Léger, de Chirico and the New Classicism 1910–1930*, exh. cat. (London: Tate Gallery, 1990), 135

[1] For Laurens's views on classical equanimity in his art, see Cowling and Mundy, 134.
[2] See *Henri Laurens*, exh. cat. Paris, cat. nos. 25 and 37, respectively. Laurens's *Architecture* from 1932 (Paris cat. no. 27) is a small reclining nude on wavy drapery, and his small *Ondine* from 1932 (Paris cat. no. 30) depicts a single figure on waves.

HENRI LAURENS RECEIVED EARLY TRAINING as an ornamental stone carver while also studying with the academic sculptor Jacques Perrin. In 1911 he met George Braque and other Cubists, and by 1915 his work began to reflect an interest in abstracted geometric form. He quickly developed a personal variant of Synthetic Cubism elaborated in collages, carvings, and constructions in stone, terracotta, or wood, often with color added. In the 1920s, Laurens, like many other French artists, underwent a classicizing transformation under the banner of a Return to Order. The result was an antigeometric sculptural vocabulary featuring ample nudes whose elongated, stylized forms are controlled by gently flowing rhythms and distortions influenced by archaic and primitive art.[1] One of his favorite themes was the reclining nude, treated in a number of different iterations, including his well-known *Grande maternité* of 1932. Two years later, in *Les ondines*, he doubled the reclining nude motif to produce an even more extravagant display of wavelike movement.[2]

The two women lie close together in complementary poses. The front figure twists her head and upper body around as if surveying the horizon, and the one behind props herself up in a more relaxed position, raising one hand to her head in a pose often emblematic of erotic beauty in ancient Greek and Roman sculpture. When viewed frontally, the lateral displacement of their heads and torsos creates an emphatic note of strong, rounded shapes while, in a counterbalancing theme, their legs weave together horizontally in curves that rhyme with the waves they float upon. In ancient mythology, *ondines* (or undines) were water sprites known for their sweet song, and they continued as subject matter into modern literature, art, and theater. Laurens's good friend Aristide Maillol had incorporated water themes in both his paintings and sculpture and produced a number of reclining nudes lying on draperies with distinctively wavelike patterns. Some of these archetypes must have been in the back of Laurens's mind when he modeled his *Ondines*.

Jacques Lipchitz
French, born Lithuania, 1891–1973
Draped Woman (Femme drapée), 1919

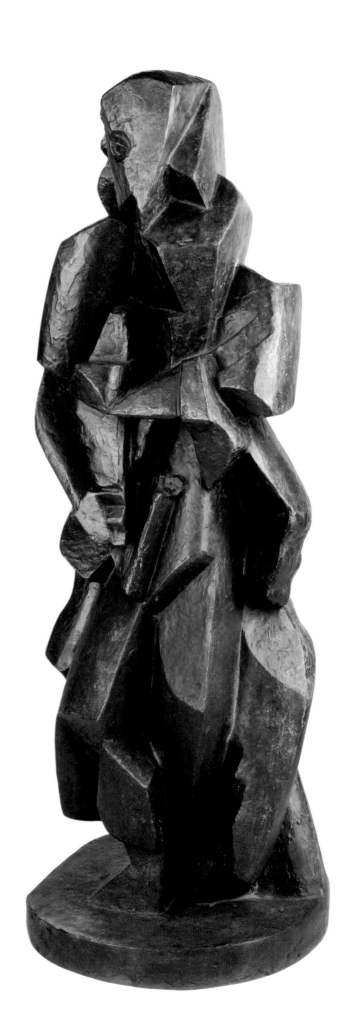

Bronze; edition 4/7

Marked: *4/7 Lipchitz* thumbprint of the
artist *Modern Art Foundry, New York*

36 ½ x 12 ¼ x 12 ¼ in. (92.7 x 31.1 x 31.1 cm)

Collection of Gwendolyn Weiner L2007-15.2

Provenance: Fine Arts Associates, New York;
to the Weiner collection, 13 September 1958

Literature and exhibitions:

Fort Worth 1959, cat. no. 17

Hammacher, 1960. pl. 27

Houston 1964, cat. no. 12

Austin 1966, cat. no. 38

Lipchitz: The Cubist Period 1913–1930, exh.
cat. (New York: Marlborough-Gerson Gallery,
1968), cat. no. 33 (different cast)

Palm Springs 1969, cat. no. 15

Douglas Cooper, *The Cubist Epoch* (New York:
Phaidon Press, 1970), cat. no. 196, pl. 311

La Jolla 1970

Wilkinson 1989, cat. no. 30 (different cast)

Wilkinson 1996, cat. no. 99

Nash and Hough 2007, 13–14, cat. no. 8

Biller 2008, 28

75 Years 2014, 68–69

[1] *75 Years*, 68.

[2] Barañano 2009, 25.

DURING HIS LONG AND EXTREMELY PRODUCTIVE CAREER, first in Paris and then the
United States, Jacques Lipchitz explored a number of stylistic idioms, ranging from the
realism of his portrait heads, to the geometric stylizations of his Cubist sculptures, to
the late, heroic treatments of mythological and biblical subjects. *Draped Woman* is an
outstanding example of his work between 1913 and 1920 when he was deeply engaged in
the groundbreaking principles of Cubism that Pablo Picasso introduced into sculpture
several years earlier. It is particularly representative of a series of standing figures from
ca. 1916–19; sharply faceted forms angle together and rotate around a central axis,
shaping human anatomy and garments in a semiabstract shorthand:

> Given the complex forms of this figure, its details are somewhat difficult to
> decipher. The woman is nude with a cloak or dressing gown draped over her
> left forearm and shoulder. It drops behind her in billows almost to the floor.
> In her hands, pressed against her right side, she holds a long vertical (and
> unidentifiable) object that tapers toward both ends. Her face, defined by flat
> planes with just one eye in front, has a particularly masklike appearance. She is
> one of a number of nudes and bathers in Lipchitz's repertoire of Cubist figures,
> which—joined with his musicians, harlequins, and dancers—form a cast of
> pleasurable personae."[1]

Lipchitz's standard working procedure was to first model his sculptures in clay, then
cast the forms into plaster models, from which bronze casts were made. This particular

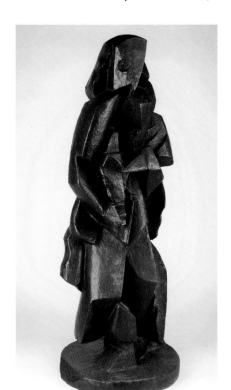

bronze was produced in an edition of seven
casts at the Modern Art Foundry in New York
sometime after Lipchitz immigrated to the
United States in 1941. The clay version of *Draped
Woman* is lost. The plaster model appeared in
Lipchitz's important retrospective exhibition
in Paris in 1930 organized by the dealer Jeanne
Boucher, owner of the Galerie de la Renaissance,
and is recorded in a photograph of Lipchitz's
studio from ca. 1939–40.[2] Its present location
is unknown, however, and it may have been
destroyed. A unique cast-stone version belongs
to the Barnes Foundation in Philadelphia.

Jacques Lipchitz, Draped Woman,
frontal view

Jacques Lipchitz
French, born Lithuania, 1891–1973
The Harpists, 1930

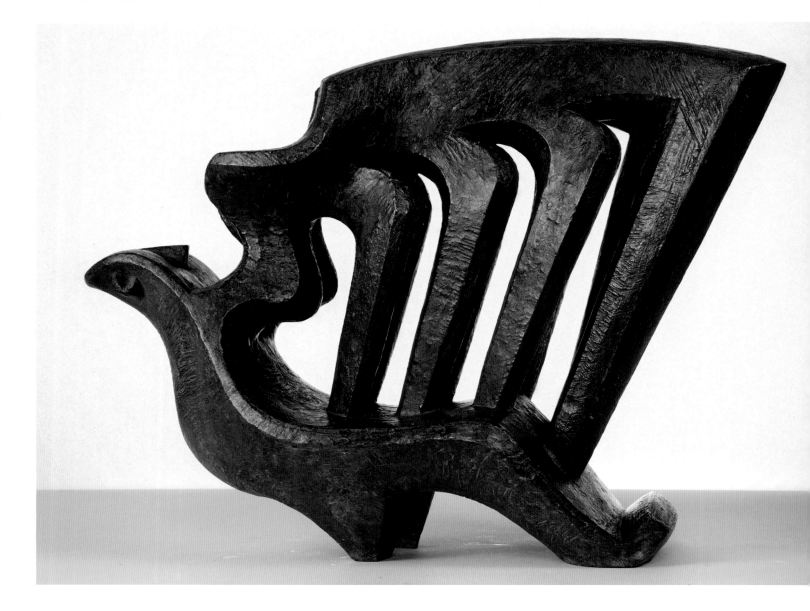

Bronze; edition of 7
Marked: *J Lipchitz*
17 x 18 ¼ x 16 ¼ in. (43.27 x 46.4 x 41.3 cm)
Collection of Gwendolyn Weiner L1980-3.12

Provenance: James Lewis collection; to the Weiner collection, 15 October 1968

Literature and exhibitions:

Henry R. Hope, *The Sculpture of Jacques Lipchitz*, exh. cat. (New York: Museum of Modern Art, 1954), 15, 58, 91 (different cast)

Hammacher, 1960, 47, 53, pls. XXXVIII and 53

Irene Patai, *Encounters: The Life of Jacques Lipchitz* (New York: Funk and Wagnalls, 1961), pl. 27

Jacques Lipchitz: A Retrospective Selected by the Artist, exh. cat. (Los Angeles: University of California Los Angeles Galleries, 1963), cat. no. 108

Bert Van Bork, *Jacques Lipchitz: The Artist at Work* (New York: Crown Publishers, 1966), 153

Lipchitz: The Cubist Period 1913–1930, exh. cat. (New York: Marlborough-Gerson Gallery, 1968), cat. no. 65 (different cast)

Palm Springs 1969, 15

La Jolla 1970

Lipchitz 1972, 115–16, fig. 97

Wilkinson 1989, cat. no. 63 (different cast)

Wilkinson 1996, cat. no. 254

Jacques Lipchitz: Sculpture and Drawings 1912–1972, exh. cat. (New York: Marlborough Gallery, 2004), cat. no. 43 (different cast)

Nash and Hough 2007, 14, cat. no. 9

[1] Lipchitz 1972, 115.
[2] Wilkinson 1996, cat. no. 216.
[3] Barañano 2009, cat. no. 162.

IN HIS AUTOBIOGRAPHY Jacques Lipchitz wrote about this sculpture:

> [It] resulted from the concerts my wife and I attended at the Salle Pleyel [in Paris] in which we were seated near the harps and I became fascinated by the intimacy between the woman harp player and the instrument, the music itself and the shimmering of the strings in the light. All of this had a very strange, almost hypnotic impact on me. The 1930 bronze I entitled *The Harpists* since I seemed to see more than one figure. Also, there was a curious visual metamorphosis of the harp player and her instrument into a bird form.[1]

The structure of this work evolved out of a series of open-form sculptures that Lipchitz termed his "transparencies." That term was based upon their construction from flat strips, plates, and strings of metal assembled so that space plays an active role in the compositions. One can see all the way through them, a feature maintained to a lesser degree in *The Harpists.* One of these works was the *Harp Player* of 1928. While highly stylized and linear in conception, it clearly portrays a seated figure reaching around a harp and strumming its strings.[2] By 1930 Lipchitz had started working with heavier, more solid forms, although the swerving shapes of the musician-cum-bird and its instrument give *The Harpists* a dynamic appearance and sense of lightness. In a clever double-entendre, the two ears of the musician also serve as the eyes of the bird. The basic form of *The Harpists* soon metamorphosed into Lipchitz's famous monumental sculpture *Song of the Vowels*, which he began to work on in 1931. A plaster model for *The Harpists* is in the Kröller-Müller Museum, Otterlo, the Netherlands.[3]

Jacques Lipchitz
French, born Lithuania,
1891–1973
Hagar in the Desert
(*Hagar III*), 1949–57

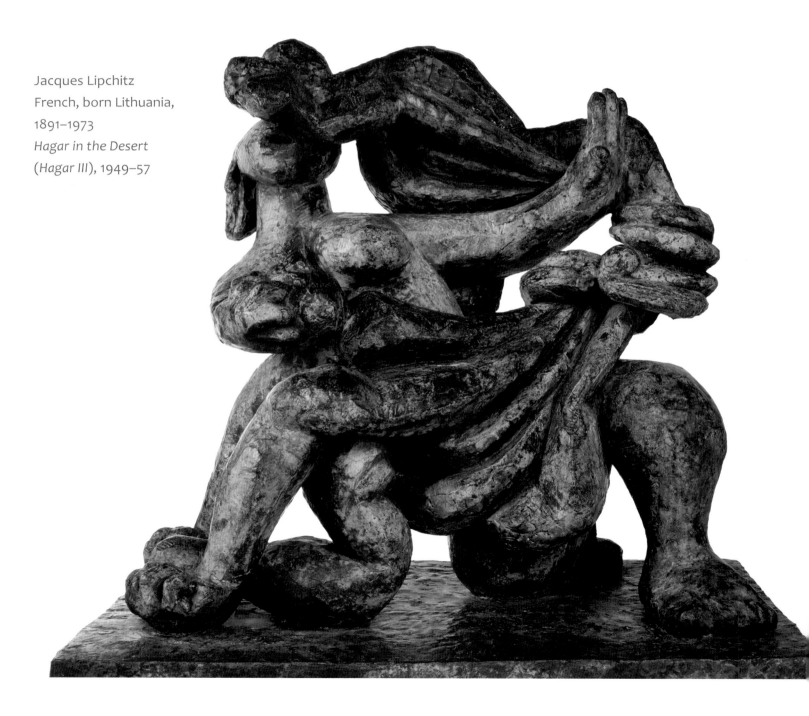

Jacques Lipchitz, Hagar in the Desert, *in the Weiner sculpture garden, Fort Worth*

Bronze; edition 3/7
Marked: *3/7 Lipchitz* thumbprint of the artist
34 ¾ x 33 x 24 ¾ in. (88.3 x 83.8 x 63 cm)
(base included)
Collection of Gwendolyn Weiner L1980-3.11

Provenance: Fine Arts Associates, New York;
to the Weiner collection, 27 February 1959

Literature and exhibitions:

Fort Worth 1959, cat. no. 17

Hammacher 1960, 66, pl. LVII

Wichita 1965, cat. no. 17

Austin 1966, cat. no. 36

Palm Springs 1969, 14

La Jolla 1970

Lipchitz 1972, 183–85, fig. 201

A Tribute to Jacques Lipchitz, exh. cat.
(New York: Marlborough Gallery, 1973),
pl. 69 (large stone version)

Wilkinson 1989, cat. no. 96 (for *Hagar I*)

Wilkinson 2000, cat. no. 440

*Jacques Lipchitz: Dohaintza/Donación/
Donation* (Bilbao: Museo de Bellas Artes de
Bilbao, 2005), n.p. (plaster of large version)

Nash and Hough 2007, 14, cat. no. 10

Biller 2008, 28

Jacques Lipchitz: Beyond Bible and Myth, exh.
cat. (New York: Marlborough Gallery, 2010),
cat. no. 22

JACQUES LIPCHITZ MOVED TO THE UNITED STATES in 1941 as a consequence of the Nazi occupation of northern France. From that time onward, his work dealt more and more emphatically with themes of suffering, sacrifice, and redemption drawn often from classical mythology and the Old Testament. He employed a formal style that is sometimes referred to as neo-baroque for its replacement of Cubist influences with animated, voluminous forms and rhetorical content. *Hagar in the Desert* is a prime example of this new direction, which would continue to characterize his work throughout the remainder of his life. The complex narrative is drawn from the book of Genesis. Abraham had a son, Ishmael, with his concubine, Hagar, and at the insistence of his wife, Sarah, banished the two of them to the desert. When their food and water ran out, God heard Hagar's laments and sent an angel who produced a well of water and promised to make for Ishmael a great nation. Lipchitz saw in the story a parable for the contemporary conflict of Arabs and Jews that proceeded from the founding of Israel. "I wished to show my sympathy for Ishmael, who is thought of as the father of the Arabs… so this is a prayer for brotherhood between the Jews and the Arabs."[1]

The sculpture evolved from a small study in clay to several maquettes and two early versions in bronze, *Hagar I* and *II* from 1948. Lipchitz then worked on *Hagar in the Desert* (or *Hagar III*) between 1949 and 1957. Its plaster maquette still exists.[2] He later made a marble version in 1969 and large-scale, 70-inch versions in bronze and stone in 1969 and 1971.[3] In all versions, Ishmael is supported in the lap of a distraught Hagar, but the drama of convulsive movement of segments of anatomy, drapery, and hair reaches a climax in *Hagar in the Desert*, where the frenzy of forms so tellingly conveys desperate emotion.

[1] Lipchitz 1972, 183–84.
[2] Barañano 2009, cat. no. 295.
[3] See Peter Bermingham, *Jacques Lipchitz: Sketches and Models in the Collection of the University of Arizona Museum of Art* (Tucson: University of Arizona Museum of Art, 1982), cat. no. 29; and Wilkinson 2000, cat. nos. 433–40, 668–69, 721.

Jacques Lipchitz
French, born Lithuania, 1891–1973
Sacrifice (also known as *Sacrifice III*),
1949–57

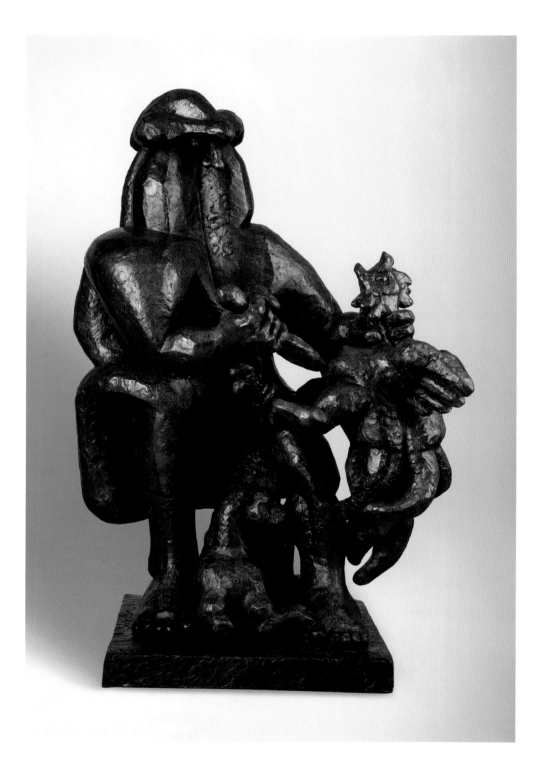

Bronze; edition 2/7
Marked: 2/7 *Lipchitz* thumbprint of the artist
Modern Art Foundry, New York
56 x 40 x 27 in. (142.3 x 101.5 x 68.5 cm)
(including base)
Collection of Gwendolyn Weiner L2008-10

Provenance: Fine Arts Associates, New York;
to the Weiner collection, 17 January 1959

Literature and exhibitions:

Henry Hope, *The Sculpture of Jacques
Lipchitz*, exh. cat. (New York: Museum
of Modern Art, 1954), 18, 92, frontispiece
(different cast)

Fort Worth 1959, cat. no. 18 (not exhibited)

Hammacher 1960, pls. XLV and 98

*Jacques Lipchitz: A Retrospective Selected by
the Artist*, exh. cat. (Los Angeles: University
of California Los Angeles Galleries, 1963), cat.
no 108 (different cast)

Wichita 1965, cat. no. 37

Bert Van Bork, *Jacques Lipchitz: The Artist at
Work* (New York: Crown Publishers, 1966),
65, 185–86

Lipchitz 1972, 180–83

A Tribute to Jacques Lipchitz, exh. cat. (New
York: Marlborough Gallery, 1973), pls. 19–21
(different cast)

Wilkinson 1989, cat. no. 99 (different cast)

Wilkinson 2000, cat. no. 446

Michael Taylor, *Jacques Lipchitz and
Philadelphia*, Philadelphia Museum of Art,
Bulletin 92, nos. 391–92 (Summer 2004), 26,
28 (drawings)

[1] Wilkinson 2000, cat. no. 379.
[2] Lipchitz 1972, 180, 183.
[3] Lipchitz 1972, 180.
[4] Lipchitz 1972, 180.
[5] Barañano 2009, cat. no. 287. For plasters of
two earlier versions, see cat. nos. 285 and 286.

SACRIFICE IS AMONG THE most imposing of Jacques Lipchitz's late heroic sculptures. For degree of physical and emotional violence, it is comparable to his *Prometheus Strangling the Vulture* of 1943.[1] Produced soon after World War II, it undoubtedly derives to some degree from memories of horrific events, although Lipchitz in his writings tied it to the recent founding of the State of Israel. He wrote, "In 1948 and 1949, still with the birth of Israel very much on my mind, I turned to the theme of sacrifice." And he noted specifically about this sculpture, "I think this is one of my major works. It certainly is strong and complete, but it unquestionably comes out of some continuing feeling of anger," perhaps in reference to the Holocaust or the violence that attended the birth of Israel.[2] In 1943 he had made a sculpture entitled *The Prayer*, which depicts a man holding a cock over his head, but he later commented with Old Testament conviction that "for the prayer to be effective, an animal must be sacrificed."[3] The iconography of sacrifice occurs in the work of other artists dealing with the horrors of the recent war, most famously in the paintings and sculpture of Pablo Picasso. Because of the powerful bulk of *Sacrifice* and the sense of extreme brutality with which the cock is grasped by the neck and the dagger is thrust into its breast, it is one of the most memorable depictions of this theme in modern art.

Lipchitz spoke of the difficulty he had bringing the sculpture to its final form:
> This subject fascinated me to the point that I made many drawings for it, and it caused me a great deal of trouble. In actuality I was working on several versions of it until at least 1957. A [unique] cast of the first version was sold to the Albright-Knox Gallery in Buffalo, and the Whitney Museum has one more or less similar. The original plaster from which the Albright bronze was made was destroyed in the fire of my studio; but fortunately, the Albright permitted me to make a mold from their bronze, so I was able to start over again.[4]

Among the changes from the earliest to the last versions was the insertion of a reclining lamb between the man's legs, a symbol of peace that adds a Christian image to a Jewish subject. A second full-scale plaster, perhaps the one molded from the Albright-Knox sculpture, is in the collection of the Nasher Sculpture Center in Dallas (at right).[5]

*Jacques Lipchitz, Sacrifice III, 1949–57,
Nasher Sculpture Center, Dallas*

Aristide Maillol

French, 1861–1944

Reclining Nude, ca. 1910

Bronze ; edition 3/6

Marked: *M* (in an oval) 3/6 *A. Rudier/Fondeur [Paris]* (indistinct)

6 ½ x 7 ¾ x 3 in. (16.5 x 19.7 x 7.6 cm)

Collection of Gwendolyn Weiner L2012-17.1

Provenance: Felix Landau Gallery, Los Angeles; to the Weiner collection, 10 March 1962

Literature and exhibitions:

Fort Worth 1959, cat. no. 81 (added to republished catalogue)

Wichita 1965, cat. no. 18

Austin 1966, cat. no. 40

Extended loan, Museum of Texas Tech University, Lubbock, 1980–2012

[1] See Elizabeth Cowling and Jennifer Mundy, *On Classic Ground: Picasso, Léger, de Chirico and the New Classicism 1910–1930*, exh. cat. (London: Tate Gallery, 1990), cat. no. 87.
[2] See John Rewald, *Maillol* (London, Paris, New York: The Hyperion Press, 1939), 83 and 86.

ARISTIDE MAILLOL WAS BORN in the fishing village of Banyuls in southern France but moved to Paris in 1887 to pursue his interests in art. He studied at the École des Beaux-Arts under the academic painters Jean-Léon Gérôme and Alexandre Cabanel. More important for his development, however, were his admiration for the work of Paul Gauguin and his friendship with the Nabis artists. He operated a tapestry workshop beginning in 1893 but turned to sculpture around 1900 because of his failing eyesight. From the start, Maillol continued the figurative tradition of Auguste Rodin, but with a more classical insistence on clear and continuous contours, attitudes of serenity and repose, and a concept of the human form as stately architecture. In an era when most leading sculptors were attacking conventional canons of figural beauty, Maillol stayed true to his early principles throughout his life, earning renown as the one exemplar of modern art most thoroughly dedicated to classical ideals.

This small bronze by Maillol typifies many of the maquettes from early in his career and can be compared, for example, to *Study for "The Mediterranean"* of 1902 for similarities of scale, composition, and surface treatment.[1] Maillol's maquettes frequently led directly to larger sculptures, and while this particular work cannot be identified with any single large composition, its reclining nude resting on a bed of drapery has much in common with, for example, *Memorial Paul Cézanne* from 1912 and *Air* from 1938.[2]

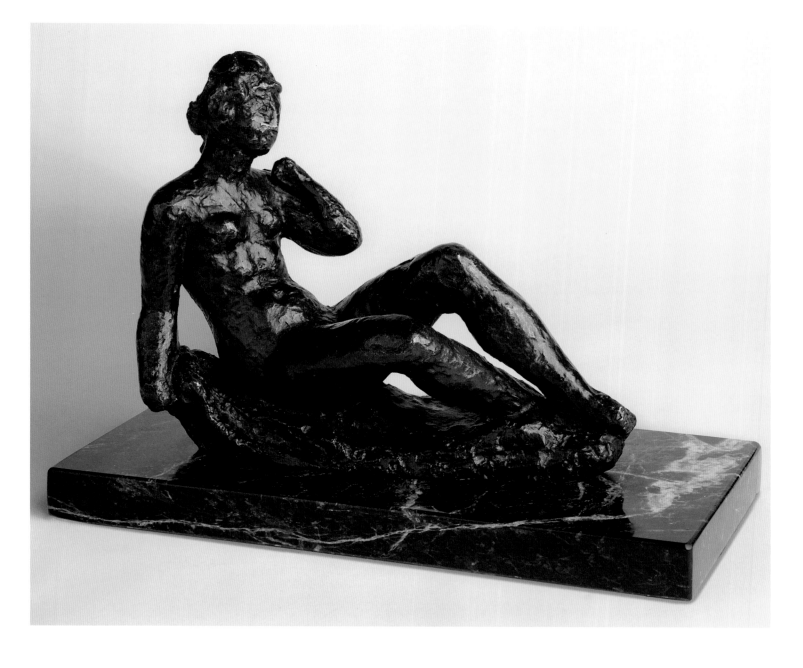

Giacomo Manzù
Italian, 1908–1991
Cardinal, 1965

Bronze
Marked: *MANZÙ/NFMM* in a circle (cast by
Fonderia MAF, Milan)
36 ½ x 11 ¼ x 7 in. (92.7 x 28.6 x 17.8 cm)
(including base)
Collection of Gwendolyn Weiner L2014.52.1

Provenance: Jeffrey H. Loria, New York; to
the Weiner collection, 15 October 1969

Literature and exhibitions:

Palm Springs 1969, 40

La Jolla 1970

*Twentieth Century Sculpture from Southern
California Collections*, exh., University of
California Los Angeles Art Galleries, 1972

[1] John Rewald, *Giacomo Manzù* (Greenwich:
New York Graphic Society, 1967), 16.
[2] Rewald, 59.

GIACOMO MANZÙ WAS BORN in Bergamo, Italy. Aside from early experience with wood-carving and other crafts and brief studies at the Accademia Cignaroli in Verona, Manzù was essentially self-taught. His art developed in Northern Italy, isolated from the major centers of avant-garde sculptural activity and untouched by the modernity of Italian Futurism. From the beginning, he followed a conservative path of figurative work based on the Italian classical tradition as well as Aristide Maillol's classicism, but always with a sensitive interpretation of the human condition by way of tender portraits, nudes, narrative bas-reliefs, and religious subjects.

The latter category includes Manzù's most famous theme, his standing and seated cardinals, notable for the calm dignity and highly stylized form of his portrayals. He pursued these subjects almost obsessively in over fifty variations of different sizes. While in Rome in January of 1934, he witnessed the pope seated between two cardinals in St. Peter's Cathedral, a visual impression that brought back childhood memories of Catholic traditions and stayed with him thereafter.[1] Following a number of drawings of cardinals, he made his first sculpture on the subject in 1936 and produced his first large-scale figures in 1949–50. Manzù claimed that he was not interested in the cardinals as religious subjects but, instead, as a kind of still-life theme allowing formal investigation of basic shapes.

The Weiner bronze is typical of many of the standing cardinals. The shape of the figure, with his cardinal's miter and voluminous cope, tapers downward from a pointed apex through the spreading garment below; the triangular neckline of the cope is echoed in an inverted V in the front folds near the hem. On the back, two cords knotted together secure a large sash. The whole form rises as a cylinder directly out of its base with no indication of feet. Manzù spoke of the series of cardinals as exhibiting "a tendency for simplification" with volumes that are "great and monumental."[2] Although all details of human anatomy except the face and one protruding hand are subsumed by the enveloping vestments, Manzù's subtle curving of contours provides a sense of a body within and softens the geometry of form. And although the figure here is only half life-size, he nevertheless projects a commanding presence.

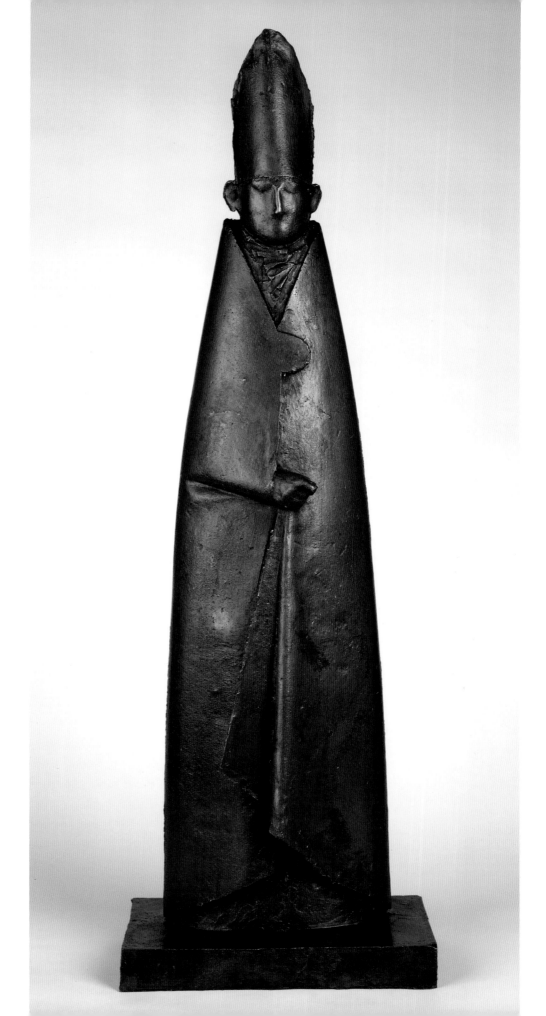

Gerhard Marcks
German, 1889–1981
Herero Woman, 1955

Bronze; edition 1/8
Marked: *GUSS BARTH. BERLIN I*
44 ¼ x 12 ⅛ x 12 ¼ in. (112.4 x 30.8 x 31.1 cm)
Collection of Gwendolyn Weiner L2007-15.7

Provenance: Fine Arts Associates, New York;
to the Weiner collection, 3 February 1959

Literature and exhibitions:

Gerhard Marcks: Recent Sculpture, exh. cat.
(New York: Fine Arts Associates, 1958),
cat. no. 14

La Jolla 1970

Martina Rudloff, *Gerhard Marcks 1889–1981:
Retrospektive*, exh. cat. (Bremen: Gerhard
Marcks–Stiftung, 1989), cat. no. 312

Nash and Hough 2007, 27, cat. no. 11

[1] See, for example, *Gerhard Marcks*, exh. cat.
(Los Angeles: University of California Los
Angeles Art Galleries, 1969), cat. nos. 71–82.
[2] Rudloff, cat. nos. 310–11.
[3] *Gerhard Marcks: Sculpture*, exh. cat. (New
York: Otto Gerson Gallery, 1961), cat. no. 10
(18 in. high).

GERHARD MARCKS BEGAN his art career around 1907 as an essentially self-taught sculptor, but he also worked later as a ceramicist and woodblock printmaker. He held several teaching positions, including appointments as director of the ceramics workshop at the Weimar Bauhaus from 1919 to 1924 and head of sculpture at the school of applied arts at Halle. Marcks served there until he was banned from teaching by the National Socialist party in 1933 and condemned as a "degenerate artist." After World War II, he revived his career and produced numerous commemorative sculptures for German cities and institutions. Various influences weave through Marcks's figuration, including the Expressionism of fellow German sculptors Wilhelm Lehmbruck and Ernst Barlach, Romanesque sculpture, an interest in archaic ancient art, and a dedication to classicism particularly evident in his large standing nudes.

Herero Woman is a relatively late work dating from soon after a trip Marcks made in 1955 to South Africa, where he was impressed by the nobility of native peoples and the beauty of the wildlife. This enthusiasm is reflected in the many drawings he made during the trip,[1] followed by sculptures and woodcuts on African themes after returning home. The Herero are an ethnic group residing in Namibia, Botswana, and Angola. They are known for their adaptation of colorful Victorian styles of clothing dating back to German occupation during the Colonial era. Marcks portrays his subject as serenely regal. She stands tall and poised. The conformation of her head and headdress clearly recalls the famous Egyptian bust of Nefertiti, and the containment of the overall sculpture in a simplified, elongated cone also has precedents in ancient art. Barely emerging from her cloak, the woman's delicately placed hands add a poignant touch. Among Marcks's many South African drawings are two studies of this same subject,[2] and in 1957 he made a smaller sculpture, *Herero Woman with Bundle*.[3]

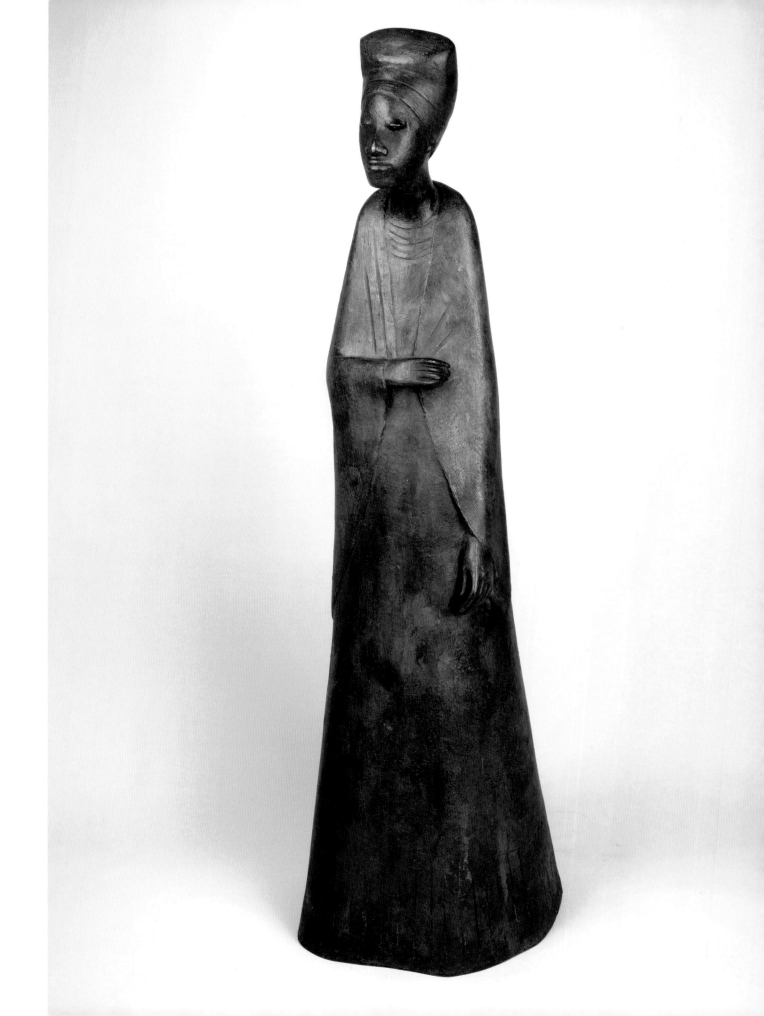

Marino Marini
Italian, 1901–1980
Horse and Rider, 1953–55

Bronze; edition 5/6
Marked: 5/6 *MM* [indecipherable foundry mark]
45 x 32 x 24 ½ in. (114.3 x 80 x 60.9 cm) (including base)
Collection of Gwendolyn Weiner L1992-6.2

Provenance: Jeffrey H. Loria & Co., New York; to Weiner collection, 17 January 1969

Literature and exhibitions:

La Jolla 1970

Ferdinand Ullrich and Hans-Jügen Schwalm, Marino Marini: Skulptur, Malerei, Zeichnung, exh. cat. (Rechlinghausen, Germany: 13. Europäisches Festival, 2003) 146 (different cast)

Nash and Hough 2007, 21, 23, cat. no. 12

75 Works 2013, 44-45

[1] Sam Hunter, *Marino Marini: The Sculpture* (New York: Harry N. Abrams, 1993), 16.

[2] See Herbert Read and Patrick Waldberg, *Marino Marini: L'oeuvre complet* (Paris: XXe Siècle, 1970) cat. nos. CS 283, 286, 296, 315, and 336.

THE THEME OF HORSE AND RIDER is dominant in Marino Marini's paintings, drawings, and sculpture. The artist was steeped in the traditions of the heroic equestrian portrait and its official uses as tribute or commemoration in ancient and Renaissance art, and his renditions of the theme prior to World War II pay homage to those precedents through their classicizing balance, stateliness, and purified forms. Following the war, however, his work swerved toward an antiheroic expressiveness reflective of the psychological distress still felt in Europe years after the conflict had ended.

The *Horse and Rider* in the Weiner collection is a clear example of this stylistic redirection. The horse is planted to the ground with frozen rigidity, seemingly in pain, and its head is strained up and to the side. The rider straddles the horse awkwardly, as if he were about to be jettisoned. His head is also pulled back in stress, and his two arms are reduced to mere stubs. Marini's modeling throughout is rough, even purposefully crude, with surfaces scraped, gouged, and pock-marked. Nothing could be farther from the equilibrium and idealized anatomies of the classical tradition.

Marini explained the goal of his postwar equestrian themes: "With each successive version of my horse, its restiveness increases; the rider, his strength waning further and further, has lost his dominion over the animal. . . . My aim is to render palpable the last stages in the dissolution of a myth, the myth of the heroic and victorious individual." He added that he was striving not for the heroic but for the tragic.[1] Indeed, the closest parallel for Marini's expressive handling of this subject in terms of emotional impact is the terrorized horse in Pablo Picasso's *Guernica* of 1937, an impassioned response to Nazi bombardment of civilians in the Spanish Civil War.

Several closely related variants on Marini's horse and rider theme date between the years 1951 and 1955 and vary in scale from roughly 25 to 70 inches in height.[2]

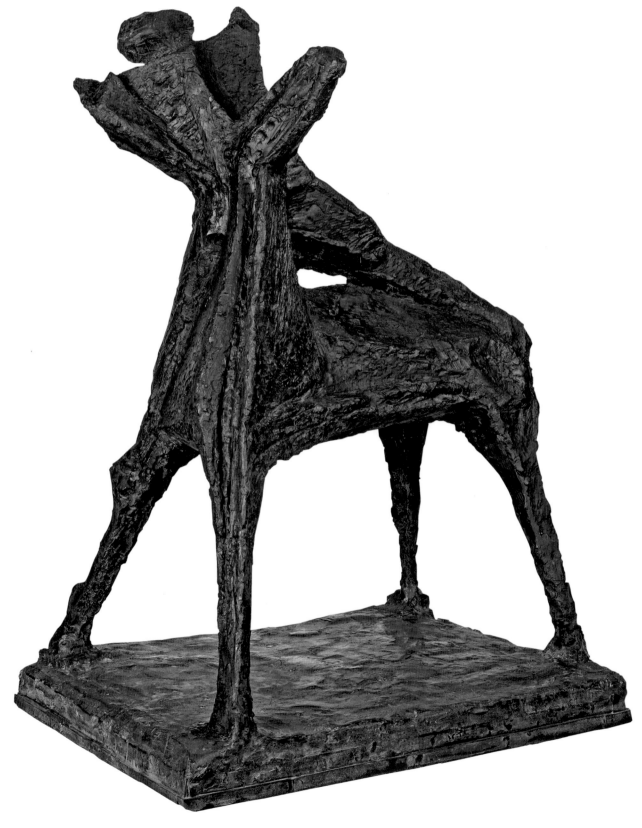

Marino Marini
Italian, 1901–1980
The Warrior, 1959–60

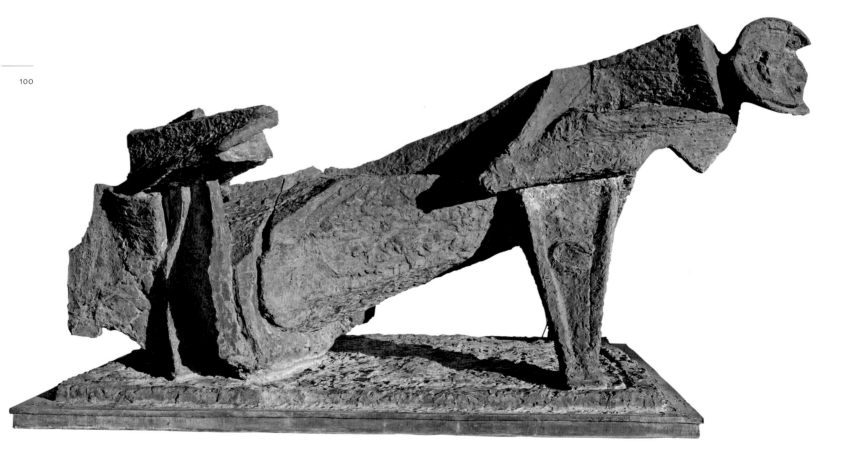

Bronze; edition 1/3
Marked: *UN CANTO DESOLATO RESTO SUL MONDO 1959/60 MM*
FOND.ART.BATTAGLIA/MILANO
75 ¾ x 144 5/8 x 82 5/8 in.
(192.4 x 367.3 x 209.9 cm) (including base)
Palm Springs Art Museum, gift of Mr. and Mrs. Ted Weiner 2-1978

Provenance: Galerie des Arts Anciens et Modernes, Zurich; to Weiner collection, 20 February 1963.

Literature and exhibitions:

Sculpture in the City, Festival of Two Worlds, Spoleto, 1962 (larger cast)

Life, 7 September 1962, Art Section

A. M. Hammacher, *Marino Marini: Sculpture, Painting, Drawing* (New York: Harry N. Abrams, 1969), pls. 270–73 (including smaller and larger versions)

Herbert Read and Patrick Waldberg, *Marino Marini: L'oeuvre complet* (Paris XXe Siècle, 1970) 489, cat. no. CS 365

Alberto Busignani, *Marini* (London: Hamlyn, 1971), 36–38, 40–42

Sam Hunter, *Marino Marini: The Sculpture* (New York: Harry Abrams, 1993), 72–77 (smaller version)

Nash and Hough 2007, 27, cat. no. 13

75 Works 2013, 44

[1] Read and Waldberg catalogue and illustrate various preliminary works and related versions of the *Warrior*. See cat. nos. CS 344, 353, 354, 359, and 360. They also illustrate two paintings by Marini based on the sculpture, cat. nos. RP 297 and 307.
[2] Busignani, fig. 24 and pl. 33 and Read and Waldberg, cat. no. CS 359.
[3] Busignani, pl. 40.

MARINO MARINI'S *WARRIOR* CONTINUES THE THEMES of anguish and loss from his earlier *Horse and Rider* (also in the Weiner collection, p. 98), but expressed here with increased monumentality and abstraction. This work began with an initial study in 1956, progressed through several intermediary works, and culminated in this giant *Warrior* of 1959–60.[1] The inscription on the base ("A Desolate Song Settled Over the World") set the tone materialized by his depiction of a fallen or stricken warrior. It is a theme not uncommon in ancient Greek and Roman sculpture, and one that found contemporary expression in Henry Moore's *Falling Warrior* of 1956–57. Although the sculpture from its earliest studies had a highly abstract, mechanized character that makes an interpretation difficult, its essential forms describe a prone figure supporting itself with an arm extended to the ground, its head jutting out to the right, and its hips and legs condensed into a bundle of geometric shapes.

By the time of the final version of 1959–60, the warrior had fused with a horse into one massive creature that fully integrates Marini's signature motifs of horse and rider. The head of the soldier with his anguished face still projects out into space, but now the detail of an arm stretched to the ground has become two legs splayed out in an inverted V, which seems reasonable only as the legs of a horse. And on the back of the soldier's head is a single eye that must also belong to the horse. The lower end of the sculpture seems to consist of different unidentifiable anatomical parts, whether animal or human. With its heavy, beveled forms thrusting upward along a steep diagonal, the sculpture is emblematic of the power of the horse and the power of the human combined into one major force, an idea famously (and perhaps uniquely until Marini's *Warrior*) explored in Raymond Duchamp-Villon's Cubist *Large Horse* from 1914. But while Duchamp-Villon's sculpture was a paean to the dynamism of a new technological age, Marini's is a lamentation over the destructiveness that marks the twentieth century.

A large painted plaster version of *The Warrior* exists,[2] and a stone version dates from 1967.[3]

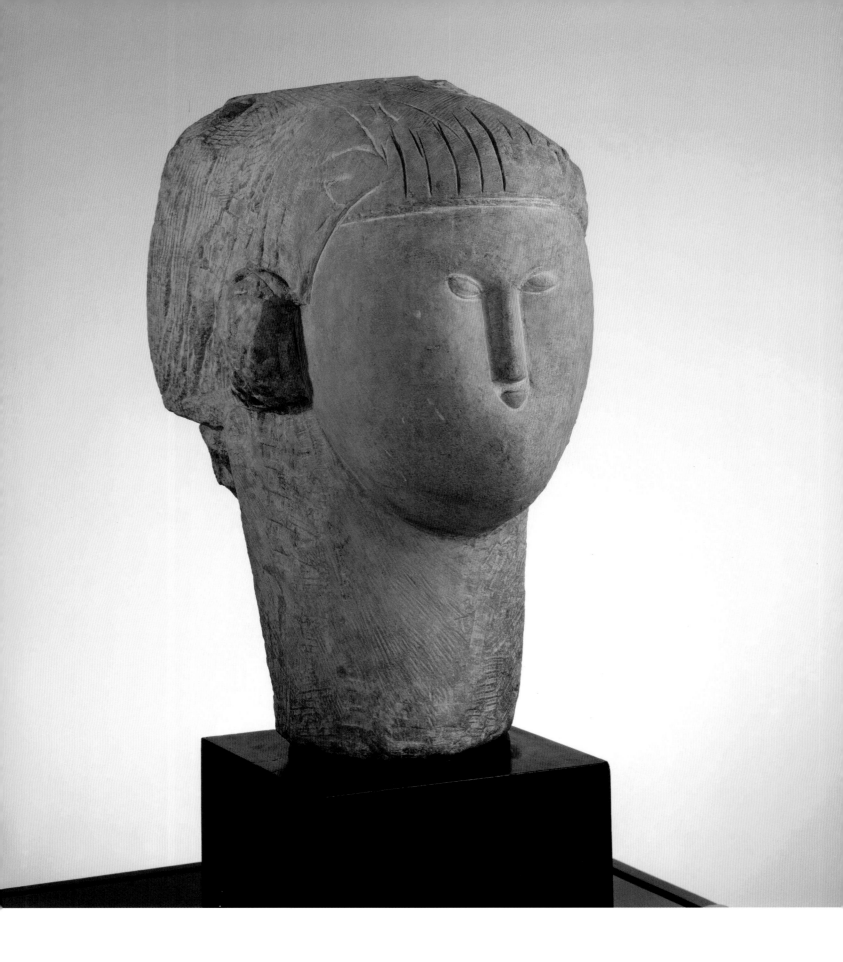

Amedeo Modigliani
Italian, 1884–1920
Head, ca. 1911–13

Limestone
20 ⅝ x 9 ¾ x 14 ¾ in. (52.4 x 24.8 x 37.5 cm)
Collection of Gwendolyn Weiner L1995-3.3

Provenance: Maurice Lefebvre-Foinet, Paris;
to Curt Valentin Gallery, by September 1951;
to Mr. and Mrs. Morton D. May, St. Louis, MI;
to M. Knoedler & Co., New York, by February
1962; to Weiner collection, 4 February 1963

Literature and exhibitions:

James Thrall Soby, *Modigliani: Paintings,
Drawings, Sculpture*, exh. cat. (New York:
Museum of Modern Art, 1951), 53

Lehmbruck and His Contemporaries, exh. cat.
(New York: Curt Valentin Gallery, 1951),
cat. no. 38

Sculpture by Painters, exh. cat. (New York:
Curt Valentin Gallery, 1951), cat. no. 59

Jeanne Modigliani, *Modigliani: Man and Myth*
(London: A. Deutsch, 1959), pl. 64

Alfred Werner, "Modigliani as a Sculptor,"
Art Journal 22, no. 2 (Winter 1960–61), 70

Alfred Werner, *Modigliani the Sculptor* (New
York: Arts, Inc., 1962), xxxi, pls. 42–45

Ambrogio Ceroni, *Amedeo Modigliani: Dessins*

THIS WORK IS ONE OF THE VERY RARE stone carvings that Amedeo Modigliani produced between roughly 1910 and 1914. In 1906 Modigliani had moved from his native Italy to Paris, where he soon became engaged with an exhilarating circle of avant-garde artists and writers that included Pablo Picasso, Constantin Brancusi, Guillaume Apollinaire, and Blaise Cendrars, among others. His early training was in painting and drawing, media he practiced at first in Paris, but sometime around 1910–11 he switched suddenly to sculpture, concentrating on three-dimensional work and drawings until late 1914. The reasons for this decisive conversion can be attributed to a number of influences, including the work of groundbreaking sculptor friends such as Brancusi and Jacob Epstein, in addition to Modigliani's fervent interest in the sculptural arts of ancient and exotic cultures from, for example, Egypt, Africa, and Cambodia.

Modigliani's production of sculpture was exceptionally small, and limited both stylistically and thematically. According to the most recent census, the total number of authentic surviving carvings is twenty-eight, mostly heads but also including one kneeling caryatid and a standing figure.[1] In addition, Modigliani made many drawings and a few oil sketches on sculptural themes. The divergent dates that have been assigned to this well-known carving in the Weiner collection demonstrate the difficulty of establishing a firm chronology for the sculptures as well as the scarcity of documentation in support of such efforts. Ceroni's pioneering catalogue of Modigliani sculptures dated the Weiner head to 1911–12, but other authorities have concluded that it could have been made either earlier or later.[2] A recent study that points out a close similarity between the rounded head and elegant features of the Weiner sculpture and two drawings of heads by Modigliani dated March 1913 prompts our dating of the work to ca. 1911–13. An early photograph of Modigliani at work in an outdoor courtyard on a stone head that may well be this particular sculpture unfortunately cannot be firmly dated.[3]

This sculpture and two other somewhat similar but much cruder heads stand out within Modigliani's sculptural oeuvre because of the rounded volume of the faces, which contrasts with the generally elongated and slender proportions of other heads.[4]

Ambrogio Ceroni, *Amedeo Modigliani: Dessins et sculptures* (Milan: Edizioni del Milione, 1965), cat. no. 1, pls. 24–25 (dated 1911–12)

Sculpture: Twentieth Century, exh. cat. (Dallas: Dallas Museum of Fine Arts, 1965), 25, cat. no. 55

La Jolla 1970

Claude Roy, *Modigliani* (New York: Rizzoli, 1985), 59, 156 (dated 1915)

Bernard Schuster and Arthur S. Pfannstiel, *Modigliani: A Study of His Sculpture* (Jacksonville, FL: Namega and Bibliothèque Modigliani, 1986), 40, 54, no. IX (dated 1906–07/1911–12)

Thérèse Castieau-Barrielle, *La vie et l'oeuvre de Amedeo Modigliani* (Paris: ACR, 1987), 88 (dated 1912–13)

Kenneth Wayne, *Modigliani and the Artists of Montparnasse*, exh. cat. (Buffalo, NY: Albright-Knox Art Gallery, 2002), cat. no. 42 (dated 1910–11)

Nash and Hough 2007, 12–13, cat. no. 14

Biller 2008, 31

Gabriella Belli et al., *Modigliani Sculptor*, exh. cat., (Roverto, Italy: Museo di Arte Moderna e Contemporanea di Trento e Rovereto, 2010), 26–27, 46, 48, 120–21, 195 (dated 1911–13)

75 Works 2013, 52–53

Typically for Modigliani, the facial features of the Weiner sculpture derive from African masks, but they are especially simplified and finely chiseled. Part of the engaging strength of this work derives from the delicacy of these facial elements juxtaposed with the powerful volumes of the head, neck, and uniquely massive block of stone behind the head. This rough-hewn block undoubtedly refers back to the *non finito* technique in certain of Michelangelo's sculptures. We seem to be witnessing some strong natural force at work—the smoothly finished face emerging from raw geologic form. Overall the work is a demonstration of different carving processes: the blunt chipping of the stone block giving way to more controlled marks of a claw chisel on the neck and sides of the face, and then the highly refined finishing of the rest of the face. We see an allegiance to the principles of direct carving and truth to materials espoused early in the century by Brancusi and Epstein, in opposition to the slick modeling that characterizes most late nineteenth-century sculpture; but Modigliani's dexterous ability to make stone speak so eloquently and powerfully is his own clear signature.

The blocks of French limestone he used for this and most of his sculptures came surreptitiously from building sites in and around Paris (see introductory essay, p. 22). It is interesting to note that Maurice Lefebvre-Foinet, the first owner of this work, who had it in his collection until 1951, was a well-known supplier of artist materials in Paris and also a packer and shipper of works of art. It is known that he shipped a number of sculptures and drawings for Modigliani, and it is certainly possible that the artist traded this work in exchange for materials and/or shipping services.[5]

[1] Belli, 120–21.
[2] See Ceroni 1965, cat. no. 1, and, for example, Wayne, cat. no. 42, and Belli, 120.
[3] This frequently reproduced photography was published recently in Belli, 27.
[4] The three heads referred to are Belli, cat. nos. I–III.
[5] For information on Lefebvre-Foinet, see Wayne, 60–61.

Picasso to Moore:
Modern Sculpture from the Weiner Collection

Picasso to Moore: Modern Sculpture from the Weiner Collection,
6 November 2007–19 October 2008, Palm Springs Art Museum

Henry Moore
British, 1898–1986
Stringed Figure: Bowl, 1938

Bronze with elastic string; edition 2/9,
plus one artist copy
Marked: *Moore* 2/9 (cast by Gaskin, London)[1]
21 ½ x 9 x 10 in. (54.6 x 22.9 x 25.4 cm)
(including base)
Collection of Gwendolyn Weiner L1980-3.19

Provenance: Jeffrey H. Loria and Co., New
York; to the Weiner collection, 16 June 1969

Literature and exhibitions:

Otterlo 1968, cat. no. 46 (different cast)

Palm Springs 1969, 21

La Jolla 1970

Lund Humphries, cat. no. 186c

*Henry Moore: Sculptures, Drawings, Graphics
1921–1981*, exh. cat. (Madrid: Palacio de
Velázquez, 1981), cat. no. 33

Henry Moore 1898–1986, exh. cat. (Sydney:
Art Gallery of New South Wales, 1992),
cat. no. 51

Mitchinson 1998, cat. no. 101

Nash and Hough 2007, 17–18, cat. no. 15

Chris Stephens, ed., *Henry Moore* (New York:
Skira Rizzoli, 2010), pl. 69

75 Years 2013, 56, 58

HENRY MOORE'S WORK OF THE 1930S, characterized by smoothly rounded forms that connote organic vitality, are drawn from different strains of Purist and Surrealist art. A series of stringed sculptures from late in the decade, including *Stringed Figure: Bowl*, added another element that is both scientific and poetic. Moore commented about the use of strings, which was still novel at the time in modern sculpture:

> Undoubtedly the source of my stringed figures was the Science Museum [in London].... I was fascinated by the mathematical models I saw there, which had been made to illustrate the difference of the form that is halfway between a square and a circle.... It wasn't the scientific study of these models but the ability to look through the strings as with a bird cage and to see one form within another which excited me.[2]

Much discussion has centered on the question of whether it was Moore or his friend Barbara Hepworth who first used strings in their sculptures, or if both were perhaps influenced by the use of inscribed lines and thin rods in sculptures by Naum Gabo, who had settled in London in 1936. Regardless, drawings of stringed sculptures had appeared in Moore's notebooks as early as 1937, and it was a device he explored thoroughly until he came to see it as too facile a technique.[3]

In *Stringed Figure: Bowl*, the pod or cocoonlike shape of the outer form creates a deep inner space recalling a motif common in Surrealist art and which carried connotations of concealment, protection, or a mother's womb. The stringing is done in two patterns, with a transversal set that describes on one side a circle and the other an oval, and a vertical set that forms a slightly tipped plane; white string is used for the first and a yellowish color for the second.[4] The strings provide lines of force that activate the inner space, and the pattern formed by their intersection recalls Moore's fascination with "one form within another" in the science museum models. Moore also capitalized on the contrast of their delicate, diaphanous quality with the solid bronze surrounding them, as well as the conjunction of abstract and semifigurative forms.

This example of the stringed sculptures in particular looks forward to works soon to follow. Its containment of shapes within an outer shell anticipates Moore's major theme of internal and external forms, and the hollow, headlike configuration led directly to Moore's helmet sculptures. Indeed, the word "figure" in the title of this work indicates that even here Moore had some notion of human form in mind.

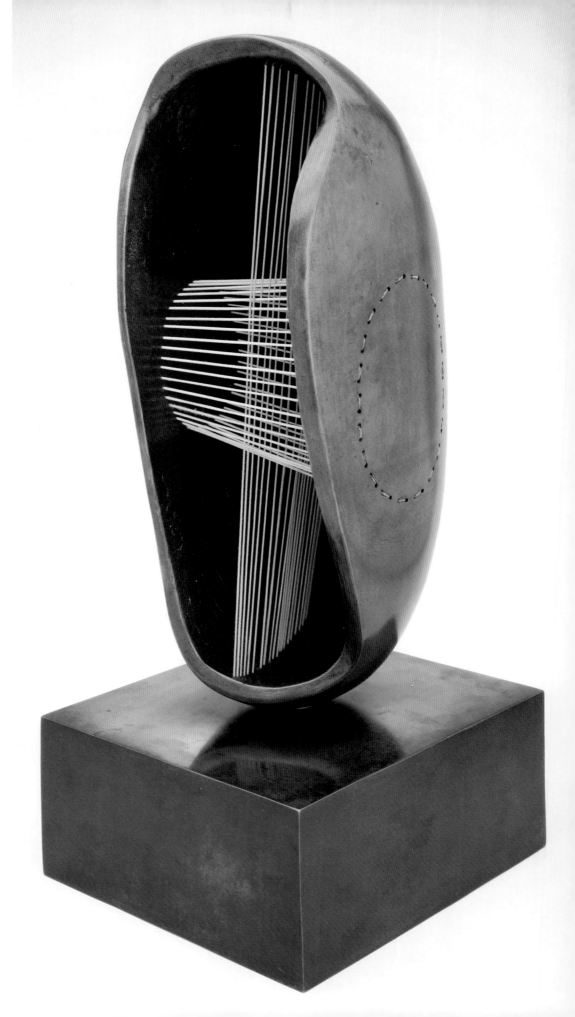

1 Information on the casting of Moore's
sculptures in the Weiner collection was very
kindly provided by Sebastiano Barassi at the
Henry Moore Foundation.
2 Quoted in Hedgecoe 1968, 105.
3 He is quoted as saying, "I found, after a
period, that the use of strings in sculpture
was almost too ingenious, too easy." See
Hedgecoe 1968, 107.
4 The strings in this sculpture had become
stretched and damaged over time and
were replaced in 2007 at the Henry Moore
Foundation with strings from Moore's
original stock.

Henry Moore
British, 1898–1986
Three Points, 1939–40

Bronze, edition of 9, plus one artist copy and
two casts in lead and iron (cast by Fiorini,
London)
5 ½ x 7 ½ x 3 ⅞ in. (13.9 x 19.1 x 9.8 cm)
Collection of Gwendolyn Weiner L2007-15.3

Provenance: Galerie des Arts Anciens et
Modernes, Zurich; to the Weiner collection,
30 November 1962

Literature and exhibitions:

Fort Worth 1959, cat. no. 90 (added in
republished catalogue)

Lund Humphries, cat. no. 211

Read 1965, pl. 108

Drawings and Sculpture by Henry Moore,
exh. cat. (Tucson: University of Arizona Art
Gallery; Little Rock: Arkansas Art Center,
1965), cat. no. 50

Austin 1966, cat. no. 50

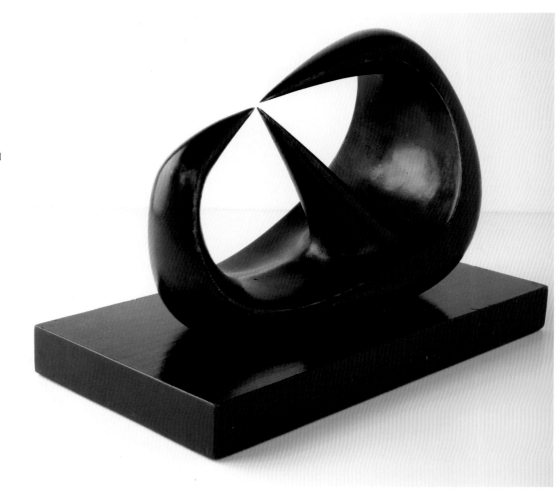

Melville 1968, cat. no. 210

Hedgecoe 1968, 148–49 (different cast)

David Sylvester, *Henry Moore*, exh. cat. (London: Tate Gallery, 1968), cat. no. 53

Otterlo 1968, cat. no. 51 (different cast)

Palm Springs 1969, 19

La Jolla 1970

Argan 1972, pl. 68

Henry Moore: 60 Years of His Art, exh. cat. (New York: Metropolitan Museum of Art, 1983) (different cast)

William Rubin, *Primitivism in 20th-Century Art*, exh. cat. (New York: Museum of Modern Art, 1984) 2: 607–08 (different cast)

Surrealism in Britain in the Thirties, exh. cat. (Leeds: Leeds City Art Gallery, 1986), cat. no. 188 (different cast)

British Art in the 20th Century: The Modern Movement, exh. cat. (London: Royal Academy of Arts, 1987), cat. no. 205 (different cast)

Wilkinson 1987, fig. 106

Compton 1988, cat. no. 40 (cast iron)

Henry Moore: 1898–1986, exh. cat. (Sydney: Art Gallery of New South Wales, 1992), cat. no. 55 (different cast)

Mitchinson 1998, cat. no. 110 (cast iron)

Dorothy Kosinski et al., *Henry Moore: Sculpting the 20th Century*, exh. cat. (Dallas: Dallas Museum of Art, 2001), cat. no. 46 (cast iron)

Nash and Hough 2007, 16, cat. no. 16

Olivier Meslay, *Hotel Texas: An Art Exhibition for the President and Mrs. John F. Kennedy*, exh. cat. (Dallas: Dallas Museum of Art, 2013), 32, 59, 60, pl. 7, cat. no. 7

[1] Gemma Levine, *With Henry Moore: The Artist at Work* (London: Sidgwick and Jackson, 1978), 28.

[2] Garrould, cat. no. 39–40.45. An earlier drawing from 1938 shows a sculpture with two opposing points that may mark a step in the early gestation of *Three Points* (Garrould, cat. no. 38–31r).

[3] See the discussion by Alan Wilkinson in Mitchinson 1998, 178–79.

COMPLETED IN 1940 DURING THE SECOND YEAR of World War II, *Three Points* seems to convey in its near-intersection of three dangerously sharp metal points the extreme anxiety of those times. Henry Moore said of this work, "I made a sculpture with three points, because this pointing has an emotional or physical action in it where things are just about to touch but don't…. There has to be a gap."[1] Moore had envisioned the form of this work in a colored drawing from 1940 entitled *Pointed Forms*, which lays out numerous ideas for sculptures, many of them involving sharp points slanting together in different combinations (below).[2] But while several of these relate to earlier or later sculptures, the study for *Three Points* is the only one that Moore translated directly into three-dimensional form.

Debate has continued for many years as to what visual sources may have provided inspiration for this work.[3] Suggestions range from certain Surrealist sculptures by Alberto Giacometti and Pablo Picasso's tempestuous *Guernica* from 1937, with its depiction of victims of a Nazi bombing raid screaming with spiked tongues, to "hook" figures or Yipwons from Papua New Guinea and a famous painting from the School of Fontainebleau that depicts one woman pinching another's nipple. Moore at one point acknowledged the last of these ideas but later denied that any single source was prevalent and said that the sculpture was based on many different memories. Given the fact that the Spanish Civil War and World War II had such a major impact on Moore's work, it seems likely that Picasso's painting of innocent civilians and animals being slaughtered (a work that Moore had seen in progress at Picasso's Paris studio) held special significance.

Despite its relatively diminutive size, the engaging form and clear drama of *Three Points* have made this work famous within Moore's vast oeuvre. He experimented with materials for the sculpture, producing unique casts in iron and lead, metals he appreciated for textural and tonal qualities different from bronze. He once said that lead had for him a "poisonous" sense.

Henry Moore, Pointed Forms, *1940, Graphische Sammlung Albertina, Vienna*

Henry Moore

British, 1898–1986

Helmet Head No. 2, 1950

Bronze; edition of 9, plus one artist copy and one lead cast (cast by Fiorini, London)
13 ¼ x 9 ½ x 9 ½ in. (33.7 x 24.1 x 24.1 cm)
Collection of Gwendolyn Weiner L1980-3.15

Provenance: Landau Gallery, Los Angeles; to the Weiner collection, 25 March 1959

Literature and exhibitions:

Fort Worth 1959, cat. no. 27

Grohmann 1960, pl. 93

Henry Moore, exh., The Art Center in La Jolla, 1963

Read 1965, pl. 158

Drawings and Sculpture by Henry Moore, exh. cat. (Tucson: University of Arizona Art Gallery; Little Rock: Arkansas Art Center, 1965), cat. no. 51

Austin 1966, cat. no. 47;

Hedgecoe 1968, 184–85

Melville 1968, pl. XVI, cat. no. 407

Otterlo 1968, cat. no. 73 (different cast)

Palm Springs 1969, 23

La Jolla 1970

Argan 1972, pls. 91–92

Seldis 1973, 93, cat. no. 30 (different cast)

Lund Humphries, cat. no. 281

Compton 1988, cat. no.115 (different cast)

Mitchinson 1998, 226

Nash and Hough 2007, 17–19, cat. no. 17

75 Works 2013, 59

HENRY MOORE'S *HELMET HEAD NO. 2* has a lengthy genealogy. Its inception dates back to 1937 and two sketches he made of a prehistoric Greek implement resembling a helmet,[1] and then to a bronze sculpture from 1939 entitled *The Helmet*.[2] As in subsequent versions of this theme, the sculpture combined an outer bronze shell in the shape of a helmet with an inner figurative form. This work and a group of related drawings were conceived at a time when Moore and many friends were highly sympathetic to the Republican cause in the Spanish Civil War and demonstrated on its behalf. There is reason to believe that these works were an expression of wartime stress (opposite, lower left).[3]

Moore then reprised the theme after an eleven-year hiatus in a series of three works entitled *Small Helmet Head*, *Helmet Head No.1*, and *Helmet Head No. 2*, all from 1950.[4] Moore also made a lengthy series of drawings of *Helmet Heads* in 1950 and 1951, one of these containing a study closely related to *Helmet Head No. 2*.[5] Further reinterpretations followed, with *Helmet Head No. 3* in 1960 and *Helmet Head No. 4* in 1963.[6]

Why did Moore give new birth to his helmet imagery so long after its initial appearances, and with so many variations? We can conjecture that it provided familiar grounds on which to expand his investigations of a theme that became increasingly important to him in the 1950s and preoccupied him off and on for the rest of his life, that is, the conjunction of internal and external forms. Many different connotations have been ascribed to the internal/external motif in Moore's work, including containment, protection, growth from within, and the nurturing powers of a womb. As found in his series of *Helmet Heads*, however, the forms convey a disruptively sinister, even threatening quality, and of all these works, *Helmet Head No. 2* is by far the most confrontational. Here the helmet wraps around the inner form with a slit that serves as a grimacing mouth. The inner shape was developed independently as an abstracted standing figure with a protruding waist and two large eyes attached at the very top.[7] With this little figure inserted into the outer helmet, the two eyes look straight out through a hole in the head's skull and engage the viewer with a blank but unsettling stare. Psychologically this construction is diametrically opposed to Moore's use of the internal/external theme in his overtly tender mother and child sculptures. A fascinating photograph by John Hedgecoe shows Moore seated behind *Helmet Head No. 2*, his head directly above the sculpture as he looks straight forward with an equally intense expression.[8]

Helmet Head No. 2 was originally cast in lead, with a bronze edition in 1955. A lead maquette measuring 6 ¼ inches high was destroyed.[9]

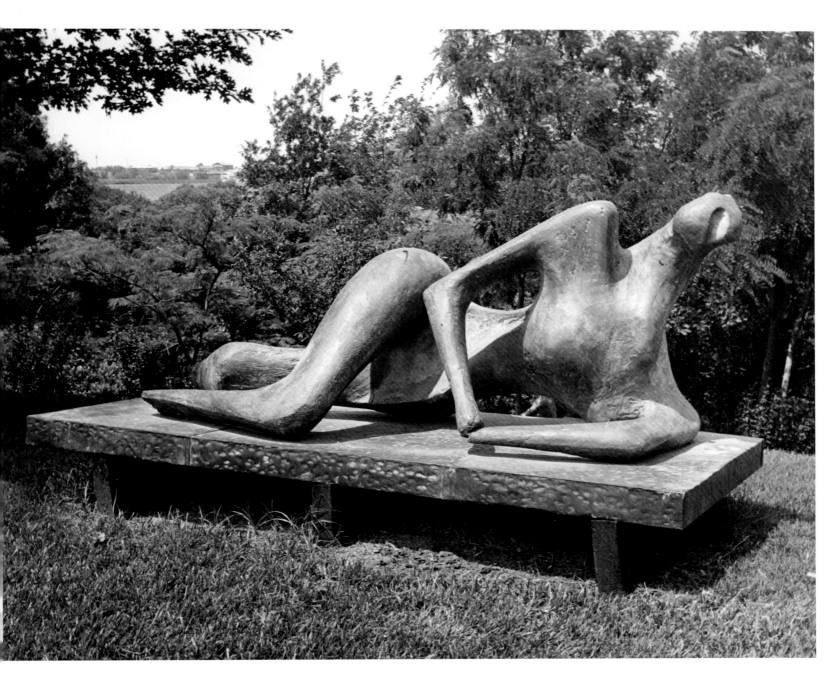

Henry Moore, Reclining Figure, in the Weiner sculpture garden, Fort Worth, 1960s

Henry Moore
British, 1898–1986
Reclining Figure, 1956

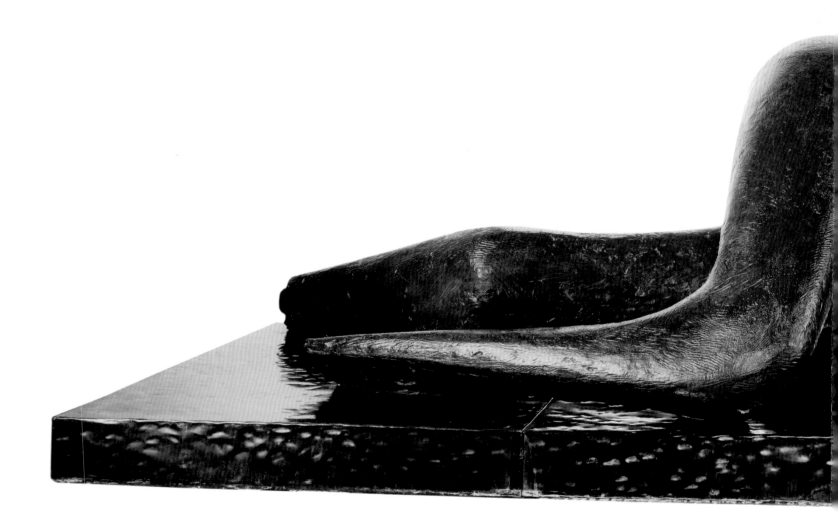

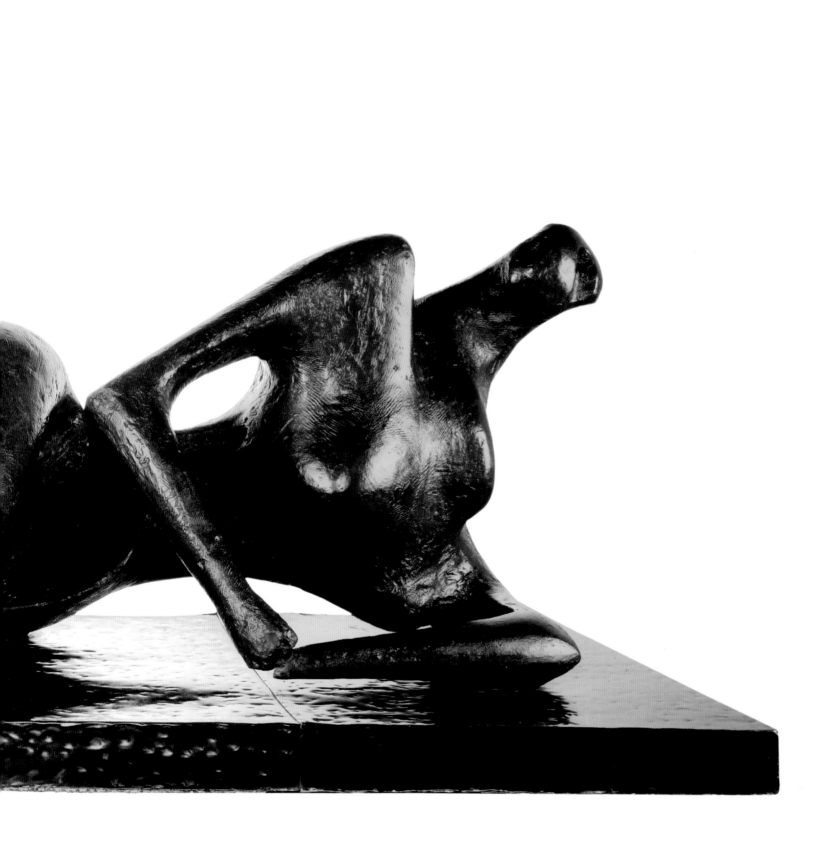

[1] Garrould, cat. no. AG 37.67r.

[2] Lund Humphries, cat. no. 212, and Mitchinson 1998, cat. no. 111. This work was based on one of six drawings for metal heads on a sheet from 1939 (Garrould, cat. no. 1939.29).

[3] One drawing closely related to *The Helmet* has a shadowy effect that could be a reflection, in its military theme of helmets and its gloomy mood, of a general state of mind among Moore and other artists at the time connected with the Spanish Civil War (Garrould, cat. no. 39.30). In fact, Moore drew similar heads placed behind barbed wire in 1939 and entitled the works *Prisoner behind Wire* and *Spanish Prisoner* (Garrould, cat. nos. 1939.32–34).

[4] Lund Humphries, cat. nos. 283, 279, and 281, respectively.

[5] See especially Garrould. The one with the study related directly to *Helmet Head No. 2* is cat. no. 50.46.

[6] Lund Humphries, cat. no. 467, and Mitchinson 1998, cat. no. 193; and Lund Humphries, cat. no.508, and Mitchinson 1998, cat. no. 202.

[7] Lund Humphries, cat. no. 282, and Compton 1988, cat. no. 113. It is interesting that Moore made several little figures for the interiors of helmets in lead, since he felt that lead was a particularly expressive material due to "a kind of poisonous quality" (quoted from Moore in Mitchinson 1998, 225).

[8] Hedgecoe 1968, 184.

[9] Hedgecoe 1968, 185.

Drawing for Metal Sculpture: Two Heads, 1939, *The Henry Moore Foundation*

Bronze; edition of 8, plus one artist copy
Marked: *Moore 3/7 GUSS. H. NOACK. BERLIN*
(incorrectly numbered)
33 ¾ x 91 ¾ x 37 ¾ in. (85.7 x 233 x 95.9 cm)
Palm Springs Art Museum, partial and
promised gift of Gwendolyn Weiner 2014.181

Provenance: M. Knoedler and Co., New York;
to the Weiner collection, 10 May 1962

Literature and exhibitions:

Fort Worth 1959, cat. no. 88 (entry added to
republished catalogue)

Henry Moore, exh. cat. (New York: M.
Knoedler and Co., 1962), 20–21, cat. no. 26
(different cast)

Emily Genauer, "Deep in the Art of Texas,"
New York Herald Tribune, 2 June 1963, sec. 4

Austin 1966, cat. no. 48

Lund Humphries, cat. no. 402

Melville 1968, cat. nos. 520–22

Palm Springs 1969, 17

La Jolla 1970

Argan 1972, pl. 68

Henry Seldis, *Henry Moore in America* (New
York: Praeger Publishers, 1973), 143, cat. no. 53

Wilkinson 1987, cat. no. 119

Nash and Hough 2007, 19, cat. no. 18

75 Works 2013, 59

[1] Lund Humphries, cat. no. 293.
[2] Lund Humphries, cat. no. 405.
[3] Wilkinson 1987, cat. no. 119.
[4] Lund Humphries, cat. no. 401.
[5] Lund Humphries, cat. no. 403.

THIS LARGE AND SINUOUS *Reclining Figure* fits into a clear evolution in Henry Moore's figurative vocabulary between the well-known *Reclining Figure: Festival* from 1951[1] and the series of large-scale seated and reclining women from around 1957–58, including *Woman* in the Weiner collection (p. 116). In the *Festival* figure, the more distorted anatomy recalls Moore's works from the 1940s with their inclination toward Surrealism; the massiveness of his bronze women from 1957–58 signals a shift toward a more powerfully physical paradigm. By comparison, the *Reclining Figure*, much like the anatomically related *Falling Warrior* from 1956–57,[2] is more classical in its proportions, pose, and sleek contours.

Classical art had been an important interest of Moore's from early in his career, as witnessed by the many drawings of nudes he made in the 1920s inspired by Greek sculpture. Classicism provided a counterbalance in his work to the dual influences of raw nature and so-called primitive art, and all three recur in differing proportions throughout his long development. In *Reclining Figure*, we can see a kinship with the river gods, fallen warriors, and other reclining figures common in the Greek canon. In fact, Moore's *Falling Warrior* is a direct descendent of the famous dying soldier with shield from the pediment of the Temple of Aegina. The figure in the Weiner collection nevertheless carries a distinctly modern sense of tension or anxiety in its stretched-out pose, extended neck, battered eye, and upward twist of the head.

Reclining Figure lies on its original copper-over-wood base, which was roughly hammered for texture. The figure originates from a small plaster maquette of 1955, and a full-scale plaster model is in the collection of the Art Gallery of Ontario.[3] There is also a bronze maquette.[4] Moore's *Upright Figure* in the Solomon R. Guggenheim Museum in New York is based quite closely on *Reclining Figure*, but with the figure positioned vertically against a wall.[5]

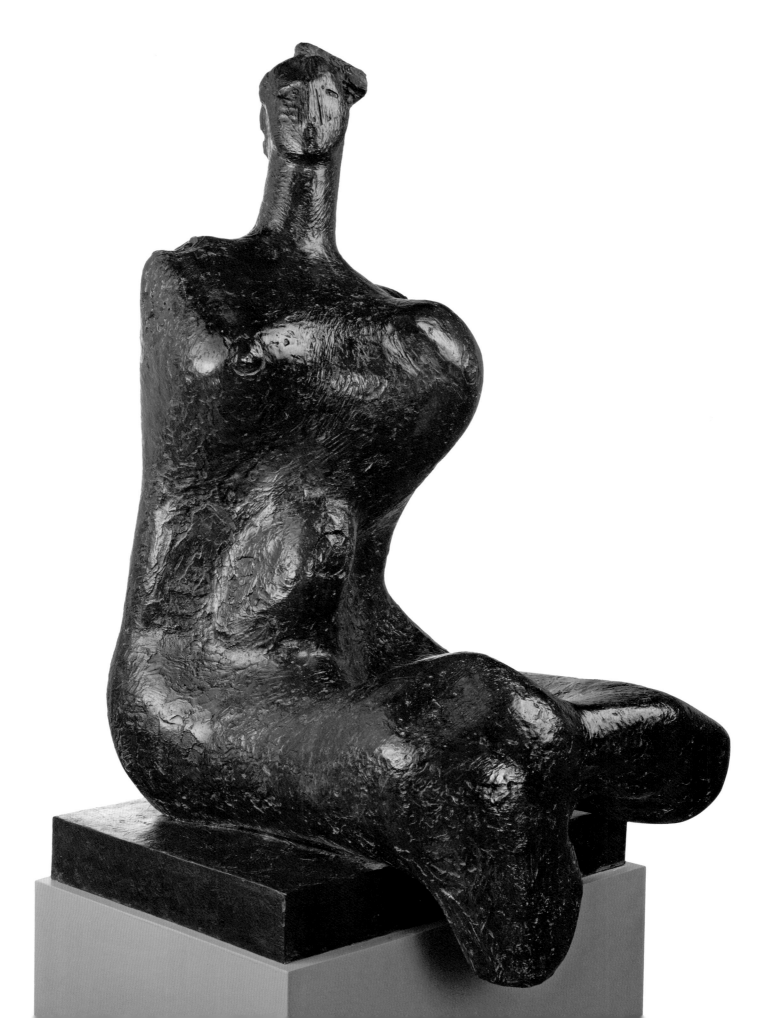

Henry Moore
British, 1898–1986
Woman, 1957–58

Bronze; edition of 8, plus one artist copy
Marked: *Moore 2/4 H NOACK BERLIN*
(incorrectly numbered)
60 ¼ x 31 ⅛ x 36 in. (153 x 79.1 x 91.4 cm)
Collection of Gwendolyn Weiner L1980-3.20

Provenance: Knoedler and Co., New York;
to the Weiner collection, 24 May 1960

Literature and exhibitions:

Fort Worth 1959, cat. no. 91

Will Grohmann, *The Art of Henry Moore* (New
York: Harry N. Abrams, 1960), pls. 181–82

Read 1965, pl. 204

Austin 1966, cat. no. 51

Melville 1968, cat. nos. 531–34

Hedgecoe 1968, cat. nos. 322–24

Otterlo 1968, cat. no. 95 (different cast)

Palm Springs 1969, 18

La Jolla 1970

Argan 1972, pl. 144

Alan Wilkinson, *Gauguin to Moore: Primitivism
in Modern Sculpture*, exh. cat. (Toronto: Art
Gallery of Ontario, 1982), cat. no. 136 (plaster)

Lund Humphries, cat. no. 439

Wilkinson 1987, 183, cat. no. 131

Mitchinson 1998, cat. no. 184

Nash and Hough, 2007, 19, cat. no. 19

WOMAN BELONGS TO A SERIES OF SCULPTURES of large, massively proportioned seated women that Henry Moore produced around 1957–59. He commented about this work, "*Woman* and *Seated Woman* [1957] both have the big form that I like my women to have. *Woman* emphasises fertility like the Paleolithic Venuses in which the roundness and fullness of form is exaggerated," and added, "*Woman* has that startling fullness of the stomach and the breasts. The smallness of the head is necessary to emphasise the massiveness of the body…. The face and particularly the neck are more like a hard column than the soft goitred female neck."[1] Moore's early interest in ancient fertility figures is documented by drawings he made in 1926 of the Paleolithic *Venus of Grimaldi* in the British Museum,[2] a work that seems to anticipate *Woman* not only in its fecund anatomy but also its amputated arms and truncated legs. This theme of fertility gave rise to the alternate title of *Parze* for Moore's sculpture, which is German for Parca, one of the names of the Roman goddess of childbirth.

The British sculptor Phillip King, who worked as an assistant to Moore in the late 1950s, recalled Moore speaking of his sculptures in a way that related particularly to *Woman*:

I do remember him talking about the head, and the twist of the head being the most important aspect of a figure for him. I noticed that he would work on that as the crucial part of the figure…. I think it was particularly so in [*Woman*] where the feet are dangling loose in space. It looks as though she is looking out at the side with a rather alert look.[3]

In some of the casts of *Woman* the base is larger, extending farther to the front. With the smaller base on the Weiner cast, the leg and knees project more into space, giving the figure a less grounded, more dynamic quality. A full-scale plaster model for this work is owned by the Art Gallery of Ontario.[4]

[1] Hedgecoe 1968, 326.
[2] Garrould, cat. nos. 26.34v, 26.35r, 26.36r.
[3] Mitchinson 1998, 256.
[4] Wilkinson 1987, cat. no. 131.

Henry Moore
British, 1898–1986
Mother and Child: Hollow, 1959

Bronze; edition of 13, plus one artist copy
(cast by Gaskin, London)
12 ¾ x 4 x 5 in. (32.4 x 10.2 x 12.7 cm)
Collection of Gwendolyn Weiner L1980-3.16

Provenance: Felix Landau Gallery, Los Angeles;
to the Weiner collection, 10 March 1962

Literature and exhibitions:

Fort Worth 1959, cat. no. 87 (added in
republished catalogue)

Grohmann 1960, pl.188

Drawings and Sculpture by Henry Moore,
exh. cat. (Tucson: University of Arizona Art
Gallery; Little Rock: Arkansas Art Center,
1965), cat. no. 53

Austin 1966, cat. no. 47a

Otterlo 1968, cat. no. 101 (different cast)

David Sylvester, *Henry Moore*, exh. cat.
(London: Tate Gallery, 1968), cat. no. 108
(different cast)

Palm Springs 1969, cat. no. 22

La Jolla 1970

Seldis 1973, cat. no. 76

Lund Humphries, cat. no. 453

Wilkinson 1987, 191

Nash and Hough 2007, 19, cat. no. 20

THE THEME OF MOTHER AND CHILD is ubiquitous in Henry Moore's art. It appears in hundreds of drawings and sculptures from all eras of his career, even in his most abstract works, and took on alternately secular and religious meanings. *Mother and Child: Hollow*, however, is unusual in form and actually resembles the highly abstract *Large Upright Internal/External Form* from 1981–82 as much as it does his more traditional representations of the Mother and Child theme.[1] As is often pointed out, that monumental study in interweaving circular rhythms suggests both a child engulfed in the arms of its mother and an unborn child within the womb. Its huge outer shell encompasses an upright inner form in an internal/external composition not unlike that of *Helmet Head No. 2* in the Weiner collection (p. 110). In the case of *Mother and Child: Hollow*, the outer shell (the "hollow"), which may at first seem fully abstract, is in fact the mother. She sits on a small rectangular base with her knees forward and her two small round eyes at the very top of the shell. The elongated and simply defined child sits on her lap in a three-quarter profile with its right arm facing forward.

It is a highly inventive format that adds a different note to Moore's long-term exploration of the internal/external motif and simultaneously expresses once again his fascination with the Mother and Child theme. Whether Moore meant to invest this work with a secular or Christian meaning is difficult to say, but its formality relates it to his Madonna and Child imagery, to which he gave such humanity and strength of conviction, especially in his large-scale sculptures commissioned for churches.[2]

[1] Lund Humphries, cat. no. 297a.
[2] Including those at St. Matthew's Church in Northampton and St. Peter's Church in Claydon, Suffolk (Lund Humphries, cat. nos. 226 and 270).

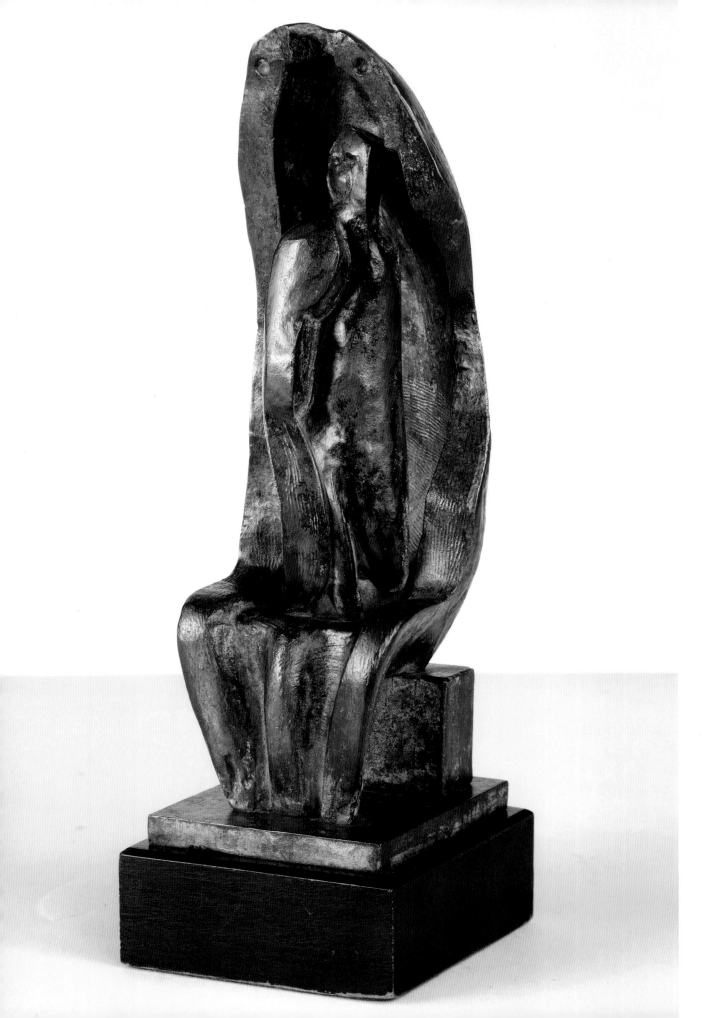

Henry Moore
British, 1898–1986
Bird, 1959

Bronze; edition of 12, plus two artist copies
(cast by Gaskin, London)
15 x 4 ¼ x 5 in. (38 x 10.8 x 12.7 cm)
Collection of Gwendolyn Weiner L1980-3.14

Provenance: Felix Landau Gallery, Los Angeles;
to the Weiner collection, 10 March 1962

Literature and exhibitions:

Fort Worth 1959, cat. no. 86 (added in
republished catalogue)

Drawings and Sculpture by Henry Moore,
exh. cat. (Tucson: University of Arizona Art
Gallery; Little Rock: Arkansas Art Center,
1965), cat. no. 52

Austin 1966, cat. no. 46

Hedgecoe 1968, cat. no. 404/405.6

Otterlo 1968, cat. no. 99 (different cast)

Palm Springs 1969, 19

La Jolla 1970

Seldis 1973, cat. no. 74

Lund Humphries, cat. no. 445

[1] Exceptions include *Animal Head* (1951),
Goat's Head (1952), and *Animal Head* (1955)
(Lund Humphries, cat. nos. 301, 302, and 396).
[2] It is visible just behind Moore's head in a
photograph of him at work in his maquette
studio. See Jeremy Lewison, *Moore*
(Cologne: Taschen, 2007), 95.

BIRD **IS PART REPRESENTATION** and part relic from natural history, a hybrid of
identifiable avian forms fused with shapes that seem influenced by weathered wood
or unusual stones. It is also two sculptures in one. Viewed from one side (below), it
features a tail swooping down and fanning out, a small round eye under a slight rise in
the head, and two long, bulbous forms with a slit between them that form the bird's
protruding bill. In a general way it resembles the profile of a pelican. Viewed from the
other side (opposite), however, the sculpture appears to be almost totally abstract,
with only the tail providing a clue to its primary identity. The sculpture sits lightly on one
central point and has a distinctly aerodynamic quality overall despite its sense of heft.

Henry Moore's great love of nature shines through in practically all of his art, although
in sculpture he made very few objects directly or even indirectly representative of
fauna,[1] whereas his drawings, especially from later years, frequently depict animals.
A plaster maquette for *Bird* is in the collection of the Henry Moore Foundation.[2]

Opposite view

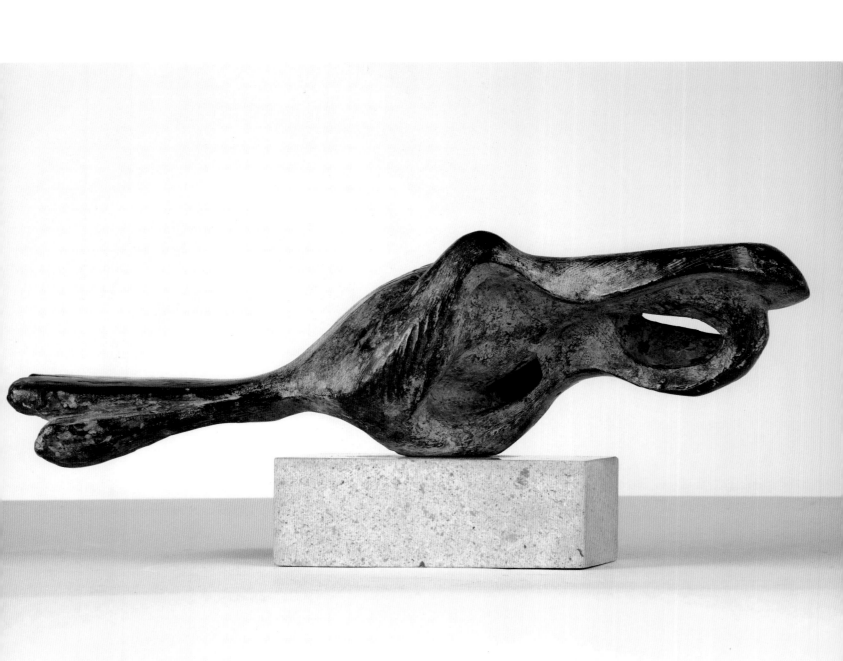

Henry Moore
British, 1898–1986
*Two Seated Figures against
Wall* (also known as
Two Seated Girls against Wall),
1960

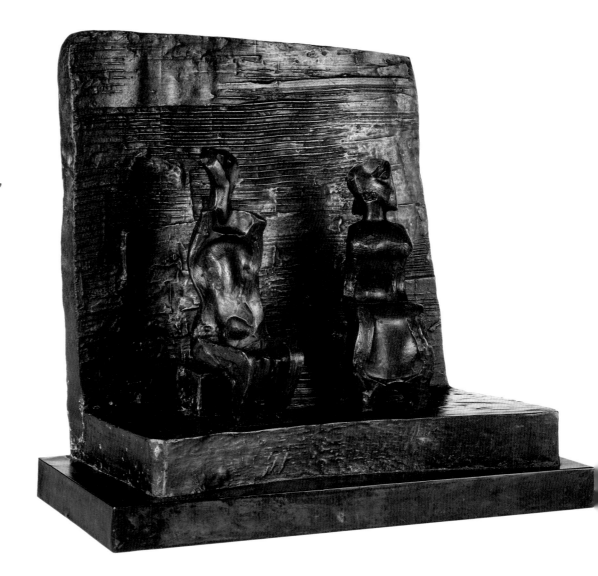

Bronze; edition of 12, plus one artist copy
(cast by Fiorini, London)
19 ⅝ x 19 ¼ x 10 in. (49.8 x 48.9 x 25.4 cm)
Collection of Gwendolyn Weiner

Provenance: M. Knoedler and Co., New York;
to the Weiner collection, 9 June 1961

Literature and exhibitions:

Fort Worth 1959, cat. no. 92 (added in
republished catalogue)

Drawings and Sculpture by Henry Moore,
exh. cat. (Tucson: University of Arizona Art
Gallery; Little Rock: Arkansas Art Center,
1965), cat. no. 54

Austin 1966, cat. no. 52

Otterlo 1968, cat. no. 105 (different cast)

Palm Springs 1969, 20

La Jolla 1970

Lund Humphries, cat. no. LH 454

Wilkinson 1987, 191, cat. no. 143

Nash and Hough 2007, 19, 21, cat. no. 21

[1] For example, see Garrould, cat. nos. 36.19,
37.47, 38.35–44, 42.206, and 42.210.
[2] This development helped lead the way to
what might be called the environmental
work of sculptors such as George Segal, Ed
Kienholz, and certain installation artists.
Although his work may not have been known
to many 20th-century artists, Medardo Rosso
had pioneered in the late nineteenth century
the idea of environmental sculpture by
placing figures, for example, in an abstract
garden and beside a lamp post.
[3] For these sculptures from 1956–57 and
notes on the UNESCO project, see Compton
1988, cat. nos. 140–43.
[4] See Compton 1988, figs. 9 and 10.
[5] Wilkinson 1987, 191, cat. no. 143.

IN THE MID-1950S, HENRY MOORE introduced architectural settings as a new element in his figurative work. Earlier, Alberto Giacometti had made sculptural scenarios involving figures in street scenes and imaginary houses and landscapes, and Moore in the 1930s and 1940s produced numerous drawings of figures and abstract forms surrounded by buildings.[1] But combining three-dimensional figures with architectural elements was a bold move for Moore; it shifted the perception of sculpture as something existing in its own space, isolated from surroundings by constructed bases, to the different sense of objects occupying a defined "place" that, by implication, is a part of our everyday world.[2] Moore mounted figures on steep steps in a number of works and placed others in front of straight or curving walls, opposing organic and geometric forms for a new type of compositional dynamic.

The earliest sculptures with walls date from 1956 and 1957. These were essentially studies for Moore, as he attempted to decide how best to situate a commissioned sculpture in front of the façade of the UNESCO headquarters in Paris.[3] They also, however, relate morphologically back to Moore's earlier relief sculptures and their wall-like structure, such as his *Time-Life Screen* of 1953 and brick relief for the Bouwcentrum building in Rotterdam from 1955.[4] But here the forms once contained in relatively flat reliefs are now released into three-dimensional space.

The figures in *Two Seated Figures against Wall* are sometimes identified as girls, although the one on the left, in contrast to the other figure with her pronounced breasts and long hair, can also be read as a male, an interpretation which makes the work a distant cousin of Moore's *King and Queen* from 1952–53. The rough horizontal striations on the background wall help throw the smoother forms of the figures into relief, and the sculpture is mounted on its original copper-on-wood base. Alan Wilkinson published the plaster maquette for this work, which is now in the Art Gallery of Ontario, and also revealed that Moore used molds from two earlier sculptures to produce this new pair of seated figures.[5]

Henry Moore

British, 1898–1986

Two Piece Reclining Figure No. 3,
1961

Bronze; edition 1/7, plus one artist copy
Marked: *Moore 1/7 GUSS. H. NOACK BERLIN*
57 ¾ x 99 x 45 ¾ in. (146.7 x 251.5 x 116.2 cm)
(excluding base)
Palm Springs Art Museum, gift of Gwendolyn
Weiner 14-1996

Provenance: M. Knoedler and Co.,
New York; to the Weiner collection,
16 April 1962

Literature and exhibitions:

Fort Worth 1959, cat. no. 89

Henry Moore, exh. cat. (New York: M. Knoedler
and Co., 1962), cat. no. 49

Read 1965, pl. 217

Austin 1966, cat. no. 49

Melville 1968, cat. nos. 614-–6

Argan 1972, pls. 167–69

Seldis 1973, 178, 188

Lund Humphries, cat. no. 478

Wilkinson 1987, cat. no. 150

Nash and Hough 2007, 19, 22, cat. no. 22

75 Years 2013, 56–57

Biller 2008, 26

THE RECLINING HUMAN FIGURE, which is the central theme in Henry Moore's work, originated very early in his development from the inspiration of such frequently cited sources as Mayan Chacmool figures and Greek pediment sculpture. As a continuation of his stylistic exploration of this theme, in 1959 he initiated his *Two Piece Reclining Figure* series, which eventually extended over a decade to include a large number of works of widely varied composition. Later, Moore eloquently described his ideas behind this series:

> I did the first one in two pieces without intending to. But after I had done it, then the second one became a conscious idea. I realised what an advantage a separated two-piece composition could have in relating figures to landscape. Knees and breasts are mountains. Once these two parts become separated you don't expect it to be a naturalistic figure, therefore you can justifiably make it like a landscape or a rock. If it's in two pieces, there's a bigger surprise.… The front doesn't enable you to foresee the back view. As you move round it, the two parts overlap or they open up and there's space between. Sculpture is like a journey. You have a different view as you return.[1]

The first four works in the series came in close succession (*No. 1* in 1959, *No. 2* in 1960, and *Nos. 3* and *4* in 1961[2]) and are relatively close in scale and composition. As Moore described, the figures are divided into two large masses composed of chest and head on one side and legs and knees on the other, and within the series of four the articulation of these masses and their spacing and rhythms of positive and negative shapes differ significantly. As a group, however, they allowed Moore an intensive study of certain themes key to his work: the metaphoric relationship of human figures and the earth, the tension between barely separated forms, the joining of front and back surfaces through tunneled holes, and the play between abstraction and representation. Moore noted that the massive, rocklike shapes in these works, with hollows all the way through them, reminded him of the dramatic arched cliffs at Étretat, France, a favorite motif of nineteenth-century French landscape painters including Gustave Courbet and Claude Monet.[3]

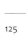

[1] Carlton Lake, "Henry Moore's World,"
Atlantic Monthly 209:1 (January 1962): 39–45.
[2] Lund Humphries, cat. nos. 457, 458, 478, 479.
[3] Melville 1968, 29.
[4] Lund Humphries, cat. no. 475. The plaster is
illustrated in Wilkinson 1987, cat. no. 150.
[5] Wilkinson 1987, cat. no. 151.

Two Piece Reclining Figure No. 3 has a particularly solid and balanced quality. The two forms are notched in such a way that they seem capable of sliding together into one continuous mass; the shapes are pierced by only one tunnel, between the torso and arm; and the leg form resembles a giant, ponderous boulder. The variety with which Moore worked the surfaces of the plaster model is remarkable, with different textures, scrapes, and grooves imparting a sense of worn or distressed surfaces as if the forms had long been subjected to the weathering processes of nature, a quality that adds to the timeless character of this genus of human geology.

Moore had the small plaster maquette for *Two Piece Reclining Figure No. 3* cast in bronze,[4] and its shapes differ considerably from the final version. The bronze in the Weiner collection sits on its original copper-on-wood base. The full-scale plaster model is in the collection of the Art Gallery of Ontario.[5]

Isamu Noguchi
American, 1904–1988
Tetsubin, 1961

Cast iron; edition of 5
9 1/2 x 10 ¼ x 10 ¾ in. (24.1 x 26 x 27.3 cm)
Collection of Gwendolyn Weiner L1980-3.22

Provenance: Collection of the artist; through the Fort Worth Art Association to the Weiner collection, 12 June 1961

Literature and exhibitions:

Isamu Noguchi, exh., Stable Gallery, New York, 1953

Noguchi: An Exhibition of Sculpture, exh. cat. (Fort Worth: Fort Worth Art Center, 1961), cat. no. 4

An Exhibition of Contemporary Paintings and Sculpture from the Collection of Mr. and Mrs. Ted Weiner, exh. pamph. (Austin: Laguna Gloria Museum, 1963), 6

Annette Michelson, *Isamu Noguchi*, exh. cat. (Paris: Galerie Claude Bernard, 1964) (different cast)

La Jolla 1970

Phyllis Plous, *7 + 5: Sculptors in the 1950s*, exh. cat. (Santa Barbara: Art Galleries, University of California at Santa Barbara, 1976), cat. no. 54

Nancy Grove and Diane Botnick, *The Sculpture of Isamu Noguchi, 1924–1979* (New York and London: Garland Publishing, 1980), cat. no. 423

Nash and Hough 2007, 15, 16, cat. no. 23

ISAMU NOGUCHI, BORN IN LOS ANGELES to a Japanese father and an American mother, spent most of his early years in Japan. He returned to the United States in 1918, studied at two art schools in New York, and was apprenticed briefly to the sculptor Gutzon Borglum. His main formative influences, however, came in Paris, where he lived for two years, 1927–28. He served as an assistant to Constantin Brancusi while meeting other leading artists, including Alexander Calder and Alberto Giacometti. Like Brancusi and Jean Arp, Noguchi in his mature years worked mostly in a sculptural language of forms distilled to a purity of shape and finish, often in dialogue with elements of the natural world. His Japanese heritage also had a profound impact throughout his career.

Tetsubin is a direct reflection of that cultural background. Tetsubin are Japanese cast-iron teapots, used both for brewing tea and carrying hot water during tea ceremonies. Noguchi had worked as a potter in Japan in the early 1930s, and here he reinterpreted a traditional teapot form into a hollow bronze cube with protuberances emerging on all sides and the top. These rounded knobby shapes produce an uncanny sense of elasticity and pressure pushing from the inside out, focusing awareness on the interior space and reprising a motif—small rounded projections like buds or fingers—frequently found elsewhere in Noguchi's work. Within a series of cast-iron objects that Noguchi made around this time, a particularly close comparison with *Tetsubin* is offered by his *Enigma (Who Knows)* from 1956–57, which also has a vessel-like shape (this one round) with protruding knobs.[1]

In a letter to Ted Weiner dated 7 July 1961, Noguchi explained what he had in mind with this work. "I made a copy [of an iron teapot] with bottom and a lid as a gift to the Teamaster Shigemori who taught me the setting of rocks for use in the Tea Ceremony. It is the idea of a pot full of mysterious energy and not just a pot with which I was concerned. That it can't hold anything is more valid than if it could."[2] In keeping with his interest in investing his work with a strong sense of Japanese material culture, Noguchi had *Tetsubin* cast in Japan by the same well-established foundry that made other iron sculptures for him. None of these works are signed or marked in any way, preserving an uninterrupted purity of form.

1 Grove and Botnick, cat. no. 425.
2 Unpublished letter in the Weiner family archives, Fort Worth.

Gene Owens
American, born 1931
And the Bush Was Not Consumed,
1960

Granite and bronze
14 ½ x 16 x 15 in. (36.8 x 40.6 x 38.1 cm)
Collection of Gwendolyn Weiner L1980-3.23

Provenance: From the artist to the Weiner collection, 11 January 1961

Literature and exhibitions:

Fort Worth 1959, cat. no. 94 (entry added in the republished catalogue)

Wichita 1965, cat. no. 30

Austin 1966, cat. no. 54

Palm Springs 1969, 13

La Jolla 1970

Nash and Hough 2007, cat. no. 24

[1] Letter to the author. Owens wrote, "The mold for the wax casting got too hot and a separation occurred in the mold. Though the mold 'Was Not Consumed' I cast it with the results that Ted liked. I am glad he did."

BORN IN BIRDVILLE, TEXAS, Gene Owens received a BA from Texas Wesleyan University in Fort Worth and an MFA from the University of Georgia in Athens. He returned to Texas to teach but in 1960 gave up that profession in order to devote himself fulltime to his own sculpture. He worked for a period with Charles T. Williams, a well-known modernist sculptor in midcentury Texas, and together they explored various techniques for the production and finishing of bronzes. Due, however, to an allergic reaction to patination and finishing processes, Owens began experimenting with the use of porcelain in his practice. In 1961 he met the sculptor Isamu Noguchi when he came to Fort Worth for an exhibition of his work at the Fort Worth Art Center and subsequently worked for him as an assistant on several projects.

Produced in 1960, *And the Bush Was Not Consumed* shows a sensibility perhaps related to the work of Noguchi even before the two men met, as seen especially in its simplified, compact form and the prominent role in the composition of rough granite. As in much of Noguchi's sculpture, there is a reference to natural forms. Short, spiky rods of bronze seem to grow like stalks out of bedrock. The title, drawn from the book of Exodus in which Moses saw a burning bush that was not consumed by the fire engulfing it, provides a further narrative dimension.

In a letter of February 2015, Owens recounted how Ted Weiner came to his studio, saw the sculpture before it was complete, and told Owens that when it was finished he would buy it. In a mishap in the casting of the wax model for the bronze, the mold overheated and split, but Owens decided that the results were still acceptable and Weiner agreed.[1] Early photographs of the sculpture show it on a tall column of granite that no longer exists.

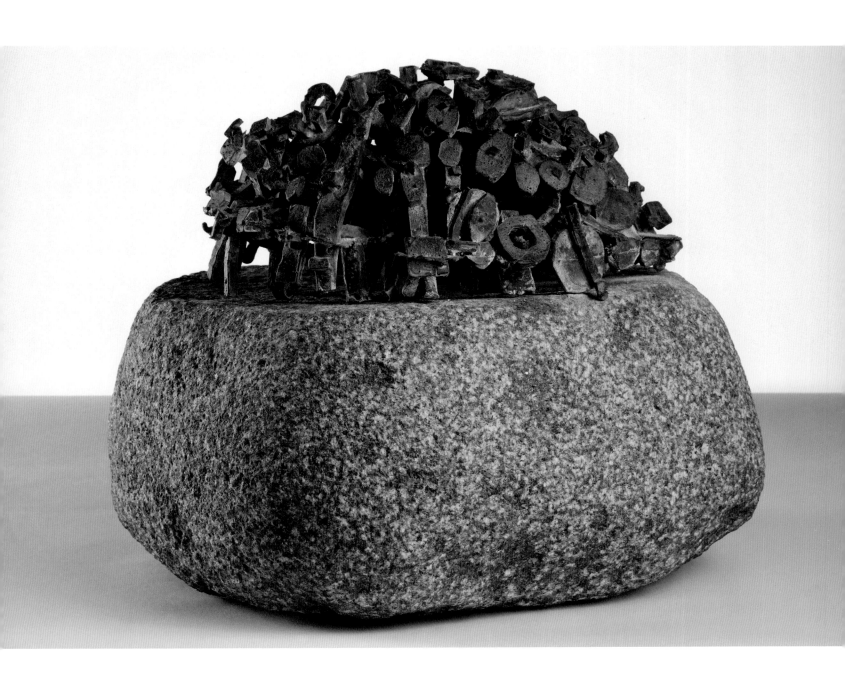

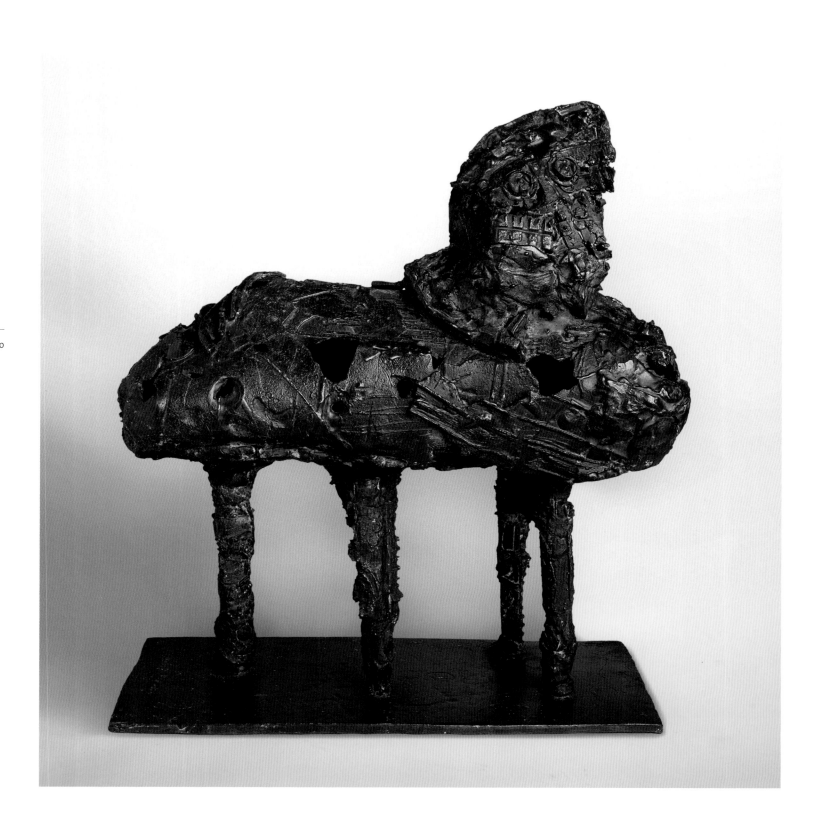

Eduardo Paolozzi
British, 1924–2005
Chinese Dog, 1956

Bronze
Marked: *E. PAOLOZZi* [sic] *DEC 1956 1/1*
23 x 19 ¾ x 10 in. (58.4 x 50.2 x 25.4 cm)
(including base)
Collection of Gwendolyn Weiner
L2014.52.5

Provenance: David Gibbs and Co., London;
to Weiner collection, 10 October 1962

Literature and exhibitions:

Fort Worth 1959, cat. no. 95 (added to
republished catalogue)

Houston 1964, cat. no. 19

Wichita 1965, cat. no. 34

Austin 1966, cat. no. 55

[1] Herbert Read, *A Concise History of Modern
Sculpture* (New York and Washington:
Frederick A. Praeger, 1966), 217–18.

EDUARDO PAOLOZZI BELONGED TO A GENERATION of English sculptors who reached maturity after World War II and sought new directions in their art in the aftermath of worldwide destruction. The idealizations of form typical of Brancusi, Arp, and Moore, among others, seemed outmoded. This new generation of artists, including Lynn Chadwick and Reg Butler, looked instead to Giacometti and Picasso and to the fantasies of Surrealism and Dada for ideas. Scarred surfaces, strange and unsettling forms, and sometimes a sense of angst seemed valid antidotes to the aesthetics of purity. For Paolozzi, a complementary interest was modern technology and mechanization. He spoke of aspirations to capture the "rational order in the technological world," which he found "as fascinating as the fetishes of a Congo witch doctor."[1] His resulting personages or "idols" are hybrids of mechanical shapes and zoomorphic emblems of animals and humans.

Chinese Dog is one such creature. The title of this work suggests that Paolozzi's inspiration may have come from Chinese bronzes of the Shang or Zhou dynasties. There is a definite resemblance between *Chinese Dog* and vessels from that tradition, especially in its stout shape with round vertical legs and its heavily worked surface. The intricate decoration on ancient Chinese bronzes often included inscriptions and decorative motifs cast into their surfaces. And zoomorphic forms, including monsters, dragons, birds, and even humans, appeared in both overall shapes and decorative motifs. Paolozzi's sculpture, while clearly an abstracted representation of a dog, resembles in its massing certain types of legged Chinese vessels, especially the *ding* form. His complexly modeled and layered surface has much of the same textural quality as these vessels, although Chinese decoration consists of very clearly defined motifs. In contrast, Paolozzi's treatment is much freer and seemingly spontaneous, with an expressive array of cuts, overlays, and gauges undoubtedly made with both his fingers and a sculpting tool on the maquette or wax mold. He also pressed small everyday objects such as knobs, wheels, and blocks into his maquette, contradicting his ancient theme with these relics from contemporary life. There is an echo here of other Paolozzi sculptures in which forms are cast from hard-edged industrial parts, but the surfaces in *Chinese Dog* dance with a form-softening touch akin to painterliness.

Victor Pasmore
British, 1908–1998
Line and Concrete: Space, 1961

132

Oil on concrete
11 ⅜ x 11 ¹³⁄₁₆ in. (29.5 x 30 cm)
Signed and dated on backing board: *Victor Pasmore 1961*
Collection of Gwendolyn Weiner L2015.19.1

Provenance: Marlborough Fine Arts, London; to the Weiner collection, 31 July 1969

Literature and exhibitions:
None identified

[1] For several examples, see Alan Bowness and Luigi Lambertini, *Victor Pasmore: A Catalogue Raisonné of the Paintings, Constructions and Graphics 1926–1979* (New York: Rizzoli, 1980), cat. nos. 483, 492, 605, 657, 529, 694.
[2] See Bowness and Lambertini, 246. The mural was later dismantled.

VICTOR PASMORE STUDIED AT the Central School of Art in London and worked at first in a representational style. He came to maturity, however, in the 1940s at a time when abstraction had established a firm foothold in English art, famously around the artist groups known as the Seven and Five Society and Unit One, as well as in avant-garde journals such as *Axis* and *Circle*. The English artists Ben Nicholson, Paul Nash, and John Piper were among those who had developed reductive styles based on geometric design and clear planes of color. Other considerable influence came from foreign pioneers of abstraction, particularly Naum Gabo from Russia and Piet Mondrian from the Netherlands, who moved to London before World War II.

Although Pasmore was primarily a painter, he worked also with relief constructions and architecture, integrating into all three media Constructivist ideas, among which was the firm belief in art's importance for shaping modern society. *Line and Space* is representative of one side of his abstract work from the 1960s, in which the strict geometry of his wall reliefs is loosened by a lighter sensibility. Delicately incised lines, bars, and organic shapes move across the lower register of this composition like notes on a musical score. The one red form punctuates the center of this flow and adds a particularly sprightly note. Although Pasmore's work in this vein might be termed "Lyrical Constructivism," the choice of concrete for the ground speaks of industrialism and his interest in architecture, and it adds physical and visual heft to the composition. He regularly painted on wood panels to give his works dimensionality; his use here of a concrete ground was highly unusual.

The basic ingredients of this composition represent a stylistic formula that Pasmore drew upon often in works from the early 1960s through the '70s.[1] It even found expression in a wall mural that he produced for the Pilkington Glass Works, St. Helens, Lancashire, in 1962–64.[2]

Eros Pellini

Italian, 1909–1993

Girl Holding Her Foot (*Ragazza che si prende il piede*), 1955

Bronze

Marked: *Pellini*

12 ¾ x 7 ¾ 6 in. (32.4 x 19.7 x 15.3 cm)

Collection of Gwendolyn Weiner L2014.52.2

Provenance: Collection of the artist; to the Weiner collection, 2 December 1960

Literature and exhibitions:

La Jolla 1970

Enzo Fabiani, *Eros Pellini* (Milan: Orlando Consonni Editore, 1989), 84, no. 72c

[1] See p. 25 for information on their friendship and Weiner's attempts to promote Pellini's work in America.

[2] Pellini's *Adolescent* (Fabiani, 40–41) seems, for example, a direct descendent of Degas's famous *Little Dancer of Fourteen Years*.

[3] For a few examples among many, see Fabiani, 34, 47, 59, 60, 64, 65, 74,75, 82, 83, 84, 87, and 90.

EROS PELLINI WAS SON OF THE important Italian sculptor Eugenio Pellini (see following entry) and lived and worked throughout his life in Milan, the city of his birth. His early training in art was sporadic. He attended two art schools in Milan and in 1930 joined the Accademia di Brera for a short time, where he studied with the sculptor Adolfo Wildt. In 1931 he was awarded an art prize that helped launch his career as a professional sculptor. Other prizes and exhibitions eventually followed, as well as ecclesiastic and governmental commissions. In later life Pellini taught sculpture and drawing at the Scuola del Castello and the Brera. Although relatively well-known in Italy, his reputation in the United States is limited despite the patronage and encouragement of Ted Weiner, who became friendly with Pellini and acquired a large number of his bronzes.

Girl Holding Her Foot is highly representative of his secular work. The human body seems to have held endless possibilities for him, and he produced a great many small-to-medium-scale studies of figures. They are mostly female, in a wide variety of standing and seated poses, all modeled with straightforward verisimilitude and light texturing of the surfaces. Edgar Degas's many studies of nudes and bathers may have been influential, but inspiration most certainly came from Pellini's fellow Italian sculptor Giacomo Manzù, who worked in and around Milan for many years. *Girl Holding Her Foot* is a case in point. Manzù made a number of sculptures of women in chairs over a lengthy period, a subject that then became one of Pellini's favorites as well, resulting in numerous variations on the theme.

Eugenio Pellini
Italian, 1864–1934
Judas, 1906

Bronze
Marked: E.PELLINI Fonderia Artistica/
Battaglia C/Milano
 62 x 26 x 45 ½ in. (157.5 x 66 x 115.6 cm)
Collection of Gwendolyn Weiner L2012-17.2

Provenance: Collection of Eros Pellini, Milan;
to the Weiner collection, 4 November 1959

Literature and exhibitions:

Austin 1966, 24 (misattributed to Eros Pellini;
not exhibited)

Elena Pontiggia, *Eugenio ed Eros Pellini:
L'espressione degli affetti* (Milan: Skira, 2003), 9

Extended loan, Museum of Texas Tech
University, Lubbock, 1980–2012

ALTHOUGH EUGENIO PELLINI IS little known in the United States, his work occupies a significant place in the history of late nineteenth-century Italian sculpture. He studied at the Academia di Brera in Milan starting in 1888, and in 1891 he moved to Rome and later to Paris for firsthand experience of contemporary sculpture in those two art capitals. In 1893 he returned to Milan, where he worked for the remainder of his life. He went on to participate in many important exhibitions, including the Exposition Universelle in Paris in 1900 and the Venice Biennale in 1905.

As part of a Europe-wide Symbolist movement bridging the nineteenth and twentieth centuries, Italian artists developed their own strong manifestations of this aesthetic approach, with currents of mysticism, spirituality, and dematerialized form flowing through both painting and sculpture. Pellini was part of this general trend. His *Sotto l'Arco della Pace (Chimney Sweep)* of 1884 presents a sleeping or sick child atmospherically blended into the materials around him in a way that anticipates the later semiabstract work of Italian sculptor Medardo Rosso. Pellini's large funerary monument for the Baj Macario family in Milan swirls the drapery of a grieving woman into the rock formation on which she sits, as animate and inanimate nature become one.[1] This theme of distress surfaces in other dolorous figures by the artist and is paramount in his *Judas*, dating from 1906.[2] The primary influence here, however, is the sculpture of Auguste Rodin, and especially his *Eve*, originally modeled in 1881 as part of the monumental *Gates of Hell*.[3] The two sculptures are strikingly similar in posture, gesture, and expression of debilitating anguish. Both have legs slightly bent as they move slowly forward, with their heads lowered into the hollows of their raised arms. And in both we are made to feel a tremendous weight pressing down on their broad shoulders and backs. Pellini also adopted the heroic musculature and taut modeling typical in Rodin's work. Overall, the *Judas* is one of the most powerful sculptural expressions in all of Pellini's oeuvre and stands apart from the softer stylistic treatment of most of his figures.

A plaster version of this work exists in the Gipsoteca in the community of Marchirolo, Northern Italy, where Pellini was born.[4] Ted Weiner purchased the bronze from Eros Pellini, son of Eugenio and a successful sculptor in his own right, from whom he also acquired numerous bronzes by Eros including *Girl Holding Her Foot* (preceding page) and *Girl from Lombardia*.[5] Weiner visited Pellini in Milan in June of 1959, and in July his secretary wrote to him asking about a price for "'Judas in marble *as is*."[6] Clearly the idea of a marble version of the sculpture did not materialize and a bronze was agreed upon instead.

[1] Illustrated in Sandra Berresford et al., *Italian Memorial Sculpture 1820–1940: A Legacy of Love* (London: Frances Lincoln Ltd, 2004), pl. 121.

[2] A preview of the despondent pose of *Judas* is seen in Pellini's *Night of Caprera (Garibaldi)* from 1901, in which Garibaldi, leader of the nineteenth-century Italian Independence movement, is shown striding forward with head and shoulders bowed. See Pontiggia, 9.

[3] On the influence of Rodin on Italian sculpture of this era, see Berresford, esp. 88–89.

[4] The website for Gipsoteca Spazio Scultura Comune di Marchirolo contains a biography for Eugenio Pellini and an illustration of the plaster *Judas*.

[5] See Olivier Meslay et al., *Hotel Texas: An Art Exhibition for the President and Mrs. John F. Kennedy*, exh. cat. (Dallas: Dallas Museum of Art, 2013), fig. 11 and pl. 8.

[6] Letter in Weiner family archive, Fort Worth.

Alicia Penalba
French, born Argentina, 1918–1982
Hommage à César Vallejo, 1955

Alicia Penalba, Hommage à César Vallejo, *in the Weiner sculpture garden, Fort Worth, 1960s*

Bronze; edition 2/4
Marked: *Penalba 2/4 5[7?]* (cast in 1957?)
105 1/4 x 21 ⅝ x 13 ¾ in. (267.5 x 55 x 35 cm)
Collection of Gwendolyn Weiner L2012-17.3

Provenance: Otto Gerson Gallery, New York; to the Weiner Collection, 8 June 1960

Literature and exhibitions:

Exposition international de sculpture contemporaine, exh. cat. (Paris: Musée Rodin, 1956), cat. no. 11 (different cast)

Arts 34, no. 2 (November 1959): 48

Documenta II: Kunst nach 1945, exh. (Kassel: Hessischen Landesmuseum, 1959) (different cast)

Michel Seuphor, *Alicia Penalba: Sculpture*, exh. cat. (New York: Otto Gerson Gallery, 1960), cat. no. 1, cover ill. (dated 1956)

Eduard Trier, *Form and Space: Sculpture of the Twentieth Century* (New York: Frederick A. Praeger, 1962), 128, fig. 113

Meisterwerk der Plastik, exh. (Vienna: Museum des 20. Jahrhunderts, 1964) (different cast)

Alicia Penalba, exh. cat. (Leverkusen: Städtisches Museum Schloss Morsbroich, 1964), cat. no. 10 (dated 1955–56)

Extended loan, Museum of Texas Tech University, Lubbock, 1980–2012

ALICIA PENALBA WAS BORN in Argentina to Spanish parents. In 1948 she immigrated to Paris to study art, first at the École des Beaux-Arts and then the Académie de la Grande Chaumière with Ossip Zadkine, among others. Impressed by the work of European modernists including Constantin Brancusi and Jean Arp, she developed a distinct style of abstract sculpture that lent itself well to large-scale expression and eventually prompted numerous commissions for monumental outdoor works. Many of her works feature wide and clustered forms suggestive of large plants with broad leaves, but her *Hommage à César Vallejo* is representative of a columnar type that she referred to as totems. It features a dense network of lobes nestled together vertically somewhat in the shape of a stalagmite. Her *Grand Hommage* dating from 1974 is a closely related vertical composition that stands twenty feet tall.[1] The datings for *Hommage à César Vallejo* vary considerably and often contain two dates. While the original sculpture was made in 1955, the second dates cited apparently denote when the subsequent casts were made.

César Vallejo was a Peruvian poet much admired by Penalba and widely considered one of the major poetic innovators of the early 20th century.

Penalba also worked as a printmaker and in other design fields, dividing her time between Paris and Pietrasanta, Italy, where she had many of her bronzes cast.

[1] Illustrated on Alicia Penalba home website, together with another cast of *Hommage à César Vallejo* belonging to the Centre Georges Pompidou in Paris (cast 3/4, dated 1955/1960).

139

Pablo Picasso
Spanish, 1881–1973
Angry Owl (Owl with Raised Wings,
La chouette en colère), 1950

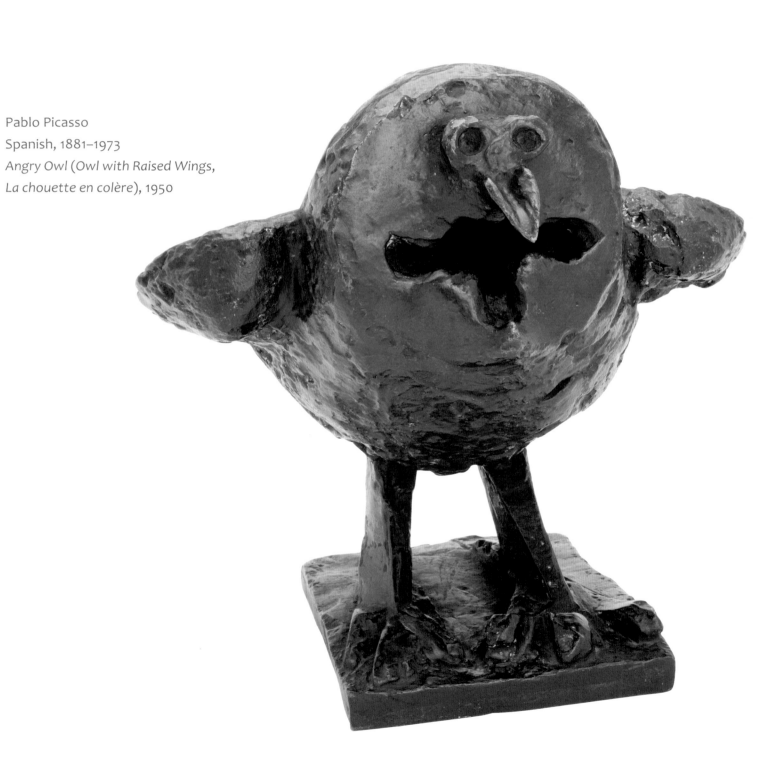

Bronze; edition of 6
12 ¾ x 12 ¼ x 12 ⅝ in. (32.5 x 31 x 32 cm)
Collection of Gwendolyn Weiner L2007-15

Provenance: Galerie Louise Leiris, Paris;
to Curt Valentin Gallery, New York; to the
Weiner collection, 7 October 1953

Literature and exhibitions:

Sculpture from Rodin to Lipchitz, exh. cat.
(Dallas: Dallas Museum of Contemporary
Arts, 1958), n. p.

Roland Penrose, *The Sculpture of Picasso*,
exh. cat. (New York: Museum of Modern Art,
1967), cat. no. 103 (different cast)

La Jolla 1970

Elizabeth Cowling and John Golding, *Picasso:
Sculptor/Painter*, exh. cat. (London: Tate
Gallery, 1994), 281 (under cat. no. 127,
a variant)

Werner Spies, *Picasso: The Sculptures*
(Ostfildern-Ruit, Germany: Hatje Cantz,
2000), cat. no. 404II

Nash and Hough 2007, 22, 24, cat. no. 25

75 Years 2013, 66–67

Olivier Meslay, *Hotel Texas: An Art Exhibition
for the President and Mrs. John F. Kennedy*,
exh. cat. (Dallas: Dallas Museum of Art,
2013; distributed by Yale University Press), 9,
24–25, 58, 60, 71, 73, 76, cat. no. 2

[1] This includes works in ceramic. See p. 144.
[2] Edward Quinn took a photograph of
Picasso at the Madoura workshops (right)
that shows a group of three white ceramic
versions of the *Angry Owl* sitting outdoors on
a makeshift bench. See also pp. 55–56.
[3] See Spies, cat. nos. 403, 404, 475, 476, 477.
[4] E.g., *The Sleep of Reason Produces Monsters*
(etching with aquatint, 1797–99) and *Can't
Anyone Untie Us?* (etching with aquatint,
1797–99), reproduced in Stephanie Stepanek
and Frederick Ilchman, *Goya: Order and
Disorder*, exh. cat. (Boston: Museum of Fine
Arts, 2014), pls, 40 and 74.
[5] Penrose, cat. no. 103. The label also
establishes the early provenance for the work.

PABLO PICASSO'S WORLD OF ART included a vast menagerie of animals of all varieties, from ferocious bulls to delicate birds to creatures half human and half horse, and within this arena, owls play a special role. They appear hundreds of times in Picasso's work in all media. In sculpture alone, they are manifest in more than twenty different forms, some of which were produced in large editions.[1] The *Angry Owl*, for example, exists as an original plaster, a bronze edition of six, several white fired-clay examples, some of which Picasso painted, and several fired-clay versions patinated black.[2] There are several close variations on this form as well.[3] Picasso may have been attracted to owls because of their distinctive appearance or the different character traits attributed to them, which include wisdom, mystery, and choleric spirit. A dark and menacing representation of owls was famously created in several works by Francisco Goya, images Picasso knew well.[4] His *Angry Owl*, however, seems most likely to represent for him a petulant domesticated example, especially considering that he kept a pet owl for a number of years.

The sculpture is constructed from a *bricoleur*'s assortment of odd objects and built forms, accreted in the original model with a wire armature and plaster. The beak and round eyes of the bird are formed by a metal object, perhaps a spout. Its legs are struts of wood, and its flared wings were made by mounding plaster on a piece of cardboard which served as a mold and left a clear pattern across the flat surface of the top of the wings. Conceptually, the sculpture is pure caricature—one can almost hear the high-pitched screech coming from the owl's wide-open mouth and feel the anger in its tense body—but he is a charming and humorous creature as well. The dexterity and ingenuity with which materials are handled mark the bird as another fine example of Picasso's inventiveness with three-dimensional form.

The dating of the work still poses a problem. In the authoritative catalogue of Picasso's sculptures by Werner Spies, the full assembly of versions of the *Angry Owl* is dated 1951–53. However, a paper label on the bottom of the Weiner cast from the Galerie Louise Leiris in Paris, Picasso's primary dealer for many years, is marked by hand "1950" in the description of the object. Based on this evidence, we have chosen to follow the alternative date of 1950 proposed by Roland Penrose in 1967.[5]

Picasso and Suzanne Ramié with plaster
casts of Angry Owl, *Vallauris 1953*

Pablo Picasso
Spanish, 1881–1973
Grand Vase with Dancers
(*Grande vase aux danseurs*), 1950

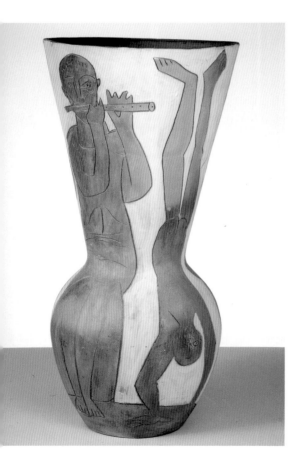

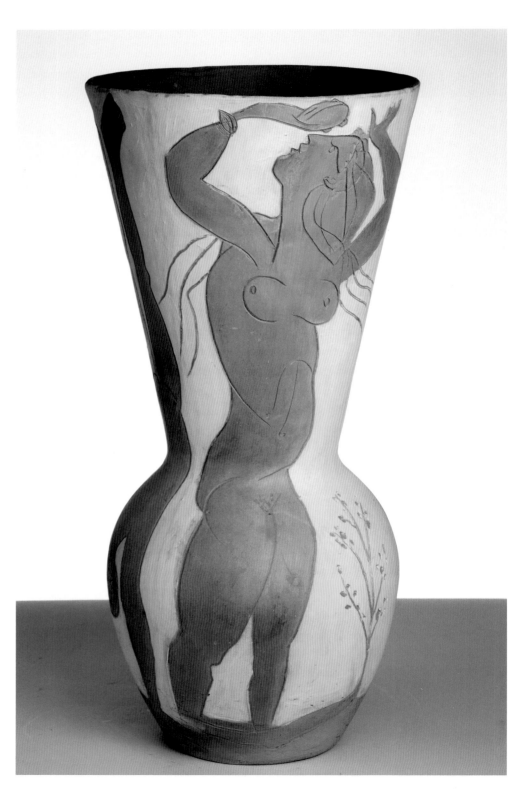

Glazed and incised ceramic; edition 23/25
Marked inside the rim: *EMPREINTE ORIGINALE
DE PICASSO MADOURA PLEINE FEU 23*
28 x 13 in. (71.1 x 33 cm)
Collection of Gwendolyn Weiner L1995-3.2

Provenance: Curt Valentin Gallery, New York;
to the Weiner collection, 5 March 1954

Literature and exhibitions:

Georges Ramié, *Picasso's Ceramics* (New
York: Viking Press, 1976), cat. no. 690
(different version)

Alain Ramié, *Picasso, catalogue de l'oeuvre
céramique édité 1947–1971* (Vallauris, France:
Madoura, 1988), cat. no. 115 (different
version)

Picasso: Céramiques, exh. cat. (Basel: Galerie
Beyeler, 1990), cat. no. 36 (variant version)

Marilyn McCully, *Picasso: Painter and Sculptor
in Clay*, exh. cat. (New York: Metropolitan
Museum of Art, 1998), 152, cat. no. 119,
(original model; entitled *Bacchanal*)

Nash and Hough 2007, 24–25, cat. no. 27

[1] G. Ramié 1976, cat. no. 689.
[2] *Picasso: Céramiques*, cat. no. 36.

THIS TALL CERAMIC VASE BY PABLO PICASSO features depictions of a dancer, flutist, acrobat, and pipe player. All are incised into the natural terracotta color of the fired clay in the simplified and elegant neoclassical style that Picasso first developed in the twenties and could conjure at any given time during his long career. In this case, the theme of pastoral revelry and the red-figure technique of the decoration are invocations of a classical past that is never far from the surface of Picasso's art. Both here and with another closely related vase featuring standing nudes,[1] Picasso shaped his figures in accord with the profile of the vases, so the curves and lines of the figures gracefully fill and rhyme the shapes of the encompassing forms in a calculated dialogue between two and three dimensions. The unusual height of the vase gives it a monumentality rare in Picasso's ceramic production. Both style and subject suggest an Arcadian spirit, also seen in other works of the period, that characterizes Picasso's postwar life in the south of France with Françoise Gilot and their two children. A variant of this vase exists, a unique work on which Picasso added further details to the figures with black paint.[2]

*Henri Matisse observing
Picasso's* Dancers *vase, 1951*

143

Pablo Picasso
Spanish, 1881–1973
Owl (*Hibou* or *Gros oiseau
visage noir*), 1951

PABLO PICASSO'S OWL FROM 1951 is one of his largest and most important ceramic sculptures. Although his work in ceramic was long considered merely an interesting sideline to his more "serious" activity in painting and sculpture, its unique character now attracts much greater appreciation. Residing in the south of France from mid-1946 until his death in 1973, Picasso became familiar with the artisan traditions of ceramic wares so prevalent in the region and devoted himself to work with local potteries, updating their historic functional forms with imaginative variations and bold decoration. He embraced the commercial nature of pottery production as a means of distributing his own artistic creations to broad audiences at low prices and worked in close partnership with ceramicists at different workshops. The most important collaboration was with the Atelier Madoura at Vallauris, owned by Suzanne and Georges Ramié, whom Picasso met on a visit to Vallauris in July 1946 (see pp. 55–56).

As discussed in regard to Picasso's bronze *Angry Owl* (p. 140), owls appear in many different guises in his paintings, drawings, and sculpture. In this ceramic rendering, with painted black-and-white decoration he cleverly transformed a tall, two-handled vase— the classical hydria[1]—into a stout bird with outspread wings. The high neck of the vase became the owl's head with a black beak and two round eyes; its wings form the handles. Picasso painted and incised a human face on what appears to be a type of necklace or pendant on the bird's chest; its smile accords with the overall lighthearted theme.

As with other techniques and materials he engaged in his art-making, Picasso devoted immense energy and creativity to the production of decorated ceramics, reformulating old processes and inventing new ones, all with staggeringly prolific results. He produced an estimated more than 3,500 fired clay objects in roughly twenty-five years, while working simultaneously in several other media. In so doing, he singlehandedly revitalized the trade in French artisanal pottery. As his friend Brassaï said of him, "I am struck by his infallible gift to give life to any material that he touches."[2]

Glazed and incised ceramic; edition 7/25
Marked inside neck: *D'APRES PICASSO 7
MADOURA PLEIN FEU*
21 ¼ x 17 ½ x 15 ¼ in. (54 x 44.5 x 38.7 cm)
Palm Springs Art Museum, gift of Gwendolyn
Weiner for the contribution of board
and staff toward the success of the 75th
Anniversary Gala 2014.74

Provenance: Curt Valentin Gallery, New York;
to the Weiner collection, 12 March 1952

Literature and exhibitions:

Wilhelm Boeck and Jaime Sabartés, *Picasso*
(London: Thames and Hudson, 1955), pl. 447
(different version)

Georges Ramié, *Picasso's Ceramics* (New
York: Viking Press, 1976), cat. no. 693
(different version)

Alain Ramié, *Picasso, catalogue de l'oeuvre
céramique édité, 1947–1971* (Vallauris, France:
Madoura, 1988), 69, cat. no. 119 (different
version)

Nash and Hough 2007, 24, cat. no. 26

[1] Unlike the hydria, however, the body of
this vessel is elongated slightly from front to
back in an ovoid shape. It is a form that, in
Picasso's hands, lent itself particularly well
to representations of birds, and he used it
for several different designs of owls. See,
for example, G. Ramié, cat. nos. 584, 708,
709, 739. The original, painted model for this
particular *Owl* appeared at auction in 2014.
See Christie's, London, Impressionist and
Modern Day Sale, 5 February 2014, lot no. 406.
[2] Gilberte Brassaï and Jane Marie Todd,
Conversations with Picasso (Chicago:
University of Chicago Press, 1999), 176.

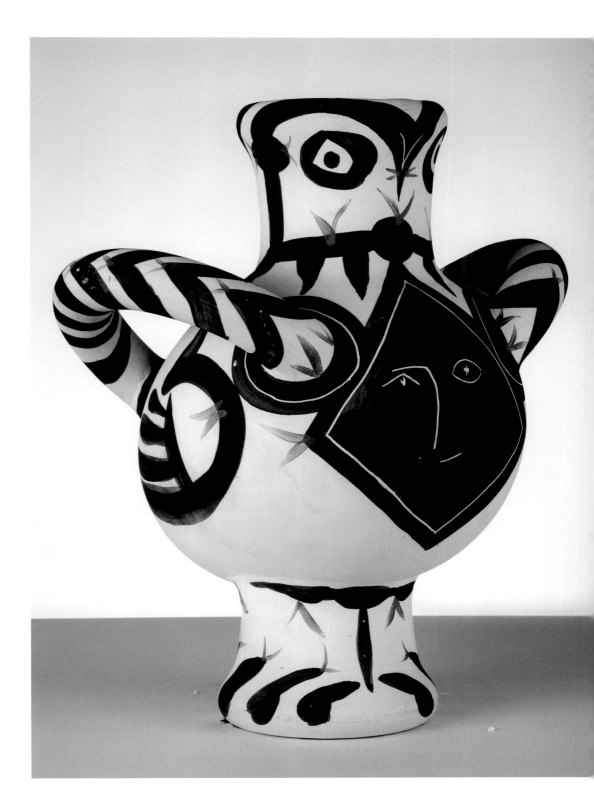

Germaine Richier
French, 1904–1959
Large Horse with Six Heads
(*Le grand cheval à six têtes*),
1954–56

Bronze; edition of 11, artist's proof
Marked: *G. Richier Epreuve
d'Artiste.*
L. Thinot. Fondeur. Paris
40 ½ x 41 ½ x 19 ¼ in. (103 x 105.5 x
49 cm) (including base)
Collection of Gwendolyn Weiner
L1980-4.15

Provenance: Galerie des Arts
Anciens et Moderne, Zurich; to the
Weiner collection,
30 November 1962

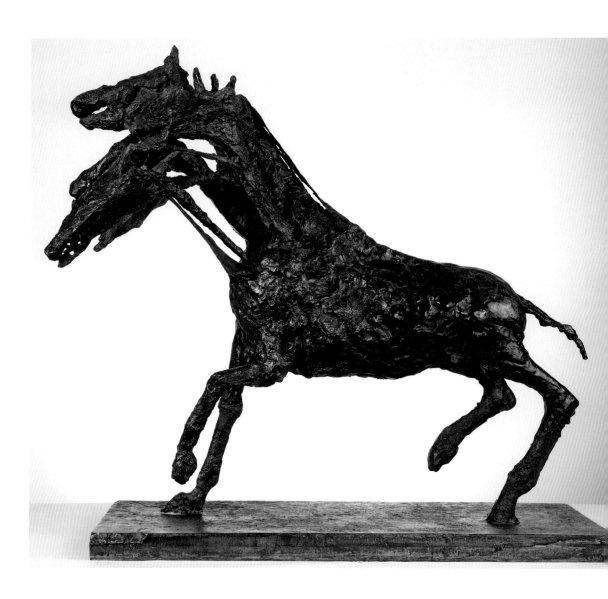

*Germaine Richier working on
maquette for small version*

Literature and exhibitions:

The Sculpture of Germaine Richier, exh. pamph. (New York: Martha Jackson Gallery, 1957), no. 21 (different cast)

Sculpture by Germaine Richier, exh. cat. (Minneapolis: Walker Art Center, 1958), cat. no. 28 (different cast)

Germaine Richier, exh. cat. (Antibes: Musée Picasso, 1959), cat. no. 21 (different cast)

Germaine Richier, exh. cat. (Zurich: Kunsthaus, 1963), cat. no. 56 (different cast)

Enrico Crispolti, *I maestri della scultura: Germaine Richier* (Milan: Fratelli Fabbri Editori, 1968), cat. no. 65 (different cast)

Brassaï, "Germaine Richier," *Les artistes de ma vie* (Paris: Denoël Editeurs, 1982), 194–97

Germaine Richier, exh. cat. (Humlebaek: Louisiana Museum of Modern Art, 1988), cat. no. 31 (different cast)

Christa Lichtenstern, *Germaine Richier Retrospektive*, exh. cat. (Berlin: Akademie der Künste, 1997, cat. no. 79 (different cast)

Germaine Richier: Rétrospective, exh. cat. (Saint-Paul: Fondation Maeght, 1996), cat. no. 78 (different cast, gold patina)

Françoise Guiter, *Richier*, exh. cat. (Venice: Peggy Guggenheim Collection, 2007), 129–35 (different cast)

Nash and Hough 2007, 21, cat. no. 28

Germaine Richier: Retrospektive, exh. cat. (Bern: Kunstmuseum Bern, 2013), 58, 137, cat. no. 68 (different cast, gold patina)

Germaine Richier: Sculpture 1934–1959, exh. cat. (New York: Dominque Lévy and Galerie Perrotin, 2014), 23, 34, 100-103, 148, 161

GERMAINE RICHIER'S SCULPTURE falls within a postwar European trend often related to the existentialism of contemporaneous philosophers and writers. Its signature aspects of distressed human and animal forms with rough, scarred or eroded surfaces can be read as expressions of the uncertain and angst-ridden human condition that existentialists posited as part of life in general, but especially as the psychic wounds emanating from the horrors of war. Richier did not disown such associations. As she put it, "What characterizes sculpture, in my opinion, is the way in which it renounces the full, solid form. Holes and perforations conduct like flashes of lightning into the material, which becomes organic and open…. A form lives to the extent to which it does not withdraw from expression. And we decidedly cannot conceal human expression in the drama of our time."[1] She saw herself as an inheritor of the traditions of Antoine Bourdelle, with whom she studied, and Auguste Rodin, but with very definite contemporary inflections.

Large Horse with Six Heads is a key example of Richier's deconstructive technique. A horse with six emaciated heads, the necks of which are stripped down to skeletal remains, charges forward. The impression is one of frenzy and some unknown torturous force at work. No sources in mythology, literature, or art have been identified for this imaginary creature, although renderings of the biblical Horses of the Apocalypse and illustrations of many-headed beasts in fantasy literature offer similarities. Also relevant is the centuries-old tradition of the *écorché*, in which bodies of animals and humans are stripped of their skin or excavated down to the bones, imagery that recurs in the history of religious, particularly medieval, art.

A photograph by Brassaï records Richier standing beside the wire, metal, and wood armature for *Large Horse with Six Heads*, and another shows her at work on the maquette for its smaller version (opposite).[2]

1 Peter Selz, *New Images of Man*, exh. cat. (New York: Museum of Modern Art, 1959) 130.
2 *Germaine Richier: Retrospektive 2013*, 58, and *Germaine Richier: Sculpture 1934–1959*, 2014, 100.

Georges Rouault
French, 1871–1958
*"Jésus sera en agonie jusqu' à
la fin du monde…"* (*"Jesus Will
Be in Agony until the End of the
World…"*). Pl. XXXV of *Miserere*,
1922/1948

GEORGES ROUAULT BEGAN HIS ART CAREER at evening classes at the École des Arts Décoratifs in Paris but transferred to the École des Beaux-Arts in 1881 where he studied under the symbolist painter Gustave Moreau (to whom he dedicated his illustrations for *Miserere* almost seventy years later). His early paintings were of historical and biblical subjects in a dark Rembrandtesque style, but his association with the Catholic novelist Léon Bloy deepened his humanistic consciousness and he turned in 1903 to his signature themes focused on humanity's emotional, physical, and moral suffering in the modern age, and its search for redemption. Between 1918 and 1927, Rouault concentrated on printmaking, and from these years date his etchings for *Miserere*, a landmark achievement in modern graphics.

Rouault originally conceived his project as one hundred large etchings to illustrate two books to be written by his friend the poet André Suarès, *Miserere* ("Have Mercy") and *Guerre* ('War"). The books never materialized, but in the years 1914–18 Rouault completed a long series of drawings on these themes, which his dealer and publisher Ambroise Vollard then had the artist transform into paintings. These images were transferred photographically onto copper plates, which Rouault worked laboriously with a revolutionary mixture of processes including etching, engraving, aquatint, drypoint, roulette, and direct application of acid with a brush. The result was fifty-eight images printed by 1927 with an astonishing tonal complexity and power, compiled under the single title *Miserere*. The plan was to publish the complete set in an edition of 450 copies (twenty-five *hors commerce*). However, Vollard died before he could finish the project, and because of legal struggles with his heirs, the prints were not released until 1948. Rouault finally collaborated with the publisher l'Étoile Filante to produce a portfolio of all fifty-eight images with preface by the artist.

Plate no. XXXV of this enterprise, *"Jesus Will Be in Agony Until the End of the World…"*, fully represents the somber, emotionally intense quality of Rouault's work throughout the entire book. Christ's body is shown close-up, giving it powerful monumentality. Contours are carved with broad black lines, and dense, dark spaces are created with an unidentifiably wide range of techniques. Unconscious or just resting, Christ lays his head on his shoulder, not so much agonized as dreamlike, portending the reserves of strength and spirituality that would soon allow him to rise from the grave. As with the so-called black paintings of Francisco Goya, Rouault's equally disturbing imagery is marked by palpable anger and hopelessness. But he was a man of deep faith, and although in the course of this huge project he had witnessed two world wars and the misery they caused, he managed nevertheless to find traces of hope in his survey of modern tragic life.

Monroe Wheeler reported that the title is a quote from the *Pensées* by Blaise Pascal.[1]

Etching and aquatint on paper
Signed and dated in the plate:
GR 1922 GR 1922/1922
Image: 22 ⅞ x 16 ¼ in. (58.2 x 41.3 cm)
Collection of Gwendolyn Weiner L2009-59.35

Provenance: Reilly Nail; to the Weiner
collection, 2 December 1953

Literature and exhibitions:

Monroe Wheeler and Georges Rouault,
Georges Rouault: "Miserere," exh. cat. (New
York: Museum of Modern Art, 1952), pl. 35
(different edition)

Frank and Dorothy Getlein, *Georges Rouault's
"Miserere"* (Milwaukee: Bruce Publishing
Company, 1964), 98–99

Austin 1966 (different selection of plates)

Holly Flora and Soo Yun Kang, *Georges
Rouault's "Miserere et Guerre": This
Anguished World of Shadows*, exh. cat. (New
York: Museum of Biblical Art, 2006), pl. 35
(different edition)

[1] Wheeler and Rouault, n.p.

Georges Rouault
French, 1871–1958
"Debout les morts!" (*"Arise, You Dead!"*). Pl. LIV of *Miserere*, 1922/1948

Etching and aquatint on paper
Signed and dated in the plate: *G Rouault 1922*
Image: 23 ¼ x 17 ½ in. (59 x 44.5 cm)
Collection of Gwendolyn Weiner
L2009-59.54

Provenance: Reilly Nail; to the Weiner collection, 2 December 1953

Literature and exhibitions:

Monroe Wheeler and Georges Rouault, *Georges Rouault: "Miserere,"* exh. cat. (New York: Museum of Modern Art, 1952), pl. 54 (different edition)

Frank and Dorothy Getlein, *Georges Rouault's "Miserere"* (Milwaukee: Bruce Publishing Company, 1964), 136–37

Austin 1966 (different selection of plates)

Holly Flora and Soo Yun Kang, *Georges Rouault's "Miserere et Guerre": This Anguished World of Shadows*, exh. cat. (New York: Museum of Biblical Art, 2006), pl. 54 (different edition)

GEORGES ROUAULT'S GRIM PHALANX OF SKELETONS rising from a grave is an obvious motif for his themes of death and suffering, but is rescued from cliché by his unusual compositional treatment and arresting range of textures and tonalities. Precedents for this subject are legion, including most prominently the ecclesiastical tradition of Last Judgment paintings, in which the damned are shown climbing out of graves, often as skeletons.

Rouault pushes his skeletons up against the picture plane, so it feels almost as if we were standing with them in the grave. They arise almost cinematically in three successive movements as the lower two follow their leader's call to action. The theme is resurrection after death, but the aggressive stance of the first skeleton, wearing a soldier's cap, seems not so much about salvation as a desire for retribution. He seems to be the one making the cry, "Arise, you dead!"

The bones of the skeletons, detailed with sharp contrasts of white and black, stand out against the murky atmosphere engulfing them, barely illuminated by a setting sun. The rich textures of this dense atmosphere would be a sensual delight if not for the sinister impact of the overall image. Once again arises the example of Goya's late paintings, in which he was able to achieve a similarly gripping mixture of deadly blacks. Rouault's dark outlining of figures in paintings, drawings, and prints alike is often said to reflect his early interest in medieval stained-glass windows and their leaded lines.

Melvin Schuler
American, 1924–2012
Caged Form, 1968

Black walnut and steel
71 ¼ x 35 x 26 ½ in. (181 x 88.9 x 67.3 cm)
Collection of Gwendolyn Weiner L1980-3.26

Provenance: Collection of the artist;
to Weiner collection, April 1969

Literature and exhibitions:

La Jolla 1970

Nash and Hough 2007, cat. no. 29

MELVIN SCHULER WAS BORN IN San Francisco and spent almost his entire career in Northern California. He studied at Yuba College in Marysville, the California College of Arts and Crafts in Oakland, and the Danish Royal Academy in Copenhagen, and began his teaching career in 1947 at Humboldt State University. There he was professor and then professor emeritus for the remainder of his life. Schuler is best known for his large-scale abstract sculptures generally in redwood or walnut or, in later years, wood covered in copper. Living most of his life in an area of Northern California renowned for its old-growth timber influenced his choice of materials; it also provided the inflection of nature in much his work, with its fluent monumentality and gentle twists and swells suggestive of organic forces.

In *Caged Form*, smoothly carved walnut segments of varied shape are stacked in a steel "cage" standing six feet tall. Its compositional dynamics work in different ways, capitalizing on the contrast of natural and industrial materials, the stark geometry of the cage versus Schuler's loose assembly of irregular forms, and the play of vertical and horizontal vectors. Although there is no reason to assume an influence, *Caged Form* calls to mind works by Alberto Giacometti from the 1930s and 40s: cagelike structures in wood or metal, and abstract or figurative forms inhabiting and sometimes reaching out from the confines of their transparent boxes. Schuler continued to work on a series of Caged Form sculptures into the early 1970s.

Gregory Sumida
American, born 1948
Amputated, 1972

Watercolor on board
Signed and dated: *G. Sumida 72*
22 x 30 in. (55.9 x 76.2 cm)
Palm Springs Art Museum,
gift of Mr. and Mrs. Ted Weiner 2-1973

Provenance: Collection of the artist; to the
Weiner collection, 21 March 1972

Literature and exhibitions:
None identified

[1] See the discussion about this point in the
introductory essay, p. 25.

GREGORY SUMIDA IS A TECHNICALLY gifted painter with oils and watercolors who came to the attention of Ted Weiner early in his career, and whose work Weiner collected enthusiastically while making efforts to promote it to wider audiences. Although Sumida has favored themes from the old American West in recent years, earlier he followed the lead of Andrew Wyeth in both watercolor technique and choice of subject matter. This influence is apparent in *Amputated* and his many other picturesque, closely observed studies of nature and scenes from rural America. Such works are crafted with an unusual intensity of detail and strength of tonal patterning that call to mind Wyeth's sober elegies of country life and serve to set them apart from the work of other traditionally oriented watercolor artists.

Amputated presents a close-up view of two scraggly tree trunks set against a barren field with high horizon. The painting's earthen colors—mostly browns and grays—and monumental treatment of the two primary forms create a somber tone for this view of nature in autumnal recession. But Sumida also included a detail that lightens the mood: an old carving of a heart in one of the trunks that is set squarely in the center of the composition, adding a note both romantic and nostalgic.

This work is one of more than forty that Weiner purchased from Sumida over a short period of time in the early 1970s, many of which he brokered to art galleries and gave to friends.[1] A large number still remain in the Weiner collection.

Rufino Tamayo
Mexican, 1899–1991
The Volcano (Le Volcan), 1958

Oil on canvas
Signed and dated: *Tamayo / o – 58*
38 ¼ x 57 ¼ in. (97.2 x 145.5 cm)
Collection of Gwendolyn Weiner L1995-3.6

Provenance: Galerie des Arts Anciens et
Modernes, Zurich; to the Weiner collection,
13 December 1962

Literature and exhibitions:

Houston 1964, cat. no. 8

Austin 1966, cat. no. 75

75 Years 2013, 40

[1] Consider such works as *Woman Reaching for the Moon, The Great Galaxy, Constellation* (Diana Du Pont, *Tamayo: A Modern Icon Reconsidered,* exh. cat. [Santa Barbara: Santa Barbara Museum of Art, 2007], pls. 74, 131, and 103), and *Sunset* (J. Corredor-Matheos, *Tamayo* [Barcelona: Ediciones Polígrafa, 1987], pl. 36).
[2] Martica Sawin, *Surrealism in Exile and the Beginning of the New York School* (Cambridge, MA: MIT Press, 1997), 209.

MANY LATIN-AMERICAN ARTISTS working in the 1940s and '50s, including Rufino Tamayo and Fernando Botero (p. 46), were aware of the strong contemporary trend toward Abstract Expressionism in North American art. They chose nevertheless to develop personal figurative styles often drawing upon ancient Mesoamerican art, the Mexican muralist tradition, and their native folk arts. For Tamayo, human and animal subjects were the primary vessels of meaning in his work, although his far-reaching investigations of humankind's place in the universe sometimes stretched to sweeping visions of the cosmos. In those instances, abstraction, or near-abstraction, gave him a nonempirical language for their expression. *Volcano* is a case in point. Here, long streamers of color shoot like fireworks out of a bright red core, creating a force field of energy and simulating the pyrotechnics of a volcanic eruption. Such geologic events are not uncommon in Mexico, and Tamayo clearly had the imagery of night eruptions engraved in his mind. In this regard *Volcano* is still a representational painting, but Tamayo's dynamic handling of color and explosive form borders on abstraction and enhances his vision of vastness and powerful natural force.

Volcano is one of numerous paintings in Tamayo's oeuvre that tackle visionary subjects in which, for example, humans reach for the moon and stars, paintings take viewers on galactic explorations, and canvases burst with the energy of the sun.[1] Such works have a Surrealist tone and also show affinities with the cosmic paintings of the Chilean painter Roberto Matta, who coincidentally had been mesmerized by Mexico's volcanoes when he traveled there, proclaiming, "My work began to take the form of volcanoes."[2] Both Tamayo and Matta gained direct knowledge of the Surrealist movement through personal associations with European artists who immigrated to the Americas during World War II. Though they both responded to Surrealism, they each integrated its influences into their individual expressive language.

William Turnbull
American, born Scotland,
1922–2012
Oedipus I, 1962

Bronze, rosewood, and stone
Bronze element marked: *T* (in a circle) 61
65 ½ x 16 ¼ in. diameter (166.4 x 41.3 cm)
Collection of Gwendolyn Weiner L2007-15.5

Provenance: David Gibbs and Co., London;
to Weiner collection, 10 October 1962

Literature and exhibitions:

Turnbull, exh. cat. (New York: Marlborough-
Gerson Gallery, 1963), cat. no. 8 (version II)

Herbert Read, *A Concise History of Modern
Sculpture* (New York and Washington:
Frederick A. Praeger, 1964), pl. 205

Sculpture: Twentieth Century, exh. cat.
(Dallas: Dallas Museum of Fine Arts, 1965),
cat. no. 78

La Jolla 1970

Richard Morphet, *William Turnbull: Sculpture
and Painting*, exh. cat. (London, Tate Gallery,
1973), fig. 17

Nash and Hough 2007, cat. no. 30.

[1] For the three works, see Morphet, figs. 17
and 18 and cat. no. 54.

FOLLOWING HIS SERVICE IN THE Second World War as an aviator, William Turnbull studied at the Slade School of Art in London from 1947 to 1948. He then moved to Paris (1948–50), where he met numerous avant-garde artists, including Pablo Picasso, Fernand Léger, Constantin Brancusi, and Alberto Giacometti. Turnbull worked throughout his career as both a sculptor and painter. In sculpture, his work veered between a number of distinctly different formal approaches. These ranged from archaic figures whose flattened, plaquelike bodies invoke tribal and Cycladic art, to totemic structures heavily indebted to Brancusi, to a Constructivist aesthetic introduced into British art by Anthony Caro that explored the severe geometry of American Minimalism. *Oedipus I* is a prime example of the second group.

The most distinguishing feature of this series is the columnar structure of the works, composed of stacked, roughly finished elements that form a tall base on which are perched small abstract objects that can be loosely interpreted as heads. The stacked approach comes directly out of Brancusi's invention of multipart bases that are a key element of the overall conception of each sculpture and have a solid, rusticated quality that calls to mind folk art carvings and Neolithic stone objects. These same qualities characterize Turnbull's stacked totems. Brancusi's influence is also felt in the formal simplicity of the "heads" in these sculptures, as seen in the one topping *Oedipus I*. This smooth, ovoid form with a large V cut into its top reappears in other works, including the closely related *Oedipus II* and *III*, also from 1962.[1]

The imprint of the numeral "61" on the back lower edge of the bronze segment in *Oedipus I* indicates that this drumlike form was cast in 1961, but the overall sculpture is traditionally dated to 1962. Various adjustments were made in the other works in the series: the central section of *Oedipus II* is stone rather than wood, and *Oedipus III* is a much taller sculpture with a five-part base. Turnbull termed these stacked works his "Permutation Sculptures," implying that owners of the sculptures are permitted a role in arranging their separate elements.

Günther Uecker
German, born 1930
Light Disc, 1961

Nails on canvas on wood painted white
Signed and dated on verso: *Uecker 61*
59 in. diameter (150 cm)
Collection of Gwendolyn Weiner

Provenance: Howard Wise Gallery, New York;
to the Weiner collection, 7 October 1968

Literature and exhibitions:

Museum Haus Lange, Krefeld, exh., 1963

Willoughby Sharp, *Günther Uecker: Ten Years of a Kineticist's Work* (New York: Kineticism Press, 1966), 39

Palm Springs 1969, 4

La Jolla 1970

Dieter Honisch, *Uecker* (New York: Harry N. Abrams, 1986), 60, cat. no. 212

[1] In his catalogue of Uecker's works, Dieter Honisch indicates that a motor was originally attached to *Light Disc*, but if so the motor was removed long ago, apparently before it entered the Weiner collection.
[2] Published in the official bulletin of the Zero group, *Zero* 3 (July 1961), n.p.

GÜNTHER UECKER IS A SCULPTOR and kinetic artist whose work with light as a formal ingredient anticipated the California Light and Space movement by several years. He studied at the Kunsthochschule Berlin-Weissensee from 1949 to 1953 and then at the Kunstakademie Düsseldorf. An early interest in philosophies and religions that stressed purity and simplicity helped shape his minimalist aesthetics, and a study of purification rituals partly influenced his signature art-making practice of pounding nails into wood, a repetitive act in which he found ritual.

Uecker's *Head* from 1955–56, a white object consisting of nails driven into a headlike form, was one of his first fully realized works in this idiom, and by 1958 his use of nails had become a dominant compositional device. *Light Disc* in the Weiner collection is a major example of his application of this methodology to flat planes of wood in various shapes and sizes, almost always painted white. In these works, slight variations in the patterns of the nails together with differences in the direction of light striking the objects create divergent effects of shadow and reflected light, as well as different virtual shapes that seem to float within the overall composition. Fashioned from mundane materials, these objects are actually sophisticated investigations of energy and optics and the way that light can seemingly dissolve solid matter. By 1960 Uecker had begun to introduce movement into his constructions by attaching motors.[1] He wrote in 1961, "To render the development of a movement visible as a dynamic state is a significant action. It is not a matter of routine but fertile in its repetition, in its very monotony, like the experience of prayer. My objects constitute a spatial reality, a zone of light. I use the means of technology to overcome the personal gesture, to objectify, to create the conditions of freedom."[2]

In 1961 Uecker joined Gruppo Zero, or Zero Group, which had been founded by fellow German artists Heinz Mack and Otto Piene with the ambition of giving postwar art a "zero base," or clean slate, from which to strike out in new directions using nontraditional methodologies. Gruppo Zero expanded to include numerous artists from different countries who shared the ideal of a new consciousness of art as a concrete, nonsubjective experience. After the group dissolved in 1966, Uecker again shifted focus, this time to land art and a more conceptual praxis, and even to stage design.

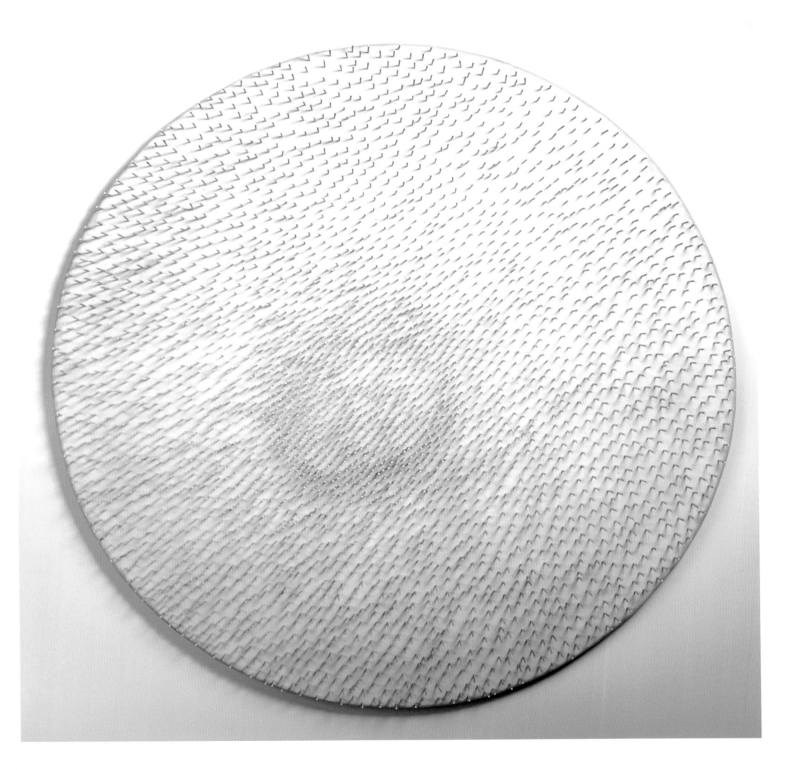

Peter Voulkos
Pottery #1
(sometimes referred to
as *Double-Neck Vase*), 1958

Stoneware with white slip painted with color slips
Signed and dated on top edge: *Voulkos 7–58*
19 ½ x 9 ½ x 9 ¼ in. (49.5 x 24.1 x 23.5 cm)
Collection of Gwendolyn Weiner L1982-9

Provenance: Felix Landau Gallery, Los Angeles; to the Weiner collection, 14 May 1959

Literature and exhibitions:

Peter Voulkos: Sculpture/Paintings/Ceramics, exh., Felix Landau Gallery, Los Angeles, 1959 [?]

Fort Worth 1959, cat. no. 118 (added to republished catalogue)

Corpus Christi, Art Museum of South Texas, exh., 1969

Peter Voulkos: A Retrospective 1948–1978, exh. cat. (San Francisco: San Francisco Museum of Art, 1978; organized by the American Crafts Council, New York), cat. no. 67

Rose Slivka, *Peter Voulkos: A Dialogue with Clay* (New York: New York Graphic Society in association with the American Crafts Council, 1978), 106, pl. 68

California Innovations, exh., California State University at Fullerton, 1981

Nash and Hough 2007, 17, cat. no. 31

[1] Correspondence with the author, 31 March 2015. I am indebted to Ms. Jornlin for sharing information that will appear in the catalogue raisonné on the work of Peter Voulkos that she is currently preparing.
[2] Information concerning this exhibition was also supplied by Sam Jornlin.

Far right: Peter Voulkos with unfired Pottery #1, *Montana, 1958*

PETER VOULKOS IS CREDITED as the primary force behind the California clay movement of the 1950s and 60s, which destroyed old hierarchical attitudes toward ceramics as "only" a craft or a decorative art. He made bold, craggy, energetically constructed ceramic objects that were clearly sculptures of major import, transposing Abstract Expressionist dynamics into three dimensions more effectively than any other artist of his generation. Voulkos was born to Greek immigrant parents in Bozeman, Montana, studied at Montana State College, and earned his MFA from the California School of Arts and Crafts in Oakland in 1952. Through his mastery of ceramic techniques he gained a reputation for elegant housewares, but during a summer of teaching at the experimental Black Mountain College and visiting New York, he also became familiar with the Abstract Expressionist movement, which would have lasting importance for his art. In 1954 he was invited to teach at Otis College of Art and Design in Los Angeles, where he established a ceramics department that attracted a number of talented students who also evolved as outstanding ceramic sculptors. His own work became larger and more powerful as he worked with massive slabs of clay that he stacked and wedged roughly together, fired, and aggressively glazed or painted while leaving large areas of untreated ceramic as an expression of the material itself. In 1959 he moved to the University of California at Berkeley, where he began to work in bronze as well as ceramics.

Pottery #1 is an example of Voulkos's work on a relatively small scale with sculptural vases and plates. Sam Jornlin of the Voulkos & Co. Catalogue Project kindly provided a full technical description of the process by which this work was made: wheel-thrown stoneware sections assembled and joined, paddled, manipulated, and altered, with applied slips and glazes, subsequently high-fired in a kiln with gas. She also affirms that the work was made in Missoula, Montana, where Voulkos taught during the summer of 1958.[1]

The vertical double necks of this vase emerging from a wider "stomach" and its coloration of black and blue spots against a white background create an especially lively impression. In keeping with Voulkos's dedication to Abstract Expressionism, made clear in both his paintings and ceramics, the decorative scheme of floating color fields relates to work by a number of painters in that movement, including Raymond Parker and Mark Rothko.

Although both *Pottery #1* and *Pottery #2* (following entry) were consigned to the Felix Landau Gallery and acquired by Weiner at the time of its 1959 exhibition of recent work by Peter Voulkos, it is not known if either or both were actually included in the show. Another work purchased by Weiner at the same time, *Pottery #3*, which is still in the collection of Gwendolyn Weiner, is pictured in an installation photograph in the exhibition catalogue, but no checklist of the show has been found.[2]

Peter Voulkos
American, 1924–2002
Pottery #2, 1959

Stoneware with slips and glaze
20 ½ x 14 ½ x 8 ½ in. (52 x 36.8 x 21.6 cm)
Collection of Gwendolyn Weiner L1980-4.14

Provenance: Felix Landau Gallery, Los Angeles;
to Weiner collection, 14 May 1959

Literature and exhibitions:

Peter Voulkos: Sculpture/Paintings/Ceramics,
exh., Felix Landau Gallery, Los Angeles, 1959 [?]

Fort Worth 1959, cat. no. 117 (added to
republished catalogue)

Daniel Rhodes, *Stoneware and Porcelain:
The Art of High-Fired Pottery* (Philadelphia:
Chilton Book Company, 1959), pl. 51

Corpus Christi, Art Museum of South Texas,
exh., 1969

Peter Voulkos: A Retrospective 1948–1978,
exh. cat. (San Francisco: San Francisco
Museum of Art, 1978; organized by the
American Crafts Council, New York),
cat. no. 71

Nash and Hough 2007, 17, cat. no. 32

INFORMATION FROM THE VOULKOS & CO. Catalogue Project provides the following technical description of *Pottery #2*: gas-fired, wheel-thrown, assembled, and altered stoneware vase with various slips and clear glaze.[1] This work provides a good example of how Peter Voulkos drew upon Abstract Expressionist aesthetics to redefine ceramic sculpture. More so than *Pottery #1* (preceding entry), this work is gestural in its conception and making, born of an aggressive shaping of clay that pushed forms outward from a central core with jagged and pointed expansions of contour. The closest analogies for this treatment come not from any ceramics tradition but from the slashing strokes in paintings by Willem de Kooning and Franz Kline. Voulkos's handling of surface carries out that same gestural approach. Different parts of both sides of the vase are scored with crisscrossing etched lines, reminiscent of freehand markings on thick grounds in works by the Spanish abstract painter Antonio Tàpies. These have an archeological quality, invoking a sense of primitive pictographs that are partially hidden beneath washes of colored slip. The application of slips is equally free-form, emphasizing through drips, uneven coloration, and rough swatches the energetic action of the brush that laid them down. Around the neck of the vase are spontaneous strokes of rusty brown that further enliven the design.

All in all, these dynamics of composition work to expand one's sense of the vase's scale considerably beyond its relatively modest dimensions. A particularly close comparison for *Pottery #2* is found in another work from 1959 entitled simply *Vase*,[2] and the application of similar stylistic traits on larger objects is seen in *Sculpture* from 1960 and *Little Big Horn* from 1959.[3]

[1] Correspondence with the author, 28 April 2015. This work will appear in the forthcoming catalogue raisonné being compiled by Sam Jorlin.
[2] Rose Slivka, *Peter Voulkos: A Dialogue with Clay* (New York: New York Graphic Society in association with the American Crafts Council, 1978), pl. 27.
[3] Slivka, pl. 32, and Rose Slivka and Karen Tsujimoto, *The Art of Peter Voulkos*, exh. cat. (Oakland: Oakland Museum, 1995), pl. 7.

Andrew Wyeth
American, 1917–2009
Afternoon Light, 1938

Watercolor on paper
Inscribed: *Andrew Wyeth / to Sam and Vicky*
17 1/2 x 21 ¾ in. (44.5 x 55.2 cm)
Collection of Gwendolyn Weiner L1995-3.7

Provenance: Given by the artist to Mr. and
Mrs. Samuel Homsey, Wilmington, Delaware;
sold at Sotheby Park Bernet, New York, 4 May
1967; to Jeffrey H. Loria and Co., New York;
to the Weiner collection, 18 February 1969

Literature and exhibitions:

Water Colors by Andrew Wyeth, exh. pamph.
(Boston: Doll and Richards, 1938), no. 7

Modern Drawings and Watercolors, auction
cat. (New York: Sotheby Parke Bernet, 4 May
1967, sale no. 2560), lot no. 101

[1] Information on the history of *Afternoon
Light* was generously provided by Mary
Landa, Wyeth Collection Manager at the
Andrew Wyeth Catalogue Raisonné project
in Chadds Ford, Pennsylvania.
[2] Wyeth often said that watercolor,
unlike tempera and dry brush, appealed
to his wilder instincts and liberated his
sensitivity to momentary impulse. See
quotes, for example, in "Andrew Wyeth,
One of America's Youngest and Most
Talented Painters," *American Artist* 6, no. 7
(September 1942), 18.

ANDREW WYETH, RENOWNED PAINTER of rural America, produced this boldly executed watercolor in 1938 on Stone Island, Maine, off the coast of Port Clyde at the mouth of the Georges River.[1] It was an area he returned to for painting trips off and on for many years.

Wyeth was only twenty-one years old in 1938 and just embarking on a seventy-year career after training under his famous father, the illustrator/painter N. C. Wyeth. Throughout his life, the younger Wyeth remained committed to a closely observed realism that produced stern and heartfelt, if sometimes sentimental, chronicles of people and places in back-country Maine and Pennsylvania, where he had homes. He is perhaps best remembered for his work in the painstaking techniques of tempera and dry-brush watercolor, both of which allowed for exceptionally detailed finishes, but he was also highly skilled with wet-on-wet watercolor, with which he made his most freely executed paintings.[2]

Afternoon Light and other watercolors painted around the same time were the works that first brought Wyeth to public attention. His one-artist exhibition in 1938 at the Doll and Richards gallery in Boston, in which this painting appeared, was only the second of his early exhibitions, following a show the year before at Macbeth Gallery in New York.[3] For a small exhibition pamphlet, the author and historian Allen French wrote presciently that the land- and seascapes on view "exhibit great power held in restraint. This young—this very young—man… concerns himself with elemental forces, which he displays in static moments before or after crises…. Power is manifest in the heavy tones of these strong and in some cases violent water colors, whether expressed in technical mastery, or in the connotation of subjects which disclose the artist's deep brooding upon land and sea."

A review of other works from around 1938 elucidates French's comment on "Wyeth's deep brooding upon land and sea." Works most similar to *Afternoon Light* include *Cat-o-Nine-Tails* and *Coming Storm*, both of which appeared in the Doll and Richards exhibition; *Shoreline*, also from 1938; and an untitled coastal scene so closely related to *Afternoon Light* that it could be considered a pendant.[4] All have the same palette of dark blues, greens, and browns and share similar lighting effects. Patches of sunlight

[3] Wyeth told Thomas Hoving about that first exhibition in 1937: "The show was a big success. Sold out. That was unusual, for it was at the end of the Depression and not too many artists were that fortunate. I achieved a sort of renown for watercolor, gained considerable confidence, and even made a little money." Thomas Hoving, *Two Worlds of Andrew Wyeth: A Conversation with Andrew Wyeth*, exh. cat. (New York: Metropolitan Museum of Art, 1978), 13.

[4] Susan Strickler, *Andrew Wyeth: Early Watercolors*, exh, cat. (Manchester, New Hampshire: Currier Museum of Art, 2004), cat. nos. 1 and 2, and Beth Venn and Adam D. Weinberg, *Unknown Terrain: The Landscapes of Andrew Wyeth*, exh. cat. (New York: Whitney Museum of American Art, 1998), cat. nos. 45 and 44.

create brilliant highlights scattered across the compositions, but the predominant tonalities and the mood of the paintings are consistently somber and autumnal. Wyeth's love of the work of Winslow Homer is manifest, especially his paintings of sea and shorelines in which he mixed so strongly his bold handling of form and color with a sense of foreboding power. The watercolors of John Singer Sargent also seem influential, particularly in Wyeth's vibrant play of lights and darks and his animated brushwork. Although evocative of place and climate, the works cited above also reveal an attention to the compositional device of patterning visual effects dynamically across the painting's entire surface, an indication of how Wyeth intuitively employed principles of abstraction to strengthen his realism.

Wyeth's dedicatory inscription on the painting—"to Sam and Vicky"—refers to friends of his from Wilmington, Delaware, the first owners of *Afternoon Light*.

Ossip Zadkine

French, born Russia, 1890–1967

Van Gogh Brothers Seated
(formerly *Two Seated Figures*),
1956/1963

Bronze; edition of 6, plus 3 proofs
Marked: *1/6 O ZADKINE 63 susse fondeur Paris*
16 ¾ x 13 5/8 x 14 in. (42.5 x 34.6 x 35.6 cm)
(including base)
Collection of Gwendolyn Weiner L1980-3.33

Provenance: Jeffrey H. Loria and Company,
New York; to the Weiner collection, 18 March
1969

Literature and exhibitions:

Denys Chevalier, *Ossip Zadkine*, exh. cat.
(Zurich: Kunsthaus, 1965), cat. no. 97
(different cast, dated 1956)

Jean Bouret, *Ossip* Zadkine, exh. cat. (Paris:
Galerie Schmit, 1970), cat. no. 58 (different
cast, dated 1956)

La Jolla 1970

Ossip Zadkine and Jean Bouret, *Sculpture
by Ossip Zadkine: 1890–1967*, exh. cat. (New
York: Hirschl and Adler Galleries, 1971), cat.
no. 41

Ionel Jianou, *Zadkine* (Paris: Arted, 1979),
cat. no. 457 (dated 1964)

Sylvain Lecombre, *Musée Zadkine: Sculptures*
(Paris: Paris-Musées, 1989), cat. no. 191

Sylvain Lecombre, *Ossip Zadkine: L'oeuvre
sculpté* (Paris: Paris-Musées, 1994), cat. no. 479

Nash and Hough 2007, 14, cat. no. 33
(entitled *Two Seated Figures*, dated 1963)

OSSIP ZADKINE WAS BORN IN RUSSIA in the city of Vitebsk, attended art school in London, and in 1910 settled in Paris. He lived in Montparnasse in a thriving colony of foreign artists that included Pablo Picasso, Amedeo Modigliani, Alexander Archipenko, Jacques Lipchitz, Constantin Brancusi, and many other important avant-garde painters and sculptors. Though he began studies at the École des Beaux-Arts, he was quickly drawn into the orbits of Primitivism and Picasso's Cubism, which was rapidly spreading as an influential movement. At first, Zadkine's work had ties especially with the sculpture of Henri Laurens and Jacques Lipchitz. As his career progressed, however, it took on a more florid, expressionistic spirit with freer, very often angular shapes, jagged rhythms, and a spatial deconstruction of the inner core of his sculptures. Coming toward the end of this trajectory, *Van Gogh Brothers Seated* represents a reversion to his early Cubist principles.

The theme of Van Gogh and his brother Théo obsessed Zadkine from around 1956 to 1965, and he made over ten different representations of Van Gogh alone or grouped with his brother, some very large in scale.[1] *Van Gogh Brothers Seated* from 1956/1963 is an enlarged version of a more loosely modeled bronze from 1956.[2] In both examples, the two figures are closely joined into a single compositional unit that is animated by its dynamic pattern of arms, legs, and heads as well as deep cavities of negative space. The larger work is distinguished by its significantly tighter handling, in which Zadkine trued the shapes with a sculpting tool into sharper geometric configurations. The back of the sculpture, for example, is stylized essentially into three vertical cubic bars. The general composition has a precedent in a work from 1948 entitled *Les Elfes*.[3] A plaster cast is in the Musée Zadkine in Paris.

[1] Lecombre 1994, cat. nos. 471–79, 533–535, 548.
[2] Lecombre 1994, cat. no. 478.
[3] Lecombre 1994, cat. no. 412.

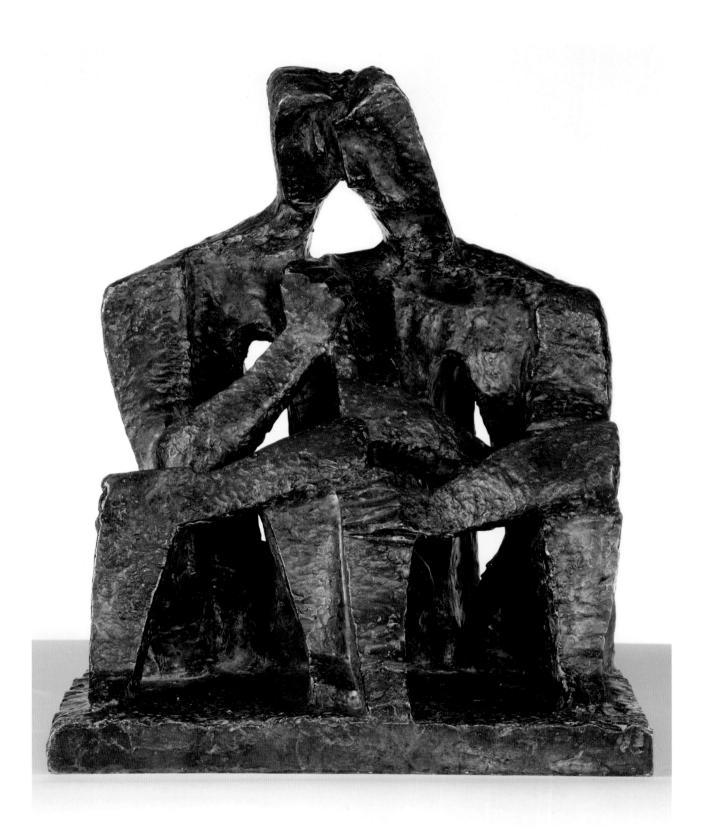

Jack Zajac
American, b. 1929
Deposition II, 1960

Bronze
73 ¼ x 47 ½ x 46 ½ in. (186.1 x 120.7 x 118.1 cm)
Collection of Gwendolyn Weiner L1980-3.34

Provenance: Collection of the artist; to the
Weiner collection, 31 August 1960

Literature and exhibitions:

La Jolla 1970

Nash and Hough 2007, 21–22, cat. no. 34

[1] Henry J. Seldis and Ulfert Wilke, *The Sculpture of Jack Zajac* (Los Angeles: Galland Press, 1960), 37. The Weiner collection contains a cast of this work.
[2] Several letters from this exchange are in the Weiner family archive in Fort Worth.

JACK ZAJAC'S CAREER IS MARKED BY a fluid alternation between abstract and figurative modes. Although he worked first as a painter, he began to concentrate on sculpture in the mid-1950s with expressive bronzes of animals and human figures in full or fragmented form. These were sometimes fused into masses of raw bronze, and often distorted as if wrenched by strong external forces. Around 1963–64, however, Zajac shifted gears and began a lengthy series of sculptural representations of falling water and other themes from nature that have a purity of form bordering on abstraction (see following page). This body of work was then interspersed with new versions of earlier themes.

Zajac spent much of his early career abroad, primarily in Rome, and exposure to European art and history helped give his sculpture a character distinct from most contemporary American work. At the time of Pop Art and Minimalism, Zajac chose to tackle grand existential themes of sacrifice, death, and redemption, which he embodied in his treatments of sacrificial animals, the Pietà, Crucifixion, Descent from the Cross, Deposition, and Resurrection. Commonalities exist with the work of certain European contemporaries, including Marino Marini and Germaine Richier, which also deal with humanity's struggle captured in part by agitated modeling and distorted anatomy.

Deposition II is one of the largest and most dramatic of Zajac's figurative works. It is a simplified version of his *Large Deposition I*, also from 1960, in which the body of Christ is held aloft as if being lowered from the cross.[1] Here, one emaciated body is shown merging into a large sculptural mass, the upper body losing definition as flesh and earth fuse into one. Similar ideas of animate and inanimate nature interlocked are found in other of Zajac's works from the era, including a long series entitled *Metamorphosis*.

Ted Weiner made Zajac's acquaintance through a mutual friend not long before the artist returned to Rome from the United States in 1959. From Rome, Zajac wrote to Weiner in March 1960 asking him to help finance the casting of new bronzes in exchange for discount prices on any selected works.[2] Weiner agreed, which led to his acquisition of both *Deposition I* and *II*. Casts of these and other smaller works were made at the Nicci foundry in Rome. Zajac wrote on June 4 to say that the mold makers were starting to work on the casting molds for both *Deposition I* and *II*, and then reported on August 22 that he had seen the bronzes and thought they were "perfect."

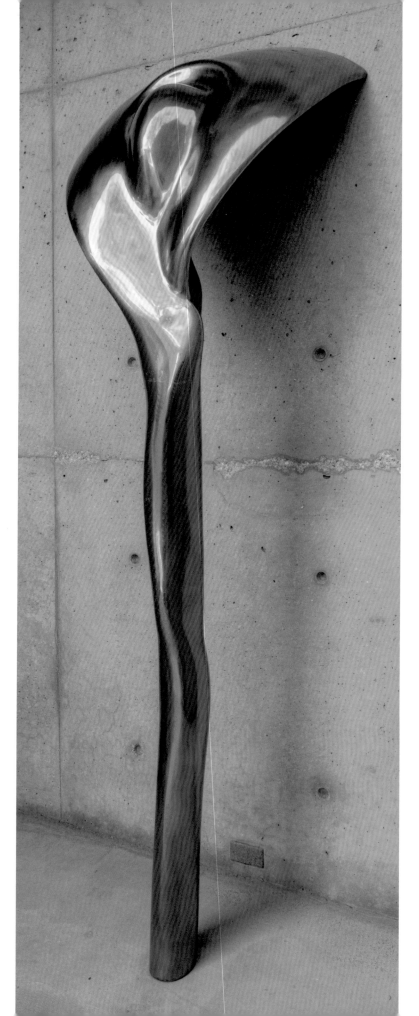

Jack Zajac
American, born 1929
Falling Water II, 1966

IN A SUDDEN DEPARTURE FROM his earlier expressionistic work with human and animal themes (see previous page), Jack Zajac began around 1963–64 a long series of highly abstracted, sculptural depictions of falling water. Living in Rome at the time, he was inspired by the "poetic caprice of water and the simple and enduring act of nature"[1] in the streams and waterfalls he viewed during train rides through the Italian countryside.

Many variations on the theme exist in different sizes and materials, including bronze (with different finishes), marble, wood, and plaster; and all bronzes were cast in editions.[2] The basic compositional form is a tall column with wavy contours and polished surfaces to suggest not just metaphorically, but physically, the vertical flow of water. Proportions vary from work to work—some are taller, some more slender, and some have wider "hoods" at the top—and the patterns of interflowing waves also change. With early examples such as *Falling Water II*, the tops are attached to walls or plinths, as if the water were emerging from those supports. But in later variants, the columns are broken roughly at the top and the sculptures stand vertically in isolation, giving them a more abstract, less depictive quality.[3]

The choice of falling water as a subject was an audacious one for Zajac. The problem was to give solid form to the ungraspable and constantly changing nature of a waterfall in a way that produced objects with independent aesthetic identity but that also captured the essence of the subject. Zajac's elegant solutions, with their distilled and purified forms, extend the traditions of Constantin Brancusi and Jean Arp, who also sought to interpret in sculpture the vitality of nature.

Bronze; edition of 4 (cast at Fonderia Olmeda and Fonderia Nicci, Rome)
94 x 28 ½ x 19 ¾ in. (238.7 x 72.4 x 50.2 cm)
Collection of Gwendolyn Weiner L2012-17.4

Provenance: Collection of the artist; to the Weiner collection, 15 November 1968

Literature and exhibitions:

Jack Zajac: Recent Sculpture, exh. cat. (Los Angeles: Felix Landau Gallery, 1967), cat. no. 7B (different cast)

Jack Zajac: Retrospective Exhibition, exh. cat. (San Diego: Fine Arts Gallery of San Diego and Santa Barbara: Santa Barbara Museum of Art, 1975), cat. no. 46 (different cast)

David S. Stevens Schaff, "An Interview with Jack Zajac," *Art International* (October 1975): 35

Extended loan, Museum of Texas Tech University, Lubbock, 1980–2012

[1] Quoted in *Jack Zajac: Falling Water: 1962–1987*, exh. cat. (San Francisco: Stephen Wirtz Gallery, 1987), 5.
[2] A second smaller waterfall sculpture is in the Weiner collection (*Falling Water VIII*, 1968, 48 in. high), also in polished bronze and very similar in composition to *Falling Water II*.
[3] For examples of later works, see *Zajac: Falling Water*, 18–31.

Credits

Index

Page numbers for illustrations are in italics.